Bernar Venet

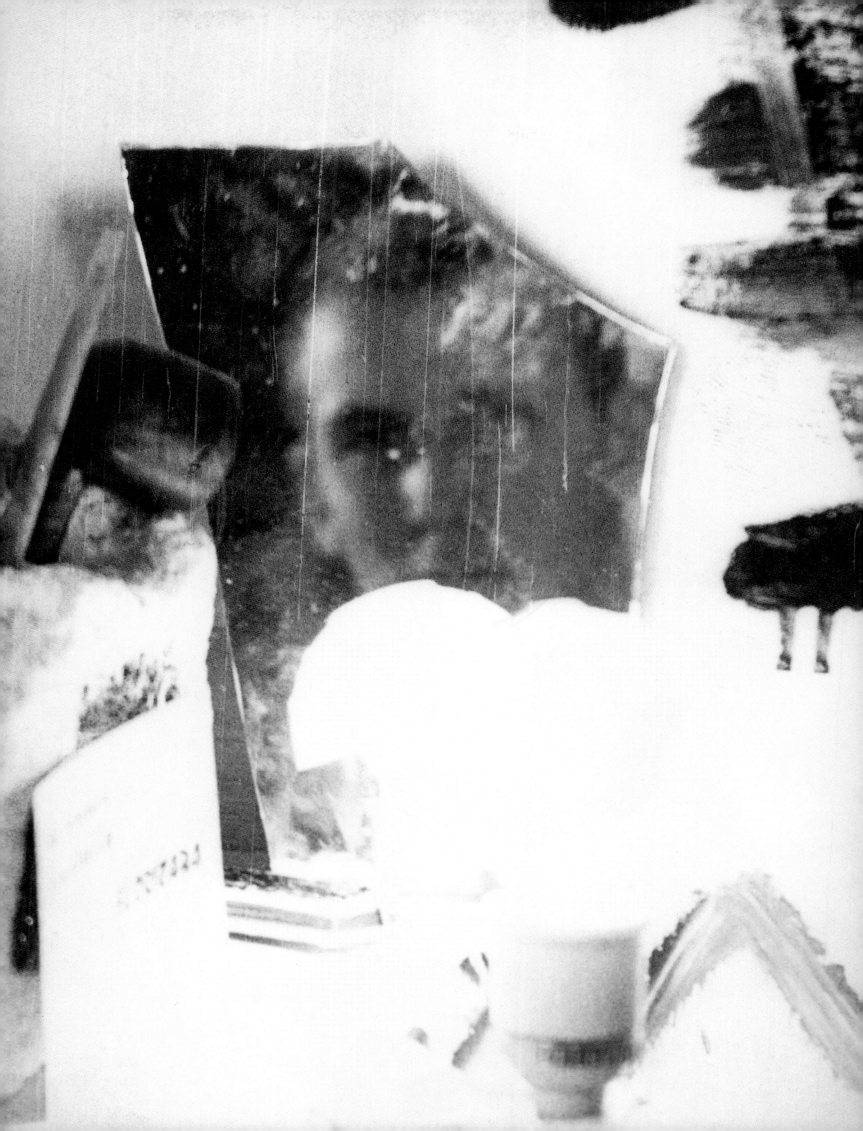

Thomas McEvilley

BERNAR VENET

ARTHA / BENTELI

SUMMARY

DISPLACING THE GRAVITY OF THE SELF

Thomas McEvilley

Bernar Venet was born into a working class family in Saint-Auban, an industrial city of perhaps 5000 in the Haute-Provence Alps. In 1955, when he was 14, his father died, and his mother had to support her four children as a typist. By the time he was ten years old the young Venet's skill at drawing was recognized in school, and his mother began to acquire books on art for him. By age 14 he knew the work of Van Gogh, Goya and Velasquez, had become aware that the profession of artist existed, and was irresistibly drawn to it. He began to sell his seascapes (oil paintings, roughly Impressionist in style) in local villages. Gradually Modern art, which was barely known in the area, began to get through to him. He discovered Picasso at age 14, Klee at 16, and at 17 got a Skira book on Modern art in general.

Venet stopped school two years before the baccalaureate and, at age 17, moved to Nice on his own. Nice was the only city of any cultural pretention in the region, and Venet eagerly entered its milieu, becoming an assistant to the decorator at the Opera, where he worked for two years.

Under the clear Mediterranean light something inevitable seemed to begin. Venet encountered Ben Vautier on the street in 1959 and subsequently met Arman at Ben's house. Arman, with his gracious and generous personality, became important in his life; and they are still good friends. Soon Venet met the great theorist of Nouveau Réalisme, Pierre Restany, at Arman's house. Without realizing it he was being absorbed into the artistic lineage which would soon become known as the School of Nice. But just as the cherished profession of artist seemed to be getting closer, Venet was deeply disappointed at being rejected by the School of Decorative Arts. Still, for a year he went to a nearby, if less prominent, art school – the municipal art school in Villa Thiole – and in 1960 began making paintings somewhat in the style of Klee, with primitivist influence. His first exhibition – of paintings and drawings – took place later that year in Saint-Auban, in a municipal recreation center.

Meanwhile the streets of Nice were lively with new currents. Venet encountered an entirely different sense of art through his acquaintance with Ben, who introduced him to the influence of the Zero Group in Dusseldorf. The young Venet was about to be drawn from a conventional art school-induced approach to art toward an avant-gardiste or "anti-art" position. In 1961, at age 20, torn between what he had learned in art school and the vague idea of freedom evinced by Ben and his talk of the Zero Group, Venet enlisted for his mandatory two years of military service. For a year he was stationed at Tarascon, near Marseilles, then for ten months in Algeria in 1962. There were 500,000 French troops in Algeria at the

time, but this was the turning point of the war; the ceasefire was declared in March. Venet saw the end of the war, after 2,695 days of violence.

Meanwhile, across the Mediterranean, the world in which Venet was about to emerge as an artist was characterized by Europe's post-war mood of redefining itself through the founding of movements. Lettrisme, one of the most radical, appeared in Paris under the leadership of Isidore Isou in 1947. It was a post-Dada attempt to return to infancy through a cultivated incoherence. It was soon followed by Situationisme, which had distinct leftist, Utopian associations, and the Zero Group began ten years later in Cologne. The artistic cult known as Nouveau Réalisme would be formed, with Restany as its prophet, in Paris in 1960, and the School of Nice would be declared in 1961.

Viewed historically, the various avant-garde movements that sprouted after World War II – not only in Europe but in Japan, Brazil and elsewhere – may be seen as transitional between Modernism and post-Modernism. They were all premised on the idea that Modernism had failed – its great adventures had sunk into the filth of war – and they tended to reverse its values. Modernism became anti-Modernism and art became anti-art. Nouveaux Réalistes, the most important such group in France at the time, was founded in 1960 by Yves Klein, Arman, Jacques de la Villeglé, Jean Tinguely, Daniel Spoerri, Martial Raysse, Raymond Hains, and François Dufrêne (César and Rotella being absent) with a manifesto, written by Pierre Restany, that was influenced by both Futurism and Dada. Nouveaux Réalistes was in fact sometimes (over Klein's objections) called Neo-Dada (as Pop art was in New York a couple of years later), and it fed into the stream of emerging anti-art enclaves that included the Zero Group, Fluxus, Cobra, and others. Venet was about ten years younger than the Nouveaux Réalistes, and theirs was not exactly his world, but a legacy he would inherit.

The School of Nice was declared into existence in 1961 – the first year of Venet's military service – by Klein, Arman, and Raysse. Historically it was a sub-category of Nouveau Réalisme, but anti-Parisian. These young artists saw the School of Paris as hopelessly immersed in Modernism as defined by the tradition of Cubism, the example of Matisse, and the post-Impressionist styles of Bonnard and Vuillard. That Paris also had emerging anti-art movements did not seem to cancel out the polarity. Though the three founders of the School of Nice may originally have meant the designation as a joke – proclaiming their small-town home to be the real cultural capital, not Paris – it has come to seem, over time, that more than a joke is involved. Seen as a historical force that perhaps went beyond its founders' intentions, the School of Nice includes (in addition to Klein, Arman, and Raysse) César, Ben, and Venet. There are in fact meaningful ways in which these artists belong together; those who were Nouveaux Réalistes tended to use found or appropriated objects (though in Venet's case it was more a question of found intellectual objects,

like the mathematical formulae he would later work with). They tended to share a desire to narrow the breach between art and life which had become scandalously wide in the age of Late Modernist abstraction. And above all there was an actual lineage or brotherhood among them, a warmth of feeling that reflected their origins in the sunny South by the blue sea.

Venet was very aware of this group, but he was ten years younger and his situation was different. "My discovery of Yves Klein," he would later say, "enabled me to switch from formal painting to surface painting." Surface painting indicates a non-representationalism like that of Minimal art, not exactly metaphysical as in Abstract Expressionism but clinging to the surface in a renunciation of the idea of the painting as a window on the wall. "Nevertheless," Venet went on, "I took exception to the excessive charm of [Klein's] blue, red or gold monochromes, which were the consequence, in my opinion, of an idealist approach."[1] The idealist or mentally based approach implied, by negation, a more materialistic approach that was not yet apparent but which Venet was inarticulately seeking.

Though he did not altogether agree with Klein's approach to art, he admired him and acknowledges that Klein (who would die in the following year) influenced the overall shape of his career. Klein, he later said, "enabled me to develop my ideas not only in the field of painting, but also (…) in disciplines such as sculpture, photography, performance art and music."[2] This multi-genred career was a part of the new spirit that was in the air.

One of the premises of the anti-art movement was the dissolution of the traditional boundaries that had kept artists engaged as specialists in a single genre. In the Renaissance an artist might pursue more than one medium – Michelangelo, for example, was painter, sculptor, and poet. But by the baroque period, and even more in succeeding centuries, most painters were simply painters, most sculptors were simply sculptors, and so on. In the 1960s and 70s many western and some non-western artists were restless within these boundaries and sought a broader field of expressiveness which might include any style, any genre, and any material. Klein had been painter, sculptor, performance artist, proto-conceptual artist, writer, composer and theatrical promoter. Venet similarly has stretched the inherited boundaries, his oeuvre containing paintings, sculptures, performances and Conceptual works in about equal measures, along with films, poetry, music, and a ballet. This type of career – in which the artist does not restrict himself or herself to a particular medium or genre but regards them all as his or her domain, is characteristic of the end of Modernism and the beginning of post-Modernism. Klein's career was one of the models. Other careers which follow this loose pattern include Joseph Beuys, Dennis Oppenheim, Jannis Kounellis, Marcel Broodthaers, and Lucas Samaras.

In other ways too the avant-garde movements of Venet's youth provided a freedom, or sense of permission – an escape from the Villa Thiole. As he would later put it: "To reach the point (…) of introducing chance, complexity, indeterminacy and above all unpredictability (…) I had to emancipate myself from the constraints that were imposed on me at the start."[3]

Venet suffered from asthma to such an extent that during his military service he was relieved of much physical labor. Instead, he walked in the countryside a lot, and developed a studio in an unused storage room in the barracks, where he worked on the resolution of the contradictory suggestions about art he had received. Rather than try to paint in some subversive way he, like many artists of his generation, chose to renounce the use of paint altogether. Paint seemed complicit with the suspect trickery of representation. Renouncing the illusionism of paint, Venet began to make "paintings" with tar, seeking "an anti-idealistic art founded exclusively on materialist premises."[4] And this preference for degraded and industrial materials rather than the colors of illusion has remained. "The materials Venet uses," one writer has noted, "are, quite literally, ignoble [and] nothing the artist [does] seeks to sublimate or redeem them."[5] The result is "a form of art that is strongly, deliberately devalued."[6] The grisly tar-sticky surfaces were meant to directly counteract the effect of Klein's somewhat gaudy transcendental monochomes, to bring the idea of the monochrome down to earth, into the realm of matter.

Seeking a way out of the formalist dead-end of "touch" which had dominated the art of the 50s, Venet at first manipulated the tar with his feet. By this displacement, one writer has noted, "The 'touch,' with all its artifice, was abandoned."[7] Perhaps it was not that simple, but at least, one can say, an attempt had been made to abandon it, though it still persisted as a problem. While not overtly a Marxist, Venet was working on the project of returning art from representation to material presence. "What I was doing," he later commented, "was not motivated by idealist thinking. I was not trying to create the ultimate painting in the manner of Rodchenko."[8] Instead, like Carl Andre using ordinary builders' bricks several years later, Venet was attempting to develop a constructive approach which might suggest that art was a socially useful activity.

Out walking near Marseille one day during the time of his military service at age 19, Venet came across a vertical cliff down which someone (a construction company, a road-builder?) had dumped a truckload of tar. The material had first flowed downward, then cooled and hardened. This was exactly the situation Robert Smithson would create with *Asphalt Rundown* eight years later. For Smithson it would involve a parody of a gigantic brushstroke. To Venet it somewhat similarly seemed like the surface of a painting, but natural, random, without color or image – and also without touch: the hand that had produced it was gravity. This was the moment when the theme of gravity entered Venet's work. He saw the surface of the rock face as like his tar paintings but free-er, less constrained by the artist's act, which his footwork had not managed to eliminate altogether. (Klein had perhaps come closer by using a roller.)

Venet returned to the site with a friend who photographed him standing, back toward the camera, gazing at the cliff face, as if in a major moment of recognition. Back in the barracks he began to make "tars" in which he would spread the material on the canvas with a scraper, then set the canvas upright so the tar

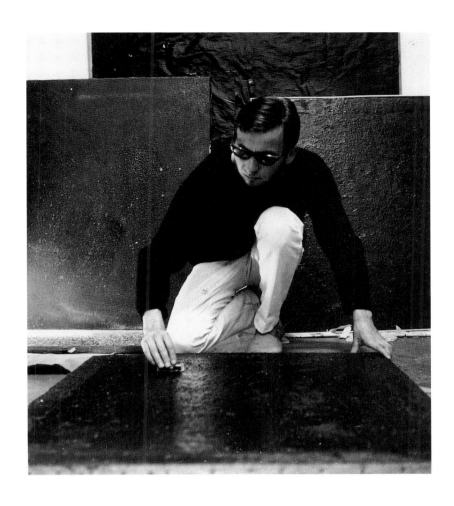

Bernar Venet, Nice (France), 1963

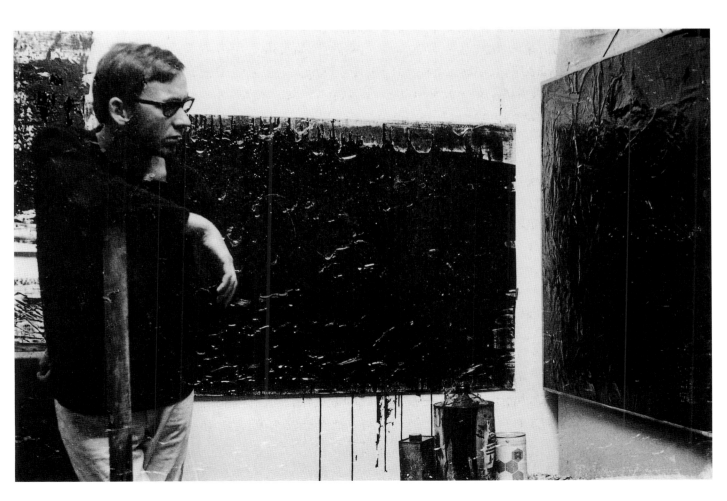

would slowly flow down the surface, then harden into a dark form. He was seeking a surface that was not decorative and idealistic like an Yves Klein monochrome – a surface that was simply itself, without aspirations of transcendental representation. "Tar," he later said, "suited me on account of its plainness."[9]

Art-historically, the *Tars* belong in the anti-Modernist category of the Attack on Painting, or the Attack on the Pretty Picture, which held sway around 1965-75. They are still to a degree connected with late Modernism. Pollock, for example, had pioneered the use of industrial materials in the form of Duco car enamel, and his process of flinging and dripping relates to Venet's use of gravity. There is also a historical relationship to Malevich's *Black Square* of 1915 which became an icon of anti-painting in the works of Late and post-Modernist artists as varied as Jannis Kounellis, Pat Steir, Mel Bochner and Richard Serra. In another sense that Venet may not have been consciously thinking of, the *Tars* may be regarded as attempts to get back to an absolute beginning, as tar is associated with geological finds that have preserved remains from the Jurassic age, such as the famous Tar Pits in Los Angeles. There is an implied reference to Prime Matter, a dark, unseeable substance that precedes all form but provides the material, which can be shaped into forms. Venet was not heavily burdened by art training or education; nevertheless, at age 20 he seems to have felt a strong impulse to get back to a ground-zero where he could begin all over again.

It was specifically art history that was to be melted down and born again in new form. This was the moment of the dawning of the anti-art impulse. Everyone felt it. For example, the early works of Dennis Oppenheim, a contemporary of Venet's, show a similar attempt, in works such as *Sitemarkers,* 1967, to find a primordial location for art in the world, as if no art institution had previously existed to present a location for it. Smithson, Kounellis and others would soon address the same problem. Venet was in the forefront of his generation, but nevertheless a part of it.

The *Tars*, his first works outside the bounds of representation, developed into a phase in which the dense black substance was applied to folded pieces of discarded cardboard. Torn and walked-on pieces of cardboard were like leaves in the urban gutter that anti-art longed to re-enter after its long trance of beauty. The use of degraded or industrial materials was a basic theme of the emerging anti-art movement, but Venet was perhaps the first to enunciate it. His *Cardboard Reliefs* appeared in 1961, two years before William Anastasi's folded cardboard works and eleven years before those of Robert Rauschenberg.

Venet's concern for what he calls "poor materials" anticipated by several years Germano Celant's phrase "arte povera." For all its simplicity, the "poor material" accomplished several ends. It enabled him, he says, "to produce works from industrial materials, cold and uncraftsmanlike." This desire for coldness was a forecast of the electrical interaction with American Minimal art that lay ahead. In addition, Venet's developing sense of materials bypassed the problem of representation that had led Modernism into the abyss of illusion. "A cardboard relief," as he says, "is a neutral object. It means nothing." Through this

coldness the material escaped the self-indulgence of aesthetic art's appeal to subjectivity: it was to be "depersonalized" rather than "expressive."

Venet's tar paintings were inversions of everything he had tried to achieve with his juvenilia based on the style of Klee. Unaesthetic, even anti-aesthetic, industrial rather than transcendental, abjuring the quality of touch, they were contributions to the anti-painting movement which was getting underway in Europe, the United States and elsewhere.

Still in his years of service, Venet made inroads into the use of randomness, which was at the time a kind of unknown force, explored by Duchamp, then long neglected. In *Realization in Three Seconds of Four Drawings in India Ink*, 1961, he laid out four sheets of paper continuously, as if they made up a long scroll, on the floor of his storage room-studio. Gripping an open bottle of Indian ink in his right hand he leaned lengthwise over the papers and flung the ink along all four of them, then separated them into four "drawings". The work connects with Duchamp's *Three Standard Stoppages*, 1915 – both in its precise science-like instructions and in the desire to come up with a line that was not conceived through aesthetic feeling – and of course with Action Painting, which in turn had the Chinese Flung-Ink style of calligraphy in its background.

Randomness or unpredictability later came to permeate Venet's work. Some of the *Cardboard Reliefs*, for example, Venet painted with a single color. But as time passed and one of them might end up in other hands, the new owner was encouraged to repaint it, every few years, in a different color, without consulting him. In fact, he declared that if they were not repainted by others for a long period of time he would renounce them: if they were no longer being randomly reconceived, then they were no longer his work!

Venet was trying to find a way to see himself – or to depict himself to himself – and at the same time hoping to eradicate any possible depiction of himself, to escape the bounds of definition in the name of existential freedom. Two months after seeing the tar cliff, now age 20, he arranged to have himself photographed, shirtless and shoeless, lying like a derelict, drunken or otherwise unconscious, in a heap of litter – old boxes and paint tins, empty food and oil packages, scraps of paper, garbage cans. The *Performance in Garbage* was in the ancient tradition of Diogenes, who lay around the streets with the dogs as a rebuke to bourgeois life-styles; more recently, in terms of art history, it hearkened back to iconic performance works of the School of Nice.

In 1958 Klein did his famous performance-installation *Le Vide* ("The void"), in which the Iris Clert gallery in Paris was emptied out and exhibited by itself. In Kleinian fashion, the work was a statement of transcendental idealism, positing a higher metaphysical reality that underlies the world of form and can be approached by bypassing it. In the following year Klein's co-founder of the School of Nice, Arman,

produced an installation called, antithetically, *Le Plein* ("The full»), in which the same gallery was filled from floor to ceiling with literal garbage brought by City of Paris garbage trucks.

Arman's work seems to have involved a counterstatement to Klein's transcendental idealism. He comes down on the side of ordinary reality, as *Le Plein* asserts the priority of the object over its absence, and of the street-level of life over the transcendent purity of The Void.

Venet's *Performance in Garbage* clearly takes sides with Arman. It underlines the correction of Klein's proposal. "I opted," Venet has said, "for matter and gravity, not for the void (…) I was rejecting illusion."[10]

There is an even more direct relationship between the *Performance in Garbage* and Klein's most famous performance work, the *Leap into the Void*, 1960. In that definitive and iconic piece, the artist was photographed leaping upward, as if into flight, from a second floor ledge in a Paris street (while a bicycle pedalled by below, in the old mode of locomotion). Klein seems to be launching himself upward into the freedom of space, while Venet lies crumpled below, entrapped in matter. The two photographs are antithetical icons from the moment of the turning of Late Modernism into post-Modernism.

Arman's *Le Plein* had formed an antithetical pair with Klein's *Le Vide,* redirecting attention downward into the street and the earth below it. *Le Plein* evoked the rotting level of life in which bodies metabolize substances and turn them into detritus which in turn becomes the seed-bed of new life.

The antithetical linkage between *Le Vide* and *Le Plein* is mirrored in even greater intensity in the performative gestures of Klein's *Leap into the Void* and Venet's *Performance in Garbage*. Venet shows (or reveals) the Leap's true, not wishful, consequence: the Fall, which Klein had always concealed and prevaricated about. While Klein faked the upward flight, Venet showed its true aftermath, affirming the reality of matter and its laws over spirit and its aspirations to escape. He presented the crumpled and seemingly broken body of the would-be Icarus after he has fallen to earth.

But the *Performance in Garbage* needs to be viewed in a larger context than the School of Nice. It was an early and iconic crystallization of the anti-art movement in a more global sense. Stated simply, its subject matter is the demystification of art and of the artist's role. In a symbolic sense garbage represents the fact that organic things die, decay, and become loam or fertilizer. Though this might be regarded as a universal condition, in the Late Modernist (or Romantic) period the artwork came to be regarded (because of its traditional religious connections) as transcending this process. Because the artwork, supposedly, participated in Platonic Ideas such as Pure or Eternal Beauty, it was regarded as unaging. In the writings of Romantics such as Schiller the person of the artist (or poet), as well as his work, was described as transcending the world of flux and somehow participating directly in eternity. What was so radical in the blunt statement of Venet's *Performance in Garbage* was that he located the figure of the artist within the garbage-reality of bodily life, death and detritus. No longer to be seen as a being above the level of transient things that come and go, no longer a creature almost transformed into an angel, the artist was

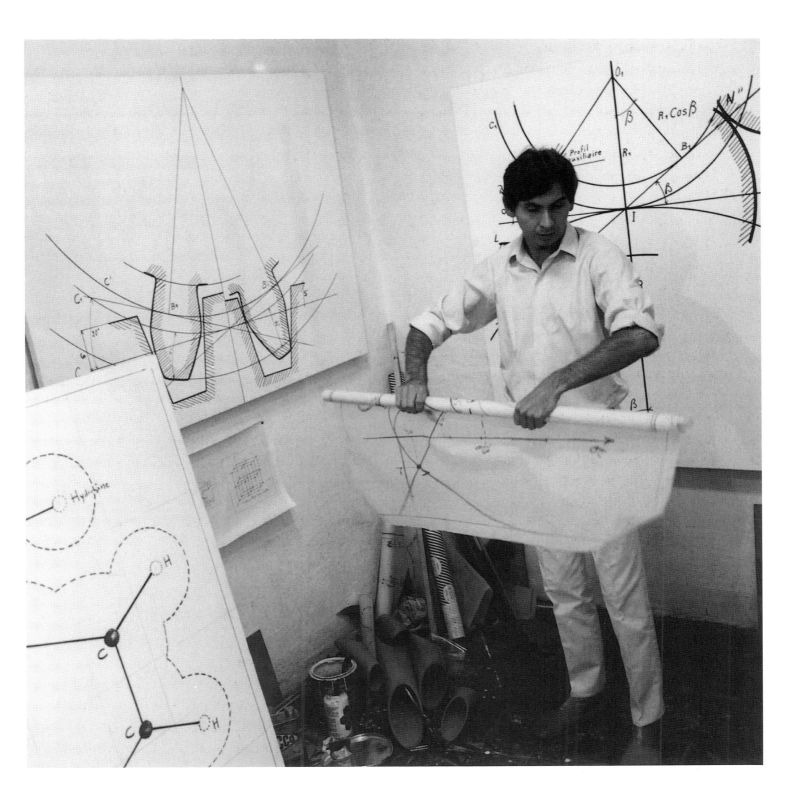

now seen as a being of the underside of things, a part of the underlying process of living and dying, the heaving of the sod beneath it all. It is the death of the old and the (re)birth of the new kind of artist that this seminal and formative work signifies – the descent into the abyss in which the artist can lose his former identity and re-emerge having remade himself.

It was 1963. Venet was back from military service and trying to penetrate further into the difficult value of the random. Happening to see a pile of gravel mixed with tar while walking by the Hôtel Ruhl in Nice one day, he again felt the tug of attraction, as at the tar cliff. He had already articulated, in the *Performance in Garbage*, the idea of a random heap constituting part of an artwork. In a general theoretical sense the random heap of detritus was a possible solution to the over-control of form that had ossified Late Modernism. Standing near the Hôtel Ruhl, faced with the pile of gravel and tar, Venet experienced a breakthrough in his freeing from "constraints." It occurred to him to change the material in order to increase the ephemerality and indeterminacy of the piece; tar mixed with gravel hardens into a fixed shape, like a traditional sculpture. Instead, Venet erected *Tas de Charbon* ("Coal Pile") in the workspace of the decorator's shop at the opera. He photographed it, had himself photographed with it, and brought people to see it as a new type of artwork characterized by indeterminacy and lack of definition. In the following year he tried to exhibit *Tas de Charbon* in Paris, but found no one who would take it seriously; even the Nouveaux Réalistes were not ready for it. (It was finally officially exhibited, at the Galerie Templon, in the early 70s, and has since had about 15 different incarnations in museums).

Tas de Charbon was the work that freed Venet from the constraints with which he began. A work that has no specified shape or dimensions, it is installed loosely in response to the dimensions of the venue. It never exists twice the same, and hence is ephemeral. Lacking dimensions, it is indeterminate. Since it is not precisely arranged but loosely thrown down, it involves randomness and unpredictability. Even more than the *Tars* it is created by gravity.

In addition to its importance in Venet's career, the *Tas de Charbon* was a milestone in art history. Somewhat similar works have been made by several artists of about Venet's age who were similarly dedicated to the project of reconceiving art or creating an anti-archetype to its aesthetic mode. This impulse involved the idea of going back to a primal beginning before control had been enforced on things. In the anti-Modernist mood that was emerging in the 1960s, the Modernist artwork's elaborate degree of finish and control was seen as draining life from it and rendering it artificial. There was a widespread desire to undo control and return the material to its original state, before any preconceived form had been enforced on it. A disbelief in the whole project of civilization seems involved, a sense that we

might be better off going back to a state before a certain form of civilization had imposed its definitions on everything. Putting it crudely, this was a nostalgia for something like an innocence before the mind had been corrupted by overcontrol – a desire for a state from which a new beginning might be made.

It was as if history had assigned this project to a certain generation of artists. Many thunderously great works enunciated the plain facts of existence. In 1964 William Anastasi constructed a stack of plain bricks in his studio and designated it an artwork (he has never publicly exhibited it.) In 1966 Carl Andre exhibited several symmetrical stacks of bricks in the Tibor de Nagy gallery. In 1969 Dennis Oppenheim designated as his artwork a shipload of unrefined cement. Starting about 1968 Robert Smithson exhibited various works of this type, from his *Non-sites* (bins of uncut rocks) to a heap of gravel *(Gravel Corner Piece*, 1968), and, in 1969, a heap of broken glass. Kounellis presented various exhibitions of heaps of coal beginning in 1967 – and so on. But there is something special about Venet's *Tas de Charbon*, something genuinely primordial: it seems to have been the first recorded act of designating an unaltered and unmanipulated natural material as a work of art – the first clear gesture of undoing what civilization had done by revealing the clean slate again.

The series of realizations and developments Venet had gone through to this point consisted primarily in removing from the artwork the traits (color, form, etc.) that had long been associated with aesthetic pleasure. "Already," he says of these early years, "I was convinced that art is not made for pleasure but for knowledge."[11] The urge to eliminate the pleasurable elements is a puritanical urge, suggesting a serious, even somber, point of view. In that period of his life, as Venet later recalled, "Darkness and sobriety surrounded my universe. The use of stylistic devices, color and the spectacular, seemed childish to me."[12] This youthful asceticism would grow, till it had his work, and him, in a kind of stranglehold from which he had to make an escape.

In 1966 (at age 24) Bernar Venet went to New York for the first time. Later in the year he moved there for good. What convinced him was a kind of revelation which occurred at the Whitney Museum of American art. There, soon after his arrival, in an iconic moment like that of facing the tar cliff in nature near Tarascon, or the tar and gravel heap by the Hôtel Ruhl, he attended an exhibition of contemporary American sculpture. This was "The Jean and Howard Lipman Collection," including works by Donald Judd, Dan Flavin, Carl Andre, Sol LeWitt, and others. Venet remembers keenly the "shock" of the work he saw there, which forced him to the surprising realization that "my intentions (…) were closer to those of the American artists than to the Europeans."[13] It was specifically the work of Minimal artists he was referring to, with their insistence on industrial inexpressiveness and their focus on the surface rather than the interior, in a rejection of implied depths in favor of a perceived and present surface.

Later in the same year, during a brief return to Nice, Venet was invited to exhibit at the Musée de Céret in a show called "Impact". Under the influence of Minimal sculpture he had arrived at the concept of the Tube – a sculpture consisting of a length of industrial tubing cut at different angles at the two ends. The first generation of *Tubes* was made of cardboard; later that year he was able to acquire tubes of polyvinyl chloride. Years later, he would make larger versions in steel. Most of these works were painted industrial yellow (the cadmium yellow with which it is customary to paint cranes and other industrial equipment). "The tubes," he later observed, attracted him because they "… are (…) objects reduced to the greatest possible simplicity…"[14] In order to remove his personality from the process as much as possible, he stated that the length of a tube would be decided by someone else, perhaps a collector or a curator.

For the "Impact" exhibition Venet, short of funds, found that he could not afford to buy the tubing for the exhibition, and decided to show only the blueprint of a tube, indicating dimensions, colour, and material. "In the logic of my thinking," he said in a rather historic statement, "the presentation of this plan was equal to the object itself."[15] A week or so after the opening he began to reconceive the piece so that a physical length of tubing would lie on the floor, while behind it a blueprint of it was mounted on the wall. The serendipity of it could not efface the fact that he had come upon a major breakthrough.

It was in the unforeseen relationship between the sculptural and pictorial elements that a new arena for the meaning of art mysteriously opened up. The significance of this work involved the theory Venet was shaping out of his reading, especially of the works of the French semiotician Jacques Bertin. Reading a great deal of analytical literature was another trait of Venet's generation. Previously, in the Romantic era, artists were presumed either not to read extensively or to read primarily ecstatic poetry. Venet was of a different age, more rational than Romantic. Bertin gripped his imagination with a distinction among three types of relationships between signifiers and signifieds.

In what Bertin called polysemy, or multi-referentiality, the signifier can be interpreted as referring potentially to a number of different signifieds, but this number is finite; on the one hand, the signifier cannot be pinned down to a single exclusive act of reference, but on the other it also cannot be opened infinitely to any conceivable interpretation. As Venet considered this in terms of art, it seemed to him that this relation applied to representational art, where a single work can cooperate with a finite number of interpretations. Gericault's *Raft of the Medusa*, for example, can be seen in terms of the allegory of the ship of state, or of the struggle of the soul toward freedom, or as a record of a historical event. Bertin posited the category of pansemy, infinite- or all-reference, for situations in which signifiers can seem to relate to any signified whatever, a category that Roland Barthes and some other semioticians have called empty signifiers. In Venet's view this was a description of works of abstract art which, as Clement Greenberg had argued, were without any subject matter or reference. Malevich's *Black Square* is a classic example of an image where one can see anything or nothing. The window in the wall had been painted

over, ambiguously. A Mondrian, in contrast, might be viewed as occupying a position between polysemy and pansemy, with its references to a mathematically-ordered Platonic substructure of the universe. It is monosemy, the third and last category in the trichotomy, that is revolutionary. Monosemy, according to Bertin, means a situation in which there is one and only one possible relationship between signifier and signified. In a monosemic act of signification there is no escape from the object's direct objecthood; it simply is itself and refers only to itself, not to anything else. "In a sense," as one author has put it, "the monosemic function in art is about denotative significance as opposed to connotative interpetations."[16] What must be emphasized is that no one before Venet had thought specifically of a monosemic artwork; it was an unknown continent, like the polar ice-cap.

"Art history," it seemed to Venet, "has evolved up to now within the limits of the first two groups," polysemy and pansemy, or representation and abstraction. "It remained necessary to deal with the third one in order to leave the field of the expressive image and to investigate that of the rational image."[17] "What is at stake," he concluded, in the attempt to free art from the whims of subjectivity, "is the introduction of monosemy into a sphere from which it had seemed excluded."

In *Tube*, Venet realized, he had by serendipity come up with a work that seemed to qualify as monosemic – perhaps the first monosemic artwork. The locked-in quality of one-meaning-and-one-only – and that simply identical with the actual physical being of the piece – was achieved by the intersection of two vectors, one the physical tube on the floor, the other the blueprint-like plan on the wall. The tube points the viewer to the diagram as a plan of itself, the diagram to the tube as an embodiment of itself. The reference goes back and forth between these two instances of the same mathematics – and points to nothing else. There is no rhetoric involved. "The plan together with the tube," Venet says, "no longer allowed the latter to be seen as a symbolic object (for example a phallic symbol) submitted to everyone's free interpretation."[18] The addition of the blueprint "stops the flow of connotation."[19] "The work has no *subject*," one author has claimed; "the symbolic codes are thwarted (…) The only possible reading is a denotative one."[20]

Venet was beginning to realize a principle that would become basic to the rest of his work: that a conception can be realized in various genres or materials and, if the conception is truly maintained, the different forms are equivalents – as the sculptural tube and the blueprint of it are equivalents. The "rule" that was emerging was that "a message can be coded in various forms without being distorted or lost."[21] "The media (…) can be changed on condition that the contents remain identical."[22] The physical existence of the piece, as an existentially unique individual, had no special meaning. Meaning was involved only in the underlying sameness of the equations embodied in shifting forms.

One result of monosemy is that the tendency toward expressiveness is all but eliminated. Anyone could take, say, the specifications for *Tube* and make another instantiation of those specifications, and it would be the same as a work of Venet's. In fact, another artist could generate specifications for a different object,

based on the principles of Venet's process, make an instantiation of them, and the same would apply. The artist himself, it seems at this point in the argument, has practically disappeared from the process. The idea is reminiscent of Sol LeWitt's method when he makes specifications for a drawing, allows others to do the drawing, and signs it himself. It goes back in a sense to Barnett Newman's primal statement that he could send the specifications for a painting out to a sign painter and the work would be the same as his own.

On the surface Venet's idea of a work that simply states itself and does not refer to anything else sounds like the formalist theory that underlay late Modernist abstraction. In Greenbergian formalism the artwork was supposed to mean nothing beyond its own form or appearance; no reference of any kind to anything outside itself was acceptable. But this was a somewhat deceptive argument. There was, in fact, another reference involved in the work – a reference to aesthetic universals, or to the quality known in the Kantian tradition as aesthetic feeling. The work was not simply a mirror image of itself. There was a triangulation involved which can be formulated in at least two ways. First, the object (A) refers to a aesthetic universal (B) and, as the viewer gazes at it, his or her aesthetic feeling (C) picks up the reference and is aroused. Second, one might say: the aesthetic feeling of the artist's soul (A) produces the object (B) as a reference to it, and the viewer's own aesthetic feeling (C) picks up the reference. Monosemy, if purely realized, supposedly does not involve this triangulation. The monosemic work involves no reference to anything external to itself – not even to anything as indefinite as a feeling. Even that would be an external involvement, a triangulation. There were only two elements involved, the object and its self-identical meaning or self-reference. Even the maker was denied. His aesthetic feeling was declared to be subjective and irrelevant. Venet's approach, as one author said, was to "deprive the artist of his involvement in the act of creation."[23] As Venet himself put it, "My work is a manifesto against aesthetics, against the expression of the individual's personality."[24]

This ambition was, of course, the opposite of the traditional ambition of western art for the previous couple of centuries, which was to attain the most intense and focused expression of the artist's individual sensibility. So in a sense one could appreciate what Venet has achieved here as a liberation, a freeing of art from the whims of subjectivity. But in another sense it could be seen as an imprisonment, a closing off of options till no choice remained. To focus in on this negative aspect of monosemy one could reflect on the locution "this phrase," which invokes a similar lack of options. The locution "this" is indefinite or polysemic; it could refer in a variety of ways. The locution "this word" is also indefinite, since it is unclear what word it refers to. But the locution "this phrase" can refer only and exclusively to itself. There is no escape from its self-reference, no escape into a world outside of it. It is monosemic, but it is also useless; it does no work of any kind in the world. It is perfect – but it is also a kind of prison or dead end.

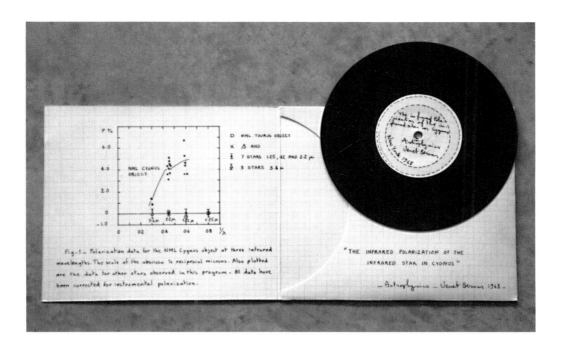

The Infrared Polarization of the Infrared Star in Cygnus, 1968
Record, Letter Edged in Black Press Inc.

Performance at the Judson Church Theater, New York, May 1968
(Jack Ullman, Edward Macagno and Martin Krieger)

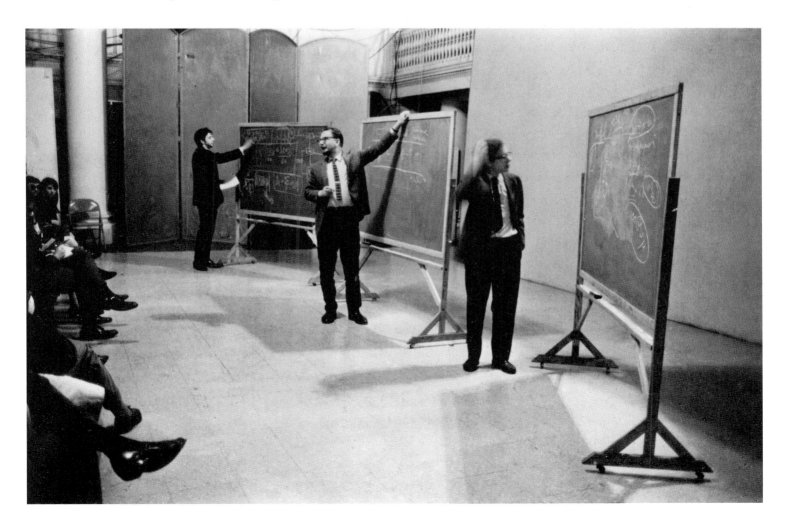

Toward the end of 1966 Venet moved permanently to New York (living at first in the School of Nice embrace of Arman's studio, which had formerly been Jean Tinguely's). Exhilirated by the breakthrough into monosemy effected in Nice by *Tube*, Venet was eager to extend his demonstration that the internal conceptual code of a work was more important than its medium, material, or genre. What was needed was to translate the monosemy of *Tube* into another medium. Following the guidance of the blueprint part of *Tube* he began making black and white photo enlargements illustrating mathematical-geometrical formulae.

These works are visually attractive without trying to be. Many of them have a simplicity rather like that of some Minimalist paintings – Robert Mangold's work is one possible comparison. *Vecteurs égaux-vecteurs opposés* ("Equal vectors-opposed vectors"), 1966, for example, was simply two parallel lines, of unequal length, running horizontally across the canvas; the title, which is a formal or geometrical description, is written below the image but within the picture plane, still a part of the picture. *Calculs de la diagonale d'un rectangle* ("Calculations of the diagonal of a rectangle"), 1966, is a classic or archetypal work – a right triangle with the Pythagorean formula for the calculation of the hypotenuse written below it. Some examples become more visually complex and flirt with the possibility of reference, such as *Représentation graphique de la fonction $y=-x^2/4$*, 1966. In such cases the conspicuous graphic element is in danger of setting loose a "flow of connotation" in the viewer's mind, leading to suggestions of external reference. But the phrase *Représentation graphique...* cannot be read simply as the title of the work, leaving the graphic aspect to create feelings in the viewer based on abstract forces and their interactions. Instead, the "title" is actually part of the picture. "It is in the same frame (...) on the same plane as the graphic representation."[25] As in *Tube*, the viewer's mind is held back from the flow of connotation by the dead-end or endless-loop relationship between the visual and verbal elements. Directed to go back and forth between these two conceptually identical aspects, the mind finds no escape into imaginative interpretation.

Duchamp's declared desire to return art into the service of the mind meant to abolish its traditional connection with religion, and force, instead, a new bond with science. Venet seems to have shared such feelings. In 1966, still exploring his new environment, Venet became acquainted with astrophysicist Jack Ullman at Columbia University, and through him with other scientists. In 1967 he went with Ullman to the annual meeting of the American Physics Society in a hall at the Hilton Hotel, where he tape-recorded a lecture on theoretical physics. Later he played the tape back to a group of artist-friends in his loft, declaring that the act of presenting it was an artwork of his own. The event bears a certain similarity to the Art and Language group's practise of publishing an essay as an artwork, which began in the same year, 1966-67.

Over the next three years, Venet made ten recordings of scientific lectures and presented them as his artworks. He would put the tape recorder on a sculpture pedestal beneath a wall-plaque which expressed in mathematical formulae the propositions being discussed on the tape. As with *Tube*, the two components of the exhibition had the same inner structure and contents, pointing back and forth to one another without making triangulations or external references. Sometimes the mode of exhibition was more performative, as in an event that occurred at the Judson Church Theater in Manhattan on 27 and 28 May, 1968. On each night the same three pieces were presented. First, "the physicist Martin Krieger [lectured] on 'Neutron Emissions from Muon Capture in Ca^{40},' with slide projections." Next, "three physicists (…) gave three lectures simultaneously in front of blackboards." Finally, "Stanley Taub, a doctor of medicine, helped by an assistant [spoke] on 'The Speech Mechanism' [and] his discoveries on the possibility of using an artificial larynx (…) Two films were shown and a video camera employed."[26]

Throughout the series of ten lecture-pieces, which transpired between 1967 and 1969, Venet attempted to eliminate his own sensibility from the process by delegating matters of choice to others. "The scientific subjects (…) were selected principally on the advice of Jack Ullman, but sometimes also on the advice of other physicists at Columbia University." He specifically requested that his consultants not use aesthetic criteria in their selections. "The criterion was the importance of the theory developed, and this (…) absolved the works from any aesthetic will…"[27] The word "absolved" implies that there is guilt in the exercise of aesthetic will, and Venet at that time aspired, as Duchamp had before him, to be absolved of that guilt. But – again like Duchamp – Venet felt he had to go farther still in seeking this absolution.

Perhaps the most extreme anti-art gesture is for an artist to stop making art on the grounds that he or she no longer believes in its premises. The prototype was Duchamp, who promulgated in the 20s the falsehood that he had quit art for chess, and who in *1957 TK* made the famous assertion that the artist of the future would "go underground" – perhaps meaning that he would make art in secret (like the *Etant donnés* ["Givens"]). Evidently the connection between the artwork and the artist's ego or subjectivity was repugnant to him; it seemed to rob the art of any claim to validity. Duchamp seems to have specially focused his criticism on the cult of craftsmanship and the worship of the pretty object – that is to say, the fetishization of "touch" and aesthetic feeling. The rumor that he had quit artmaking for the pursuit of chess underscored the idea that he was abandoning aesthetic feeling in favor of cognition. When the anti-art movement came back and moved into full career in the 1960s and 70s, this, like the gesture of the Attack on Painting, became a standard formalization of anti-art feeling. John Baldessari was acting in this tradition when, in 1970, he burned his paintings, exhibiting the ashes in a cremation urn shaped like a book. The book shape indicated, as in Duchamp's reference to chess, a preference for cognition over aesthetic

feeling. The emphasis on cognition exactly matched Venet's uneasy feeling, as early as his military years, that art should strive for knowledge rather than pleasure.

Venet's handling of this motif was unusually uncompromising. It was not merely a gesture but, in its intention anyway, a real alteration of his life's course. It comprised an out-and-out declaration that he would quit making art absolutely, in any mode whatever, after certain projected pieces were completed. He would, by that point, it seemed to him, have completed all the work that was proper to him in terms of his difficult requirement that art, in order to be legitimate, had to be theoretically innovative. The procedure followed a somewhat theatrical format; it began with an announcement, early in 1967, that for the following four years Venet would restrict his activity to exhibiting a set of disciplines by various means, including photoenlargements, performance elements, tapes of lectures – after which he would quit art-making altogether.

The orientation of the project was an attempt to redirect aesthetic activity toward the mind. Venet tended to select theoretical areas that had long (since the Pythagoreans) been perceived as forms of intellectual beauty. In 1967 he would present the disciplines of Astrophysics, Nuclear Physics and Space Sciences; in 1968 it would be Mathematics by Computation, Meteorology and the Stock Market; in 1969, Meta-mathematics, Psychophysics and Psychochronometry, Sociology and Politics; in 1970, Mathematical Logic. (That final, culminating phase had an outspokenly Pythagorean-Platonic atmosphere.)

As in the lecture presentations, Venet removed himself from the decisions involved by relegating the selection of topics and works to experts in the various fields. "For each discipline," he wrote, "an expert will be consulted concerning the subjects to be presented (the standard of choice being based on their importance). Thus the plastic qualities which some people might notice in [the] work will be independent of my intentions"[28] "Their material and plastic characteristics [will be] independent from the concept, which alone takes precedence."[29] This programmatic attempt to eliminate subjectivity from the artmaking process as he practised it expressed a belief that cognition or rationality had a special claim to leadership among human faculties.

Toward the end of the project, Venet featured "book presentations" following a quasi-Minimal form. In *Elementary Number Theory*, 1970, for example, a book of that title by Underwood Dudley of DePaul University lay on a pedestal, open at its title and contents pages, which were reproduced on the wall just beside it. In such works, Venet relentlessly pursued his project of displacing the self and avoiding subjectivity. As one author has put it, he "eliminated all remaining traces of subjectivity (...) by substituting photographic enlargements for hand-made copies."[30] One might say that at last the element of touch was entirely gone. "The direct participation of the artist," as Catherine Millet has observed, "was reduced to zero."[31]

Furthermore, the works are monosemic along the lines of *Tube*, because the contents of the object on the sculpture pedestal are the same as those of the picture hung on the wall. As in *Tube*, there is no

possibility of external reference. The two objects refer back and forth to one another without offering any escape from the loop. In other works of the same period, Venet combined the use of found texts with the distancing of touch through photoenlargement, exhibiting newspaper columns about the stock market and newspaper weather reports (which Venet regarded as implied landscapes). In the 1970 show *Information* at the Museum of Modern Art in New York City, Venet had a television set installed in a gallery with instructions to the staff that it was to be turned on for programs dealing with the Stock Market reports, and otherwise turned off. This was a seminal instance of the use of video or broadcast TV in an art setting.

In Venet's determination to act out the profession of artist with all possible integrity, his withdrawal from the field seemed inevitable. It followed from two difficult principles he had articulated in the austere or renunciatory years before 1966: 1) "It's not art if it's not changing the history of art"; 2) "The history of art is the history of the evolution of the theory of art."[32] The bottom line, in other words, is that it's not art if it isn't changing the theory of art. So art, like various forms of philosophy, became Uroboric or self-devouring. As Wittgenstein said in the *Tractatus* that his propositions were a ladder that one should throw away once one has ascended it, so the practise of art, for Venet, was to be abandoned once one had shaped or reshaped its premises. Since the essence of the activity was to change the theory of the activity, and thus the activity itself, the activity existed only in the state of flux or becoming, always pursuing itself with its theoretical reformulations, the serpent biting its own tail.

In the 1960s Venet had in fact made significant alterations to the shape of art theory. The idea – and the practise – of monosemy amounted to an actual structural change, not just an attitudinal one. Venet's feeling was that aesthetic delectation was invalidated by its subjectivity, and relativity was an attitudinal change characteristic of the generation of artists who matured in the 1960s. Artists proposed various modes of escape from the aesthetic, such as ugliness (Joseph Beuys), anti-social performance (Vito Acconci), critical analysis (Joseph Kosuth), Earth Art (Dennis Oppenheim), and so on. Venet's solution can be seen as going further. While affirming the general attitudinal change, he suggested a more than attitudinal response. His use of the semiotic trichotomy – pansemy, polysemy, monosemy – by prying monosemy out of the heap of meaning and elevating it to the top, amounts to an actual structural shift in the theoretical landscape.

The youthful mood underlying such changes (Venet was only thirty in 1971) can be called puritanical, but this was not unusual for the time; much of the avant-garde or anti-art complex was driven by puritanism. Aesthetic delectation was widely seen at that time as a socially useless hedonic indulgence. In fact, it was not only seen as socially useless but often as socially destructive, distracting cognition from reality by flashing pretty pictures before it. As Venet had said, he felt that art should not be made for pleasure but

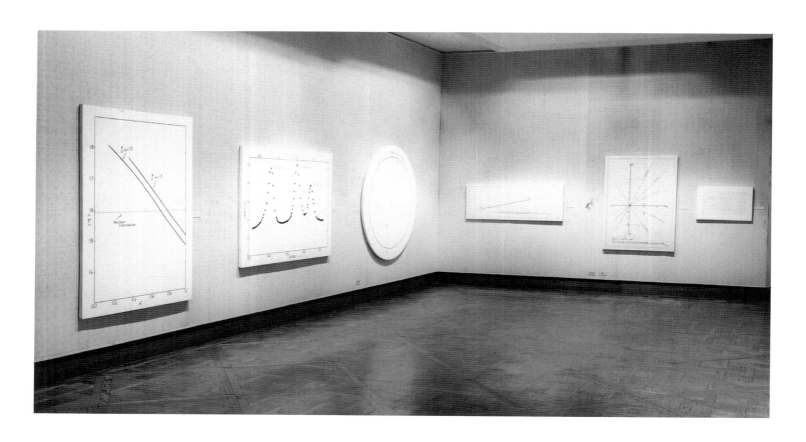

Retrospective *Bernar Venet*, New York Cultural Center, New York, 1971

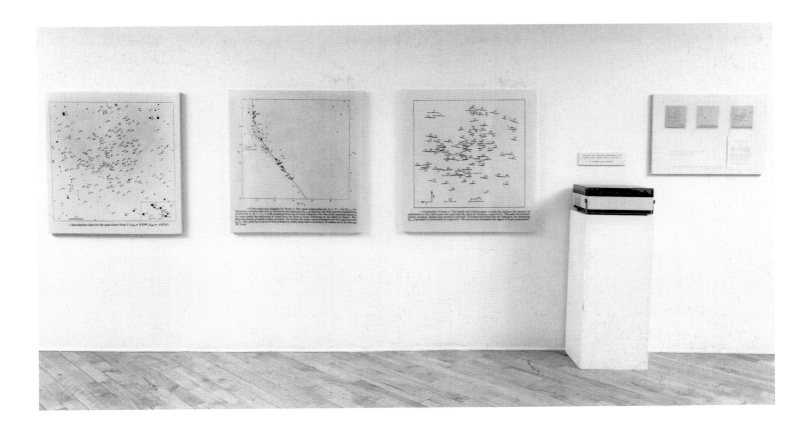

Photometric and Polarimetric Observations of the Nearby Strongly Reddened Open Cluster Stock 2, 1967-1968
Photographic blow-up and lecture on tape

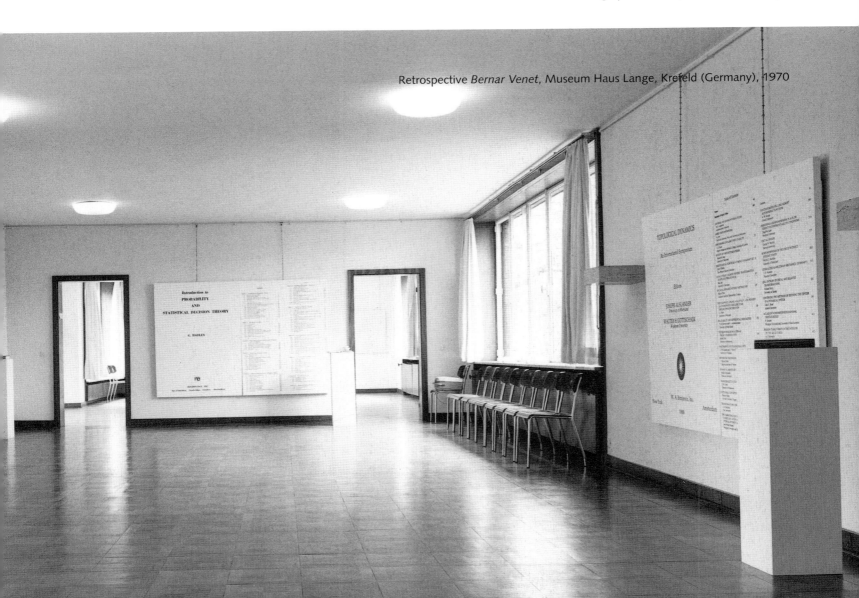

Retrospective *Bernar Venet*, Museum Haus Lange, Krefeld (Germany), 1970

for knowledge. He still conceived knowledge somewhat in the Modernist way, as a matter of certainties; and certainty, as he saw it, was not to be attained through subjectivity, but through objectivity, the unquestionable facticity that was embodied in monosemy. The fact that monosemy eliminated so much was an austerity one had to live with – this was an aspect of the darkness that Venet has said surrounded his life and work at this time. It was the darkness imposed by ascesis – the objection to the voluptuous in raw daylight. The early or classical era of Conceptual art was characterized in general by puritanism; this was an aspect of the anti-aesthetic or anti-sensual mood. The spareness of the works of Joseph Kosuth, Lawrence Weiner and William Anastasi in this period, for example, resulted from a similarly puritanical stripping away of the "merely" pleasurable. As Eric Orr, another artist of that generation, declared to me in about 1970, "We're not concerned with making pretty objects anymore."

Venet's resignation from artmaking was earnest, not a joke or an imposture. He was really acting out in his life the implications of all the 1960s theorizing that hoped to enable a saner world. It seemed inevitable, in particular in terms of Venet's analysis of the artistic career into three stages. First was "the learning stage," which in Venet's case included the juvenilia (Impressionist seascapes) and the art-school works (Klee-like abstractions). Second was a period "when the object 'art' is subjected to doubt and questioning and the development of an original concept takes place." In Venet's case the second stage begins with the *Tars* and culminates in the "original concept" of monosemy. "The third stage," he felt, " consists of the production of variations that can only fulfill the artist's pathological urge to make objects."[33] This third stage accomplishes nothing, since "the history of art is the history of the evolution of the theory of art" – not the history of objects. The idea that the urge to make objects is "pathological" restates Venet's underlying puritanism at this stage of his life. Desiring not to add more pointless non-theoretical objects to the world, Venet declared that even if he had not been a Conceptual artist more or less in the tradition of Duchamp, even if he had been an abstract painter in an aesthetic mode, he would, sooner or later, have stopped practising in order to avoid the ego-inflated emptiness of repeating himself.[34]

So Venet's oeuvre, as he saw it at age twenty-nine, was to end with the theoretical breakthroughs of stage two, and omit the tedious third stage with its multitude of redundant objects. His career as an artist was to culminate and end in a retrospective of his specifically Conceptualist works ("The Five Years of Bernar Venet") at the New York Cultural Center in 1971 featuring photoenlargement works, book presentations and lecture presentations. Despite its size (it contained 180 works on two floors) the show unfolded with an austere dignity appropriate to the work. It did indeed seem a kind of apogee, with its look of maturity and mastery, yet a strange tomb-like quiet lay over it all. Vitrines and pedestals holding scientific and mathematical books lay in a pristine purity beneath wall-mounted reproductions of their title and contents pages. Black-and-white photoenlargements of mathematical formulae austerely studded the walls. The sense of sobriety and ascesis seemed to call for an almost pious silence. This was the

ultimate statement of Venet's puritanism, his view that art was not about pleasure but knowledge. Cognition reigned as an absolute. There was only the purity of silent unchanging knowledge speaking back and forth from book to wall, and from work to work. It was the artist's triumphant farewell to art.

For Venet, the years from 1971 through 1976 might be compared to the seven years Odysseus spent on Calypso's island. However idyllic that long forced idleness might seem, Odysseus went out to the beach every day, gazed over the ocean toward home, and wept. Through those years Venet in fact made no art but, as if estranged on a solitary island, did scrutinize the haze on the horizon, sometimes longingly. True to his principles, he went radically underground, not even making art in secret. As the years passed he spent a lot of time reading and, as the import of what he read came through, he thought things over again and again. In time he found himself coming to question the rigidity of his youthful puritanism. As he put it, he "learned to relativize the value of the rational approach."[35] In Venet's vocabulary of that period rational meant objective, and objective meant monosemic. Monosemy forestalled the flow of connotation, which is subjectivity, and hence was the ultimate objectivity. Even though Venet had then, and still has to an extent, a root respect for the facticity or objectivity of the monosemic, he also came, during these years of reconsideration, to feel that the rejection of aesthetic pleasure for the sake of objectivity was an unnecessarily harsh response to the problem of subjectivity. It came to seem that various values – such as monosemy and polysemy – might coexist through a mutual relativization where none becomes absolute.

In the early 70s many people in art professions (or professions of art teaching) were hearing about Conceptual Art for the first time; it was a puzzling body of information, and curiosity about it was in the air. Venet, one of the artists who had formed or defined the medium, was asked to explain it at the School of Visual Arts in New York, the School of the Art Institute of Chicago, and at other venues in the US, Canada, Poland, Japan, and elsewhere. (Despite the appropriated lecture works he had presented to the world, he did not think of his own lectures as artworks.) He taught for a while at the Sorbonne, and continued to show and sell works through Bruno Bischofberger in Zurich, Hans Mayer in Düsseldorf and Daniel Templon in Paris. For the first time in his life, his livelihood was not a problem.

There *was* a problem, however – one which had not been foreseen. After a few years Venet found himself getting depressed as he faced the question what he was going to do with the rest of his life. Deprived of artmaking by the anti-art ideology, it loomed before him somewhat emptily. Since he was free, he considered all options. What, he kept wondering, was *worth* doing? His fantasies focused repetitively on two options: 1) to live alone as a hermit in a forest in Canada; 2) to find a way to understand the world and be able to explain it to others, somewhat as Buckminster Fuller had done. At the end of 1972 he left New York to teach and lecture abroad, and in September of 1976, when he returned to that city

where artmaking is such a prominent force, he was depressed by and engrossed in the dilemma. While on a visit with friends in upstate New York he felt himself becoming disturbingly nervous. The forest seemed full of owls, and he found the thought occurring that the way to deal with this nervousness was to make art again. He went back to the city in the dead of night and began to make paintings in secret. One day he was visited by Jan van der Marck, a subcurator of the forthcoming Documenta, and showed the new work to him. Van der Marck put some of it in the 1977 Documenta, and, after six years, Venet was back in the profession that he, like Duchamp, had somewhat prematurely resigned from.

The psychological difference between the ages 29 and 35 seems partly to account for this correction of course. It was a revision in Venet's basic understanding of life, or his basic mood about it. As Jung famously remarked, you never solve problems, you just outlive them. By age 35, Venet had become less convinced of his earlier puritanism. Again this was a part of the story of his generation. A similar shift has happened to numerous other first-generation Conceptual artists who, since about 1980, have partially redirected their energy into Conceptual painting, Conceptual sculpture, and other compromise or fusion modes that emerged in post-Modernism. While these modes maintained the Conceptualist orientation, they allowed a limited, and always ironized, reintroduction of aesthetic feeling. Venet's strategy was an attempt to survive the crisis as himself, without losing himself. He would hold onto the principle of monosemy while nevertheless "competing with real painting." "I will accept aesthetic considerations," he decided – and that momentous decision was the beginning of the second half of his career, in which he primarily came to terms with the traditional media of painting and sculpture.

In a recent interview, Venet was asked, "What explains the fact that today you accept the idea of producing a beautiful painting when thirty years ago you strongly rejected it?" "As I've grown older," he replied, "I've learned that *jouissance* is not prohibited and pleasure is not outlawed."[36] This Sadian-Bataillian recognition of the autonomy of desire confronted his previous puritanical rationalism. "I used to try to be totally rational," he says, "like a computer producing art with absolutely no emotion, but now I am older and more human. I'm more liberated."[37] The concept of liberation focuses on the fact that the puritanical restriction to monosemy had been a kind of imprisonment, a cell bereft of desire and the whiff of its objects. This again is something that has characterized the history of Conceptual art. Puristic anti-art – which prevailed for about a decade, 1965-75 – was as puritanical as Modernist abstraction had been. Anti-art was the dark alter ego of the seemingly bright ego of aesthetic art. It reproduced in reversal the very failings of the system it sought to overthrow. By the late 70s, various fusion forms were trying to bring life, or sensuality, back into the project.

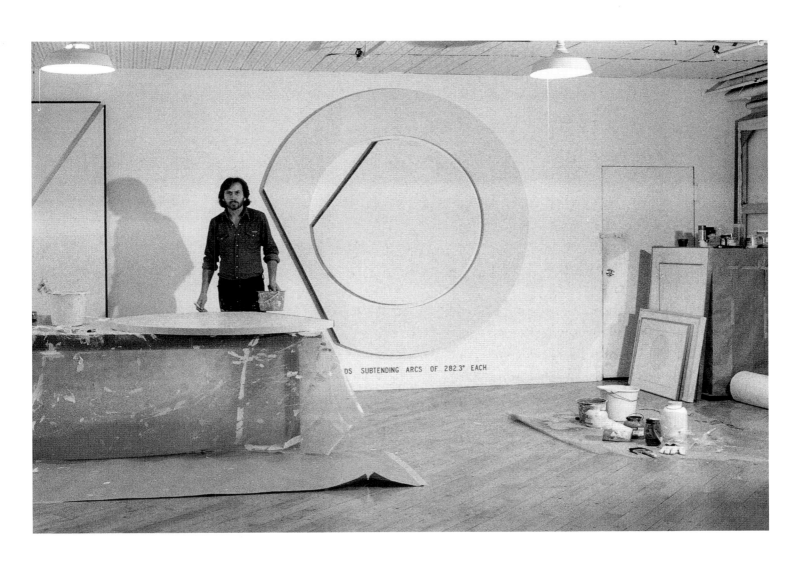

The artist in his studio, New York, 1977

The ferocious eagerness of Venet's newly unstopped creative urge soon settled down into serious solid objects, like precipitations in a beaker. His first metal sculptures appeared in 1979. They continued to observe the principle of monosemy, but now that was not the *only* principle at work. *Arc de 235 decrees*, 1979, for example, is monosemic in the fact that its title simply says what it is in a physical sense (like a blueprint), rather than surrounding it with poetic evocation as Late Modernist titles by artists such as Pollock (*The Deep*) and Newman (*Day before One*) had done. As with the earlier mathematical photo-enlargements, the title was a part of the work, engraved into it to close off the flow of connotation, as the blueprint had closed off or isolated *Tube*. Still, there was compromise, or at least an opening of options. In addition to the monosemy there were other decisions that were traditionally aesthetic – decisions about materials and how to treat them, for example. These decisions were outside the monosemic relationship between the work and its "title". They were *jouissance*.

Other works adopted a looser relationship to the rigid self-identity of monosemy. In *Arcs*, 1979,[38] and *Angles*, 1979, Venet explored a fundamental post-Modernist theme: the phenomenon of fragmentation. Breaking linear elements free from their representational matrices in drawings, he would exhibit them as fragmentary pieces by themselves – an array of arcs or angles exhibited without any representational frame-work, as if they were materials waiting for a demiurge to make them into a world. They are like elements of drawings withdrawn from the totality of the representation and isolated by themselves – an alphabet.

These works are made from steel bars about 3.5 inches square and of varying lengths, commonly 20 to 25 feet, weighing 800 pounds or more. They are deformed by overheadcranes which pull them with occasional odd turns caused by the somewhat unpredictable effects of heating. Venet engages them physically in the process. The metal warps and turns as if with a mind of its own, in intimate relationship with his physical pressure on it. "It is a confrontation and a struggle," Venet says, "between the steel bar and me. I propose directions but am at the same time directed by the steel bar which resists."[39]

Something like Action Painting is involved. Venet starts the process of deforming the straight bar of steel, watches how it responds, then reacts in turn to its reaction, creating a new reaction in it, and so on. It is Action Painting translated into slow motion, vast size, and heavy metal. Venet sees the reaction of the steal beams as expressing an intention or inner nature; the metal is stating its own programs in response to his. The installation of *Indeterminate Lines* at the foot of the Eiffel Tower on the Champ-de-Mars illustrates the variances of uses of the material. In the intricate metal work of the tower the inner will of the steel has been completely subordinated to the artist's desire to control it. Venet however collaborates with his material, the steel line curled at the base of the tower like a primary substance that has been halfway – but not yet all the way – transmogrified into definite form.

Monosemy might seem to be the most determinate state available, and pansemy the most indeterminate. Still, in what Venet has called his "fresh start" after 1976, he found himself on the side of the

indeterminate. Indeterminacy involves questions of will: why has the controlling mind not willed this substance into some definable shape? The random, which is a value that he, like the John Cage generation in general, respects in a somewhat intimidated way, equates with the indeterminate state, the element of choice with determinacy. In Venet's sculpture there is always an element of choice and a random aspect balancing it out.

In the works called *Random Combinations of Indeterminate Lines* the elements are meant to be variable in placement, which is to say in compositional relation to one another. They can be installed with walking space between them in a loosely organized kind of grid, or the grid can be unbalanced by more density toward one end of it than another, or the pieces can be heaped together so they lock onto one another, not so much sharing the space as contesting it. Venet tends to leave this decision up to some outside factor – a curator, or the landscape – as in 1963 he left the choice of color for his painted folded cardboards up to someone else, and as in 1966 he left the decision about the length of the tubes to someone else. All this stresses and restresses the Duchampian theme of the artist attempting to remove his subjectivity from the process of making his art. It is an exact reversal of the Late Modernist worship of subjectivity.

The *Indeterminate Lines* seem to ask to be put back together into some picture or other. They represent the state of indeterminacy as an aspect of everything that has to do with flux. As Aristotle put it, "Nothing is true of what is changing" – so anything in the process of flux is indeterminate. It's as if the Arcs and Angles had started out as *Indeterminate Lines*; then, as the ontogenetic process advanced, they hardened or rigidified (at least for now) into a determinate state. As in Plato's *Timaeus* the fragmentary arcs and angles, straight lines and diagonals are constructivist elements lying hugely around a giant's table. Similarly the large *Random Combinations of Indeterminate Lines* are like a world either just torn apart, like a paper drawing in scraps, or just about to coalesce out of squirming indeterminacy.

One critic has seen the metal sculptures as strictly monosemic, dedicated to the values of Venet's earlier years: "objectivity, literality, neutrality, coldness, precision, anti-expressionism and anti-subjectivism."[40] Each work is "an affirmation of the thing in itself and (...) a barrier against substitute discourse."[41] "It thus becomes impossible," he concludes, "to deduce any kind of meaning."[42]

But this position seems exaggerated. After his "fresh start" the point of Venet's work was no longer exclusive monosemy but a balance between monosemy and reference, determinacy and indeterminacy, choice and randomness. Each element of one of these pairs keeps the other one sane.

Another critic recognizes the new situation – the new element of reference in the work – when he says that the coiled indeterminate lines remind him of sprung works of watches – that they suggest that industrial soctiety is about to break down or lose its mind, like a cartoon of a mad scientist with springs popping out of his head. So it's not, in fact, "impossible to deduce any kind of meaning." The fact that the works "look like" something means that they do involve reference or at least association; they are no

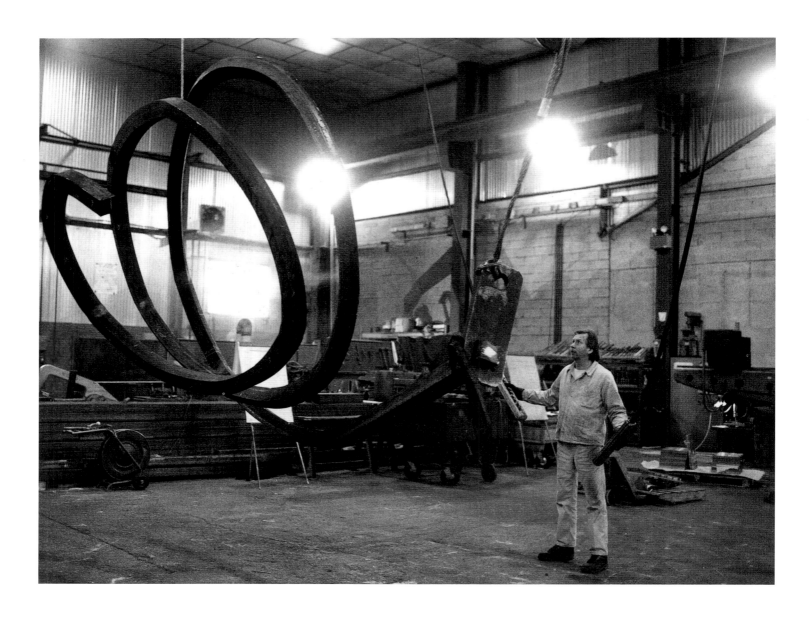

Bernar Venet at work

longer exclusively monosemic. (Maybe only *Tube* was.) In this stage of Venet's work a new mode of polysemy is emerging in which monosemy itself becomes one element among others.

In 1989 Venet began making works in which the entire sphere of the earth was incorporated into his sculpture. In line with his focus on the elements of drawings (arcs, angles, straight lines) the works involved the straight-line fragment, but magnified to cosmic scale. In a classic example, *La grande diagonale* ("The Large Diagonal"), 1989, a metal pole or axis starts 330 feet above the ground in Paris, then dives down into the ground, and its inferred other end, right exactly in line with it, appears and rises 330 feet up in Hong Kong.

Something similar occurred when Klein dipped a globe of the earth in IKB and declared the world to be his artwork. Even more similar is a work of an artist peripheral to the School of Nice but who did nevertheless interact meaningfully with it, Piero Manzoni. His *Socle du Monde* ("Pedestal of the world"), like Venet's *Grande Diagonale*, posits the Whole Earth as an object that can be incorporated into an artwork if the conception of the artwork is big enough or simple enough. With these Great Diagonals as its most recent component Venet's sculptural oeuvre now extends from the hypostatized fragment to the world-encompassing whole.

According to the theory of monosemy, objects can be the same in their inner conception even if their materials and media are different. The inner conception, similar to a numerical ratio in the Pythagorean system, is like the soul which does not change though the body shifts its forms. In this spirit, in 1999 Venet shifted his gaze at last from the world of sculpture back to that of painting, where he had begun. The move had an explosive effect. Suddenly, for the first time in the thirty years of Venet's mature work, color entered, as a conspicuous new element of *jouissance*. In the new paintings a mathematical formula-plus-diagram is painted on top of a monochrome ground, usually of a primary color but sometimes slightly tinted. The pictorial elements, the formulas and figures, are no longer photoenlargements but painted with the help of a plastic stencil made from a photoenlargement. In a limited way, in other words, touch has re-entered the work as an element of its newly-affirmed *jouissance*.

The transition from black-and-white photoenlargements to painted color brings up ethical questions. "Do you not worry," an interviewer asked once, "that you may be suspected of conceding to aestheticism and that it may be said of you, not without malice: 'Wait! Bernar Venet is compromising his austerity and radicalism, and he too is beginning to flatter the eye of the public?'"[43]

A similar question that hovers about the recent paintings is how and why the particular diagrams were chosen. In Venet's earlier period of making mathematical photoenlargements he left the choice of diagrams to experts in the fields involved, who were requested to choose not for aesthetic appeal but for the

practical importance of the formula in its actual discipline. But in the recent generation of mathematical paintings with monochrome grounds, Venet himself chooses the formula-plus-diagram, and he does not dismiss aesthetic considerations in the choices. Clearly mathematical diagrams and formulae do have aesthetic appeal, which Venet now feels it would be perverse to repress when it is so obviously present. Still, he rejects the idea that these are simply abstract paintings in the Modernist sense of the term. Modernist abstractions always have hints of reference or representation, however fiercely Clement Greenberg and others of his generation might have denied that. Yves Klein once said his blue monochromes were paintings of the sky seen through his studio window. The drip-paintings of Pollock represent flux somewhat in the way that the Grass Style calligraphy of Sung dynasty China did. The abstract sublime, as in the works of Rothko and Newman, represents metaphysical qualities. Rothko once said the Rothko Chapel paintings represent – or portray or illustrate – the "infinity of death." Newman used Kabalistic terms like *Zim-zum*. But the abstraction of the mathematical formula, as Venet has observed, is a higher or more rigorous abstraction; its meaning is locked within it and withdrawn. It is not a matter of representation but something more difficult, more a mystery in its aloofness. There is no symbolic realm involved at all. The works are ultimately self-referential. This locked-away quality is a part of the *jouissance* for Venet, who declares that he is "fascinated by what I don't understand, in love with being lost in an unknown area," not in order to figure it out, but in order to appreciate the distance, the condition of being separated cognitively from what you already master. (Venet meticulously neglects to study mathematics, keeping it in a privileged zone of mystery.) So in the new paintings, the structure of the picture plane – formula-plus-diagram – preserves the closed system of monosemy, but the aspect of *jouissance* now balances it with a different kind of presence.

The new paintings are aesthetically compelling in a way the earlier ones were not – though they too had an austere beauty. In the new works the color is powerfully gripping; it comes off the wall and takes hold of the eye while the diagrams and formulae hold the surface with a grace like that which a Kandinsky abstraction once exercised. Venet has acknowledged the beauty of mathematical graphics. It's a new mode of beauty, he feels, as "when the introduction of geometrical forms led to a radical renewal of established aesthetics."[44] Still, he describes it as a "cold," relatively "inexpressive aesthetic."

The structure of the new paintings, with its balance between the cold inexpressive formula and the *jouissance* of the brightly colored ground, is a variant on the tradition that relates the sublime to the ground of a painting and the beautiful to the figure. Venet has rearranged things in a way that some other artists are also finding in the post-Modernist reversal of hierarchies. For the figure – the mathematical formula – is at least as much the sublime as is the monochrome ground. Both are sublime in their inability to change – the ground because one color cannot change without intermixture with another, the figure because like the most inviolate cosmic virgin it asserts a message that in its impersonality trivializes all

human idiosyncrasy, such as the psychology of desire. So both the ground and the figure are the sublime – yet they combine to create something that recognizably belongs to the realm of the beautiful.

Finally there is, in my opinion, a kind of polysemy to these works even more pronouncedly than in the sculptures. Even though the formula and its diagram are different embodiments of the same conception, there are additional associations that arise from a sense of resemblance – from the "looks like" or "reminds me of" type of reference. *Parametric ordinary differential equation of the first order in two dimensions*, 2000, for example, looks like a bunch of arrows shot across a blue sky in some ancient battle. There are other ways that one could read its narrative, but in any case the picture seems to invite such an association. (When I first saw it, it "reminded me of" the fragment of Archilochus in which he said that in a certain battle on a certain day the air got dark from the shadows of so many arrows whizzing by overhead.)

Related to "Canonical Field Quantization", 2000, "looks like" the musical notation of a melody. *Related to: "The Mayer-Vietoris Sequence of a Proper Triad"*, 1999, "looks like" Duchamp's *Bottle Rack*. And *Related to: "The Continuity Uniqueness Theorem"*, 1999, "looks like" an analogue of architectural solidity and early urban development. And so on.

Finally, the viewer is presented with at least three tracks of meaning: there is the inviolate virgin of monosemy enshrined in the mathematical formula; there is the possibly contradictory upsurge of aesthetic feeling based on purely formal qualities; then there is the "look-a-like" track of cartoon-like representational associations. The works seem comfortably balanced on this three-track experience where the "idea" of the artwork hangs on a framework of three interesecting axes, like a tripod. The bowl suspended by the three axes is the mind of the viewer, where the fire is kindled as in a brazier.

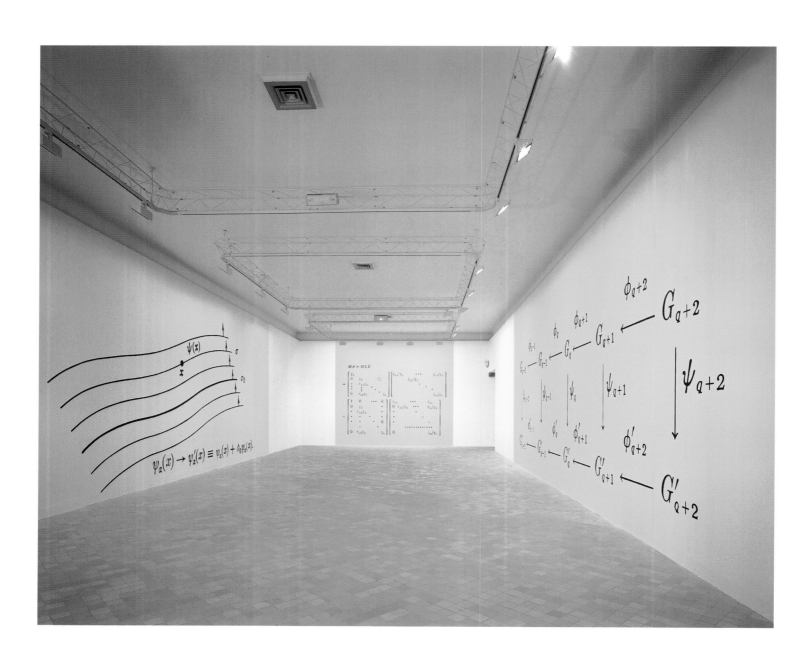

Wall Paintings exhibition: *Équations majeures*, Cajarc (France), centre d'Art contemporain Georges Pompidou, 2000

1 Catherine Millet, *Bernar Venet*, English translation, Milan, Gianpaolo Prearo Editore, 1974, p. 13.

2 Françoise Gaillard, interview with Bernar Venet, in Bernar Venet, *La Conversion du regard, Textes et Entretiens, 1975-2000*, Geneva, Musée d'Art Moderne et Contemporain, 2000; p. 8 of the unpublished English translation provided by the Bernar Venet studio.

3 *Ibid.*

4 Arnauld Pierre, *Bernar Venet, Sculptures et reliefs,* Gianpaolo Prearo Editore, Milan / Éditions Marval, Paris, 2000, p. 83.

5 *Ibid.*

6 *Ibid.*

7 Gilbert Perlein, "Conversation with Bernar Venet", in the exhibition catalogue *Bernar Venet, New Sculptures and Drawings*, New York, Andre Emmerich Gallery, 1993, p. 10.

8 *Ibid.*

9 Catherine Millet, *op. cit.*, p. 13.

10 Françoise Gaillard, *op. cit.*, p. 8.

11 Gilbert Perlein, *op. cit.*, p. 10.

12 Françoise Gaillard, *op. cit.*, p. 8.

13 Catherine Millet, *op. cit.*, p. 17.

14 *Ibid.*, p. 15.

15 *Ibid.*, p. 17.

16 Robert C. Morgan, *Bernar Venet 1961-1970*, Saint-Etienne, Editions des Cahiers Intempestifs, 1999, p. 112.

17 Catherine Millet, *op. cit.*, p. 25.

18 *Ibid.*, p. 17.

19 Thierry Kuntzel, "Bernar Venet: Logic of the Neutral," in the exhibition catalogue *Bernar Venet*, La Jolla, Museum of Contemporary Art, p. 10.

20 *Ibid.*, p. 11.

21 Lawrence Alloway, "Textual Criticism," in *ibid.*, p. 2.

22 Catherine Millet, *op. cit.*, p. 22.

23 *Ibid.*, p. 17.

24 Bernar Venet in Exhibition Catalog *Five Years of Bernar Venet*, New York Cultural Center, 1971, p. 11.

25 Bernar Venet and Thierry Kuntzel, "Study of *Représentation Graphique de la Fonction $y=-x^2/4$*", in the La Jolla catalogue, p. 18.

26 Catherine Millet, *op. cit.*, p. 23. Of the second piece, Venet has remarked, "This piece, which was the most successful of the three, was certainly the least probative as far I was concerned. I have since regarded it as an error in so far as it had a collage, or happening effect, resulting from the simultaneity of the lectures."

27 *Ibid.*, p. 25.

28 *Ibid.*, p. 18.

29 *Ibid.*

30 Arnauld Pierre, *op. cit.*, p. 72.

31 Catherine Millet, interview, 1998, "Bernar Venet: Dans et hors la logique," in *Bernar Venet, Conversion du regard*, p. 117.

32 Catherine Millet, *Bernar Venet*, p. 20.

33 *Ibid.*

34 *Ibid.*, p. 19.

35 Catherine Millet, "Bernar Venet: Dans et hors la logique," p. 5.

36 Philippe Piguet, interview with Bernar Venet in *L'Œil*, March 2001, p. 3.

37 Stephen Kennedy, "Symbols of Power," in *Math Horizons*, April 2001, p. 20.

38 Arnauld Pierre, *op. cit.*, p. 28.

39 Gilbert Perlein, *op. cit.*, p. 14.

40 Arnauld Pierre, *op. cit.*, p. 72.

41 *Ibid.*

42 *Ibid.*

43 Françoise Gaillard, *op. cit.*, p. 1.

44 *Ibid.*, p. 5.

WORKS 1961-2002

Bernar Venet: selected comments

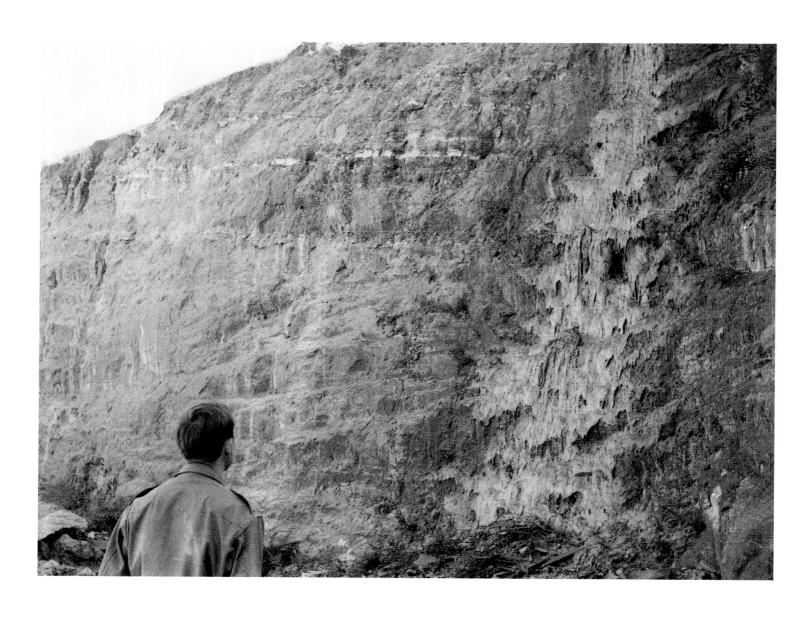

Bernar Venet in front of the tar flow at Carpiagne (France), 1961

CARPIAGNE

Only few weeks after I had myself photographed in front of an expanse of tar in Carpiagne, in a big natural cirque where all kinds waste had been dumped, I decided to make the "extreme" gesture [...]. I lay down in the middle of the trash, outside the refectory. It was a very simple action and lasted only a minute – an ephemeral act, the bizarreness of wich my comrades no doubt jeered at (but I don't remember, and I didn't really care anyway).

This was not a symbolic action – even though these were the fraught days of the war in Algeria, where I was transferred a few months later. No, it was more a question making manifest a working context, of establishing a coherence, between the action and its relation to my visual work, particularly certain photographs of waste and my first paintings which were constituted by tar dripped over assemblages of torn cardboard.

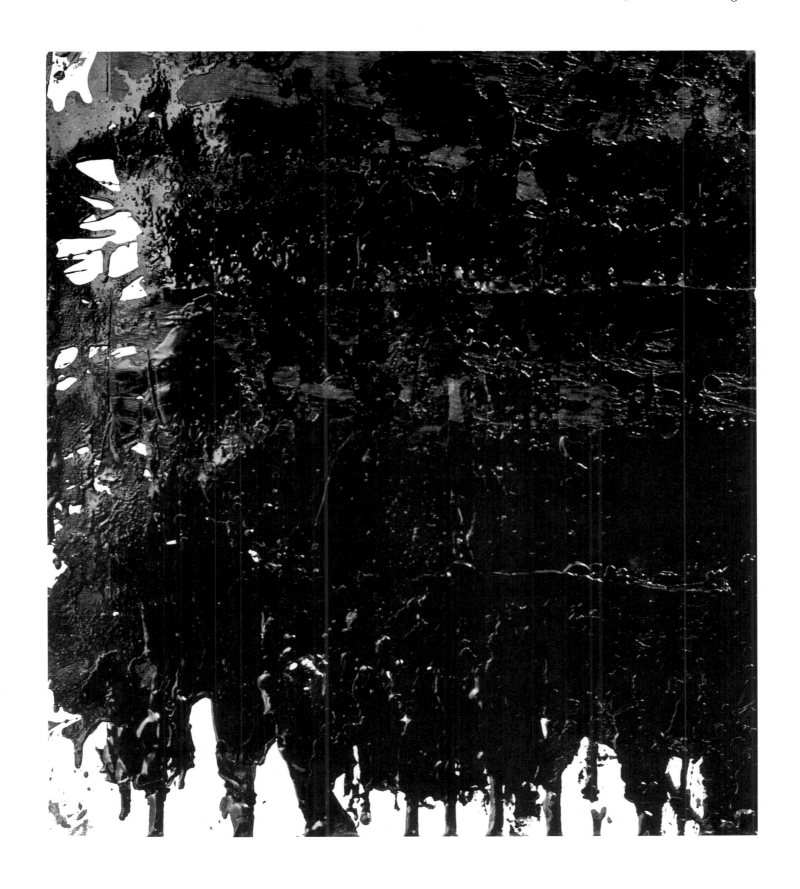

Performance in the Garbage
Tarascon (France), 1961

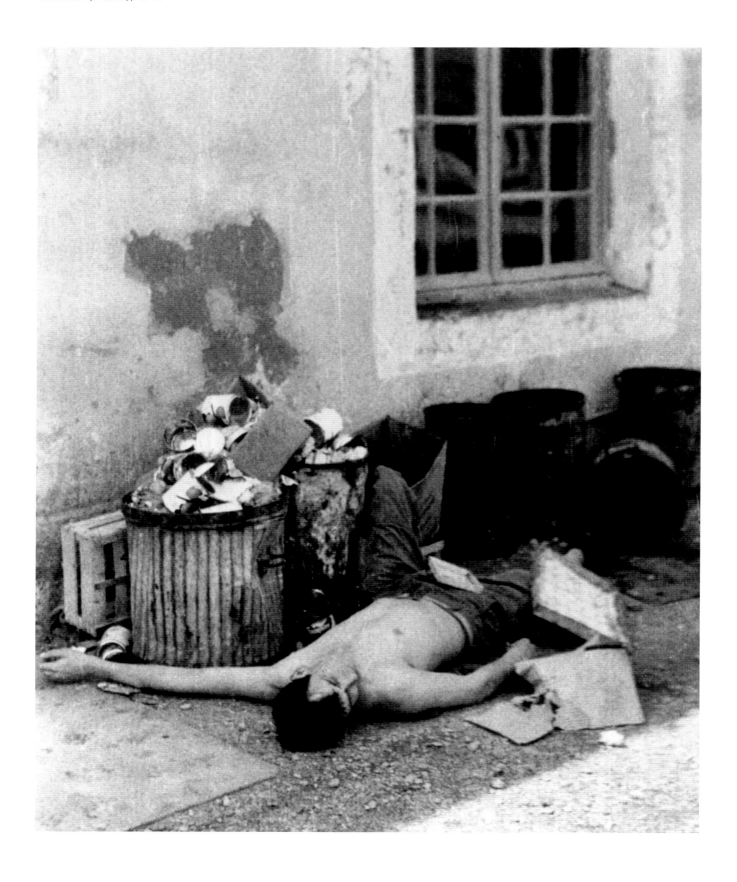

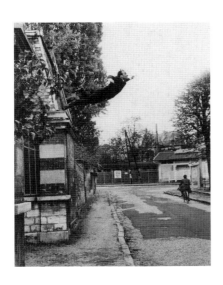

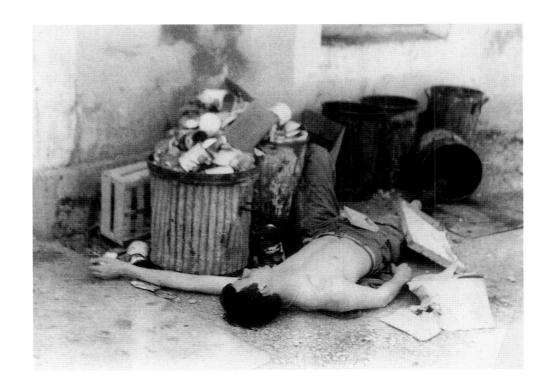

Yves Klein, *Le peintre de l'espace
se jette dans le vide*, 1960
Photograph : Harry Shunk

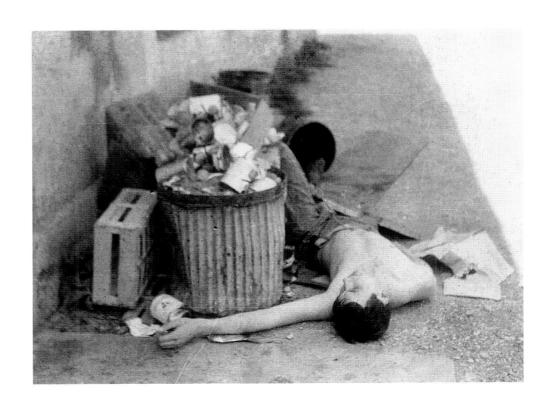

COAL PILE

The *Coal Piles* demonstrated this even more explicitly. It was not the use of the material as a means of creating forms that I was emphasizing but rather the material as form "per se". […] By rejecting the compositional principle and by not choosing material for arbitrary reasons related to taste – or for the symbolic meanings that could be attached to it – I began to let the idea of "distance" between the work and myself, and the idea of the "on permanence" of the work's visual aspect (the *Coal Pile*, for instance, changes shape each time it is exhibited) intervene in my work. I would like to reiterate the idea of "distance" so as to underscore the fact that the work does not mirror my personality. It does not "echo" my moods or my nature – be it happy, sad, or tormented.

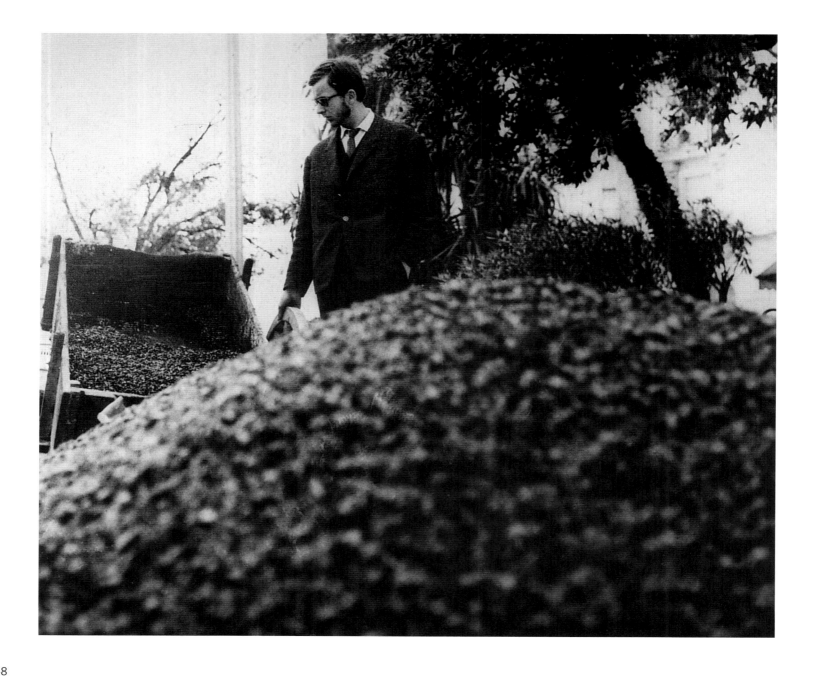

Bernar Venet in Nice, in front of the tar and gravel pile, March-April 1963

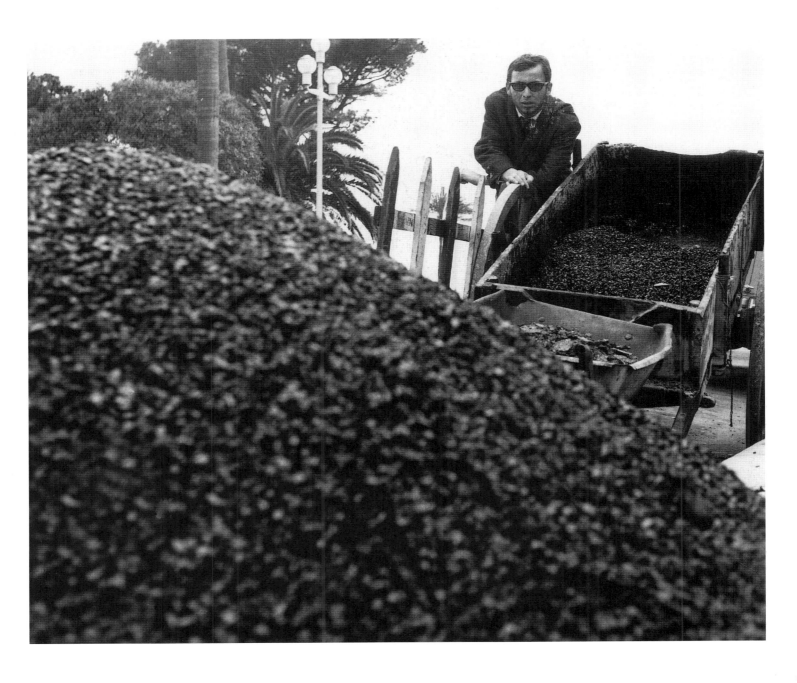

Tars (diptych), 1961
Tar on paper, 39 x 50.75 in.
Collection Aimery Langlois Meurinne

TAR

Tar painting. Break away from gestural painting: the canvases very soon become monochromatic. Black is uniformly spread over the entire surface of the canvas to avoid any effects due to color or medium.

Divide the surface into rectangles. A program to cover the surface: paint the rectangles over a specified periode of time (one a month), in a specified order (from left-to-right, from top-to-bottom, as dictated by the convention of Western writing) and according to methods determined by a buyer: "At first, I wanted black canvases. Then I thought that if the choice of color and format were left up to the owner of the painting, the demonstration would be clearer".

Cardboard reliefs. Distanciate, break down the anecdote, frustrate attempts at interpretation: "The layers of lacquer which cover the surface of the cardboard hide all the markings "fragile", "top", "bottom", etc. to prevent the works from becoming Pop Art, to avoid multiple meanings and anecdotal associations. A cardboard relief is a neutral object which signifies and represents nothing." Danger of a return to aesthetics through composition: "the arrangement of the pieces of cardboard was so elaborate that it began to bother me."

The artist's studio, Nice (France), 1963

Macadam, 1963
Photographs
Exhibition at Nouveau musée, Institut d'Art contemporain, Villeurbanne (France),1997

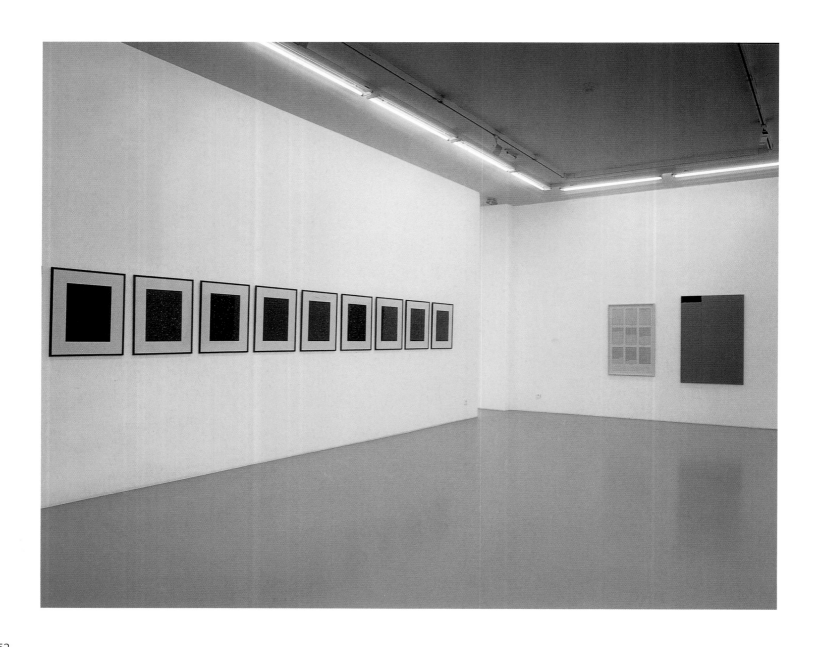

Tar, 1963
Tar on canvas, 59 x 47.25 in.

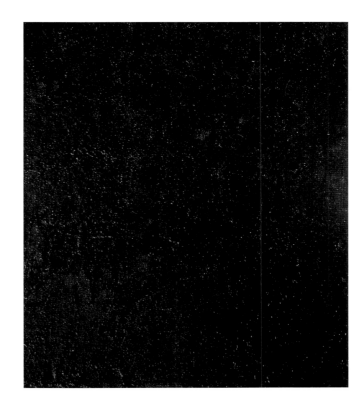

Tars, 1963
Tar on canvas, 59 x 47.25 in. each
Exhibition at Nouveau musée, Institut d'Art contemporain,
Villeurbanne (France),1997

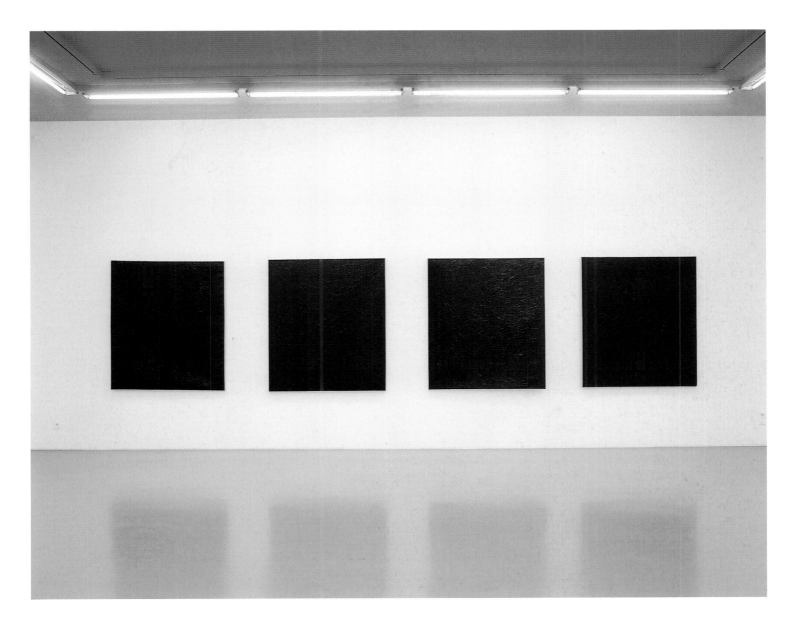

The Black Mirror Room, 1963
Project for the Ursula Girardon Gallery, Paris. All the walls were to be covered in this fashion from floor to ceiling. The installation reproduced here was realized for the exhibit of works 1961-1963 at the Museum of Modern and Contemporary Art, Geneva, summer 1999.

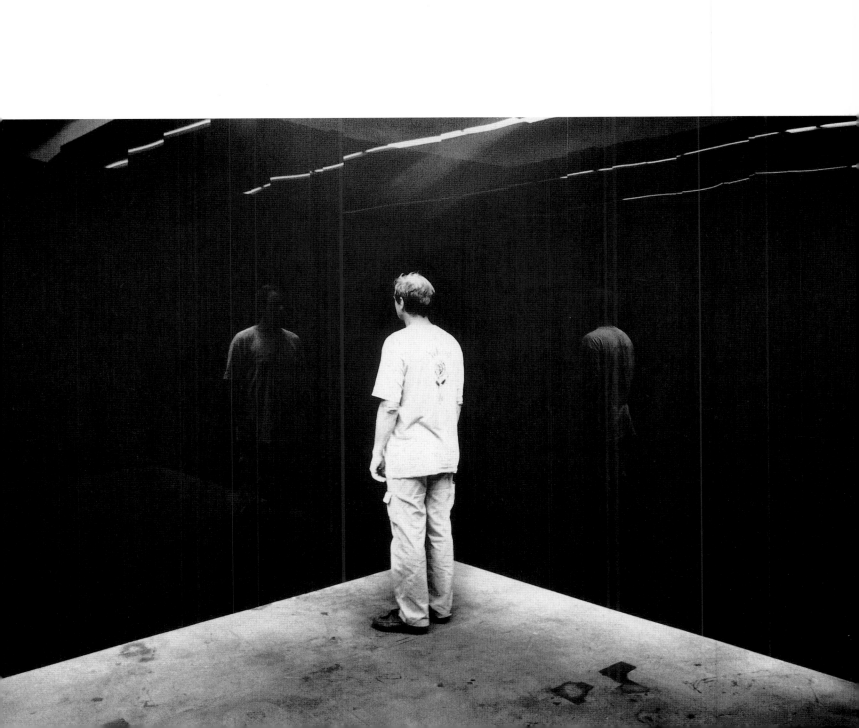

Tarmacadam, 1963
B/W film, 3 minutes, chief operator Henri Beneteau, production Arkadin, Paris. Long regular running of a close view, perpendicular to a tarred road. This film was made several times, but no version could be considered satisfactory until the one produced for the MAMCO, Geneva in 1999.

Black Book, 1963
Linked directly to the rest of my work, especially the "tar" paintings and the "pile of coal" photographs and sculptures, I thought that a "black" book would make its own sense and could be published. It would function as an object in itself, something autonomous and independent of any subordination, i.e. of the description of something else or of anything that might be exterior to it.

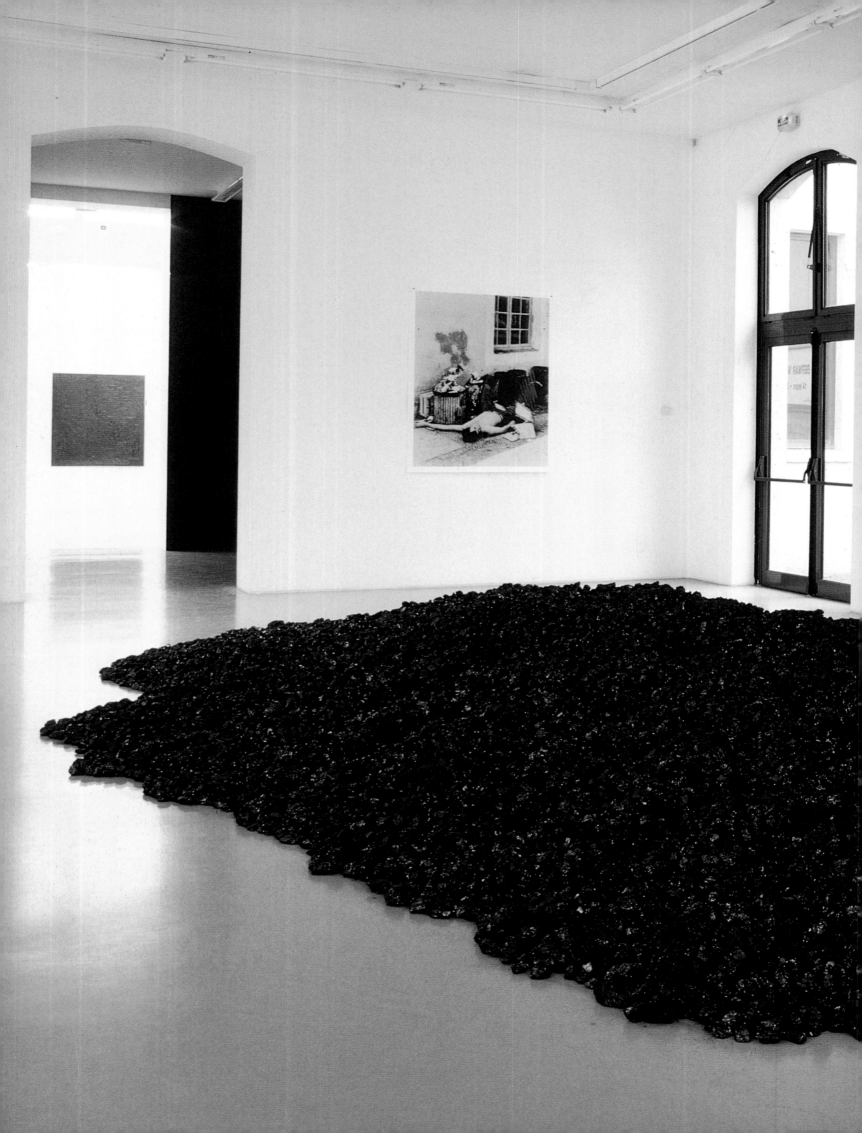

Coal Pile, 1963
Dimensions random
Collection Martine and Didier Guichard.
Exhibition at Nouveau musée, Institut d'Art contemporain, Villeurbanne (France),1997

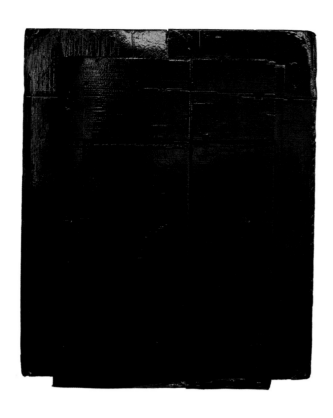

Cardboard Relief, 1964
Industrial paint on cardboard, 69.5 x 63 in.
Grenoble (France), Musée de Grenoble

Cardboard Reliefs, 1964
Industrial paint on cardboard
Exhibition at Nouveau musée, Institut d'Art contemporain,
Villeurbanne (France),1997

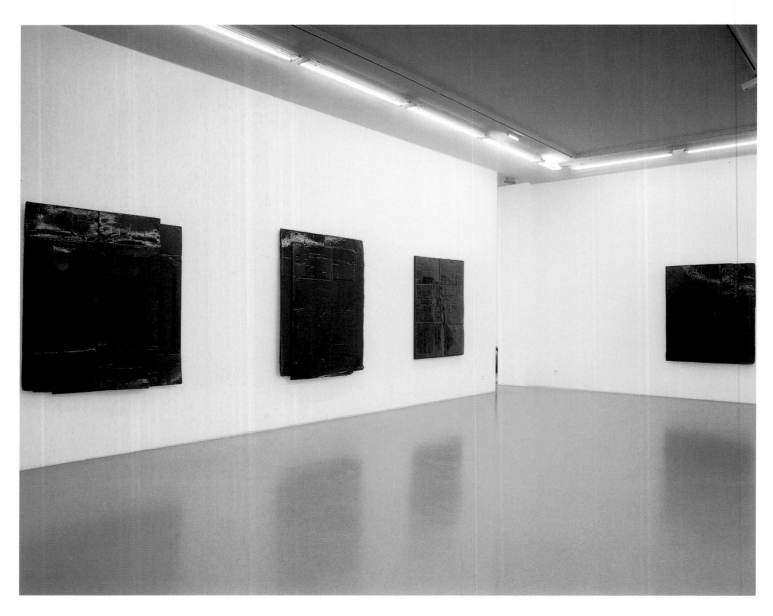

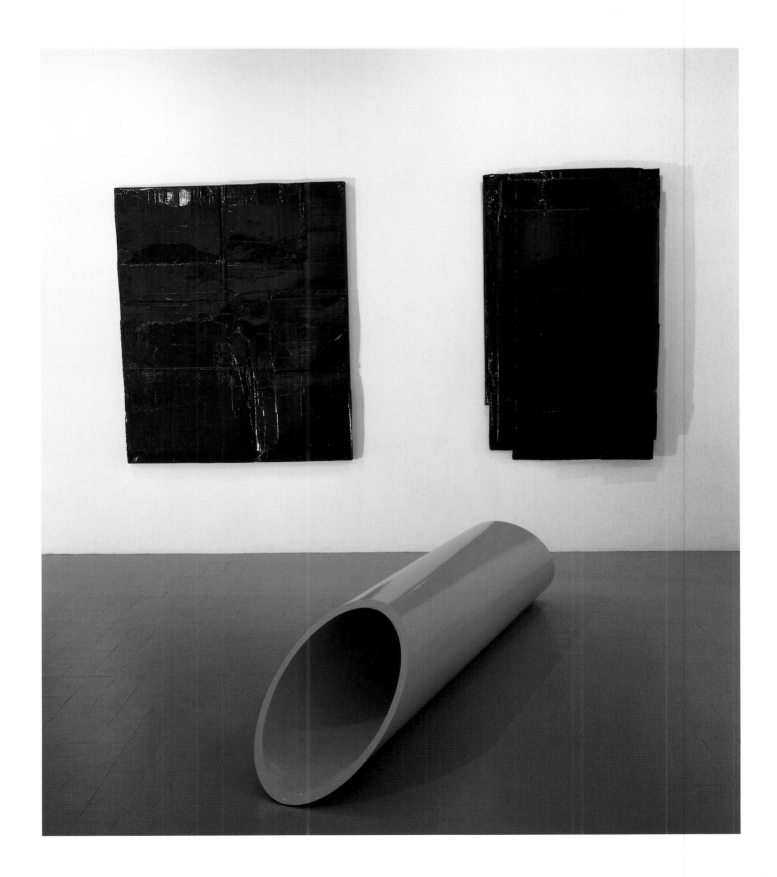

Cardboard Reliefs, 1963-1964 ; *Tube*, 1966
Industrial paint on cardboard ; painted steel
Collection Espace de l'Art concret, Mouans-Sartoux (France),
gift of Sybil Albers and Gottfried Honegger

Tube # 150/45/60/1000, 1966
Drawing on tracing paper and bakelite tube
Collection musée d'Art moderne et
d'Art contemporain, Nice (France)

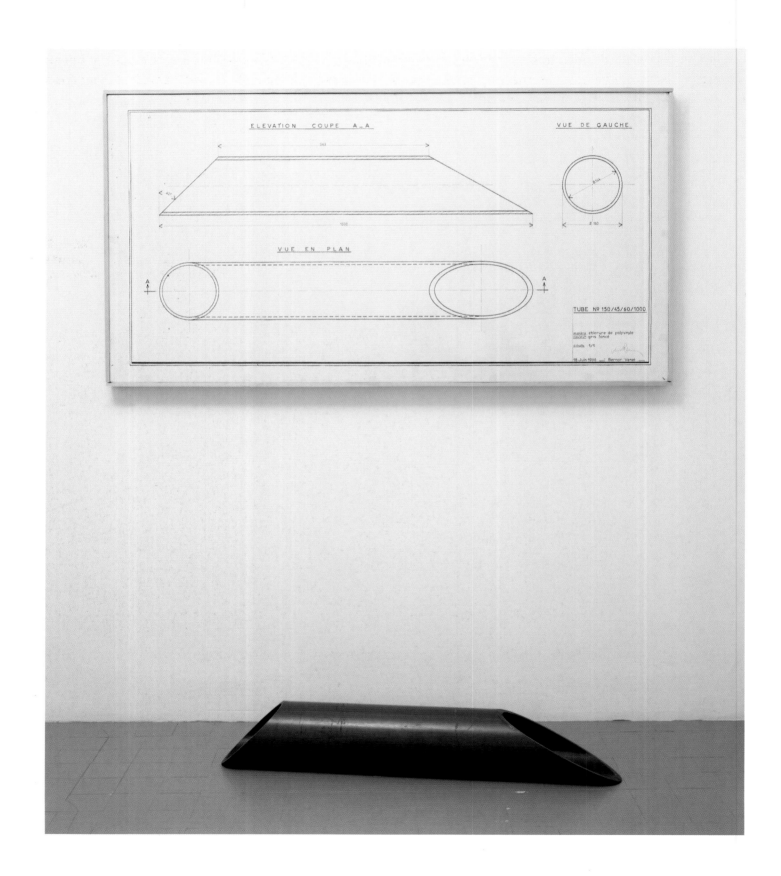

TUBES

The suppression of the base constitutes a giant step for sculpture, endowing it with its own identity, and placing it in a setting where the spectator grasps it on a one-to-one scale, on a human scale.

Due to the *Coal Pile*, the 1966 tubes and my recent sculptures are placed directly on the ground, they are perceveid as an integrated entity, dependent on the spectator's environment and space. The wall and the ground become structural elements in the work of art. [...] It is clear that the "tube" sculptures are of particular interest in terms of my subsequent work, even though I only made a few examples of these in small format. I did not have the financial means necessary to produce these works in a larger format, and therefore in answer to an invitation to exhibit at the Musée de Céret in June 1966 I decided to send a blueprint of the sculpture. The codified system of this industrial blueprint immediately caught my interest; it turned out to be the critical moment leading up to my mathematical diagrams and the whole of my subsequent conceptual work.

Tubes, 1966
Painted steel
Collection of the artist, Le Muy (France)

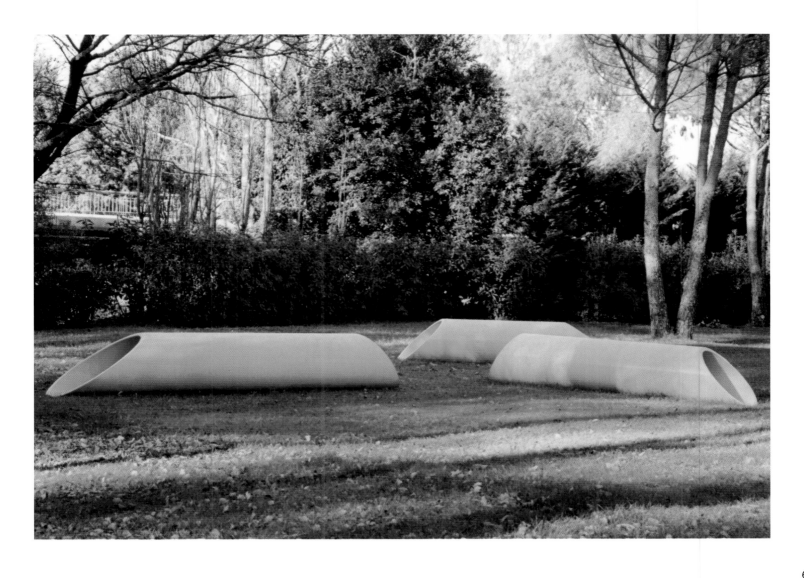

Filetage trapezoïdal, 1966 ; *Représentation graphique de la Fonction y=-x²/4*, 1966
Acrylic on canvas, 59 x 47.25 in. ; 57.5 x 47.5 in.
Collection Mr and Mrs Esselier, Zurich

DIAGRAMS

In a work such as *Parabola of the function y=2x²+3x-2*, one can read the definition corresponding to the graph illustrating this definition. In this case, the system of signs used is a mathematical language added to a completely non-figurative graph freed of any other interpretation. The semantic reference functions on the basis of a mathematical universe: all philosophical, religious or social interpretations lack any legitimate grounds.

Let us first of all remember therefore that we are in the presence of a work using signs which have the quality of being monosemic and, in opposition to those used in all previously produced works of art, possess only one level of meaning.

Fig: 21
Profils conjugués à développantes.

Profils conjugués à développantes, 1966
Acrylic on canvas, 58.75 x 47.75 in.
Collection Mrs Guiseppe Cohen, Turin

Rapport de deux grandeurs, 1966
Acrylic on canvas, 58.75 x 47.75 in.
Collection Solomon R. Guggenheim Museum, New York

Rapport de deux grandeurs — $AB = 3\,CD$ — de même $CD = \frac{1}{3}\,AB$, donc : $\frac{CD}{AB} = \frac{1}{3}$.

Parabole de la fonction y=2x²+3x-2, 1966
Acrylic on canvas

Parabole de la fonction y=2x²+3x-2.

Vecteurs égaux – vecteurs opposés, 1966
Acrylic on canvas, 39.37 x 59 in.

Comete Arend-Roland, 1967
Acrylic on canvas, 70.75 x 52 in.
Collection Santa Barbara Museum of Art

A Phenominological Model for "Disparitions brusques", 1967
Acrylic on canvas, 52 x 41 in.
Collection Marc Blondeau, Paris

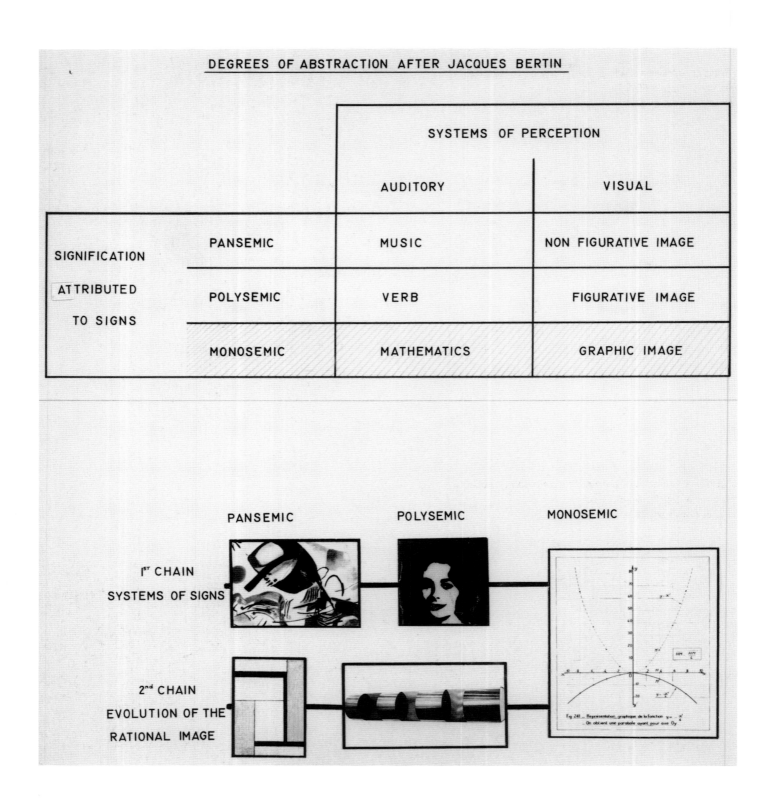

		SYSTEMS OF PERCEPTION	
		AUDITORY	VISUAL
SIGNIFICATION ATTRIBUTED TO SIGNS	PANSEMIC	MUSIC	NON FIGURATIVE IMAGE
	POLYSEMIC	VERB	FIGURATIVE IMAGE
	MONOSEMIC	MATHEMATICS	GRAPHIC IMAGE

Degrees of Abstraction after Jacques Bertin, 1971
Collection Enrico Pedrini, Genova (Italy)

MATHEMATICS

 If one refers to Jacques Bertin's table of "systems of fundamental signs", we recognise, to begin with, that a work which uses mathematical symbols or presents a diagram stands apart from the usual domains of art.

 Whereas pictorial work has up to now been carried out, on the figurative side, in the polysemic (several signifieds for a given signifier), and, on the non-figurative side, in the pansemic (a floating signifier-signified relationship), the crux of the matter in this instance is the introduction of the monosemic into a field in which it would have been considered incapable of operating: a painting evades the expressive and the aesthetic because what structures it is a mathematical code which can in no way be imbued with values, and which is valuable only as a functionality.

The Relation Between e and e. for Nearly Circular Orbit, 1967
Acrylic on canvas, ø 60.5 in.
Collection Christo and Jeanne Claude, New York

Distribution des électrons d'un atome de chlore, 1966
Acrylic on canvas, 36.6 x 56.6 in.
Collection of the artist

Time Spectrum of Coincidences Between Electron and Gamma Rays, 1967
Acrylic on canvas, 70.75 x 70.75 in.
Collection Museum of Modern Art, New York

Spectrum Calibration Diagram, 1967
Acrylic on canvas, 48 x 70 in.
Collection New York University, New York

Depth of Imaginary Potential for 96 MeV Neutrons ;
Depth of Imaginary Potential for 25 MeV Neutrons, 1967
51.5 x 71.5 in. ; 34.1 x 71.5 in.
Collection Guggenheim Museum, New York

Image de la molécule de Phénol, 1966
Acrylic on canvas, 55 x 50 in.
Collection of the artist

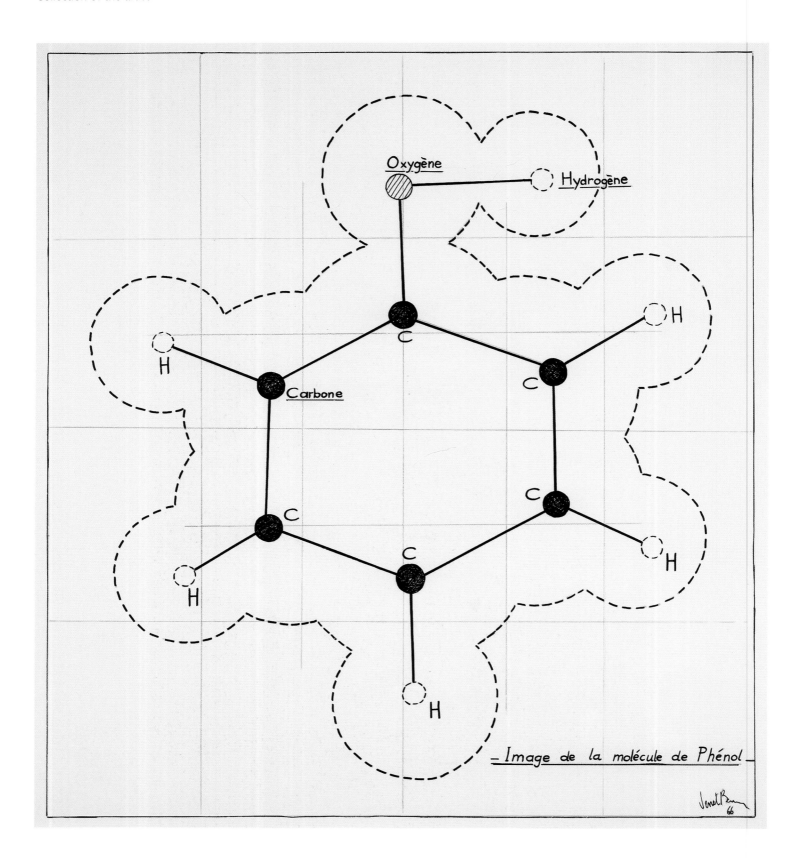

A & B - Electron - position pair production in a bubble chamber, 1967
Acrylic on canvas, 13.25 x 20 in.
Collection Enrico Pedrini, Genova (Italy)

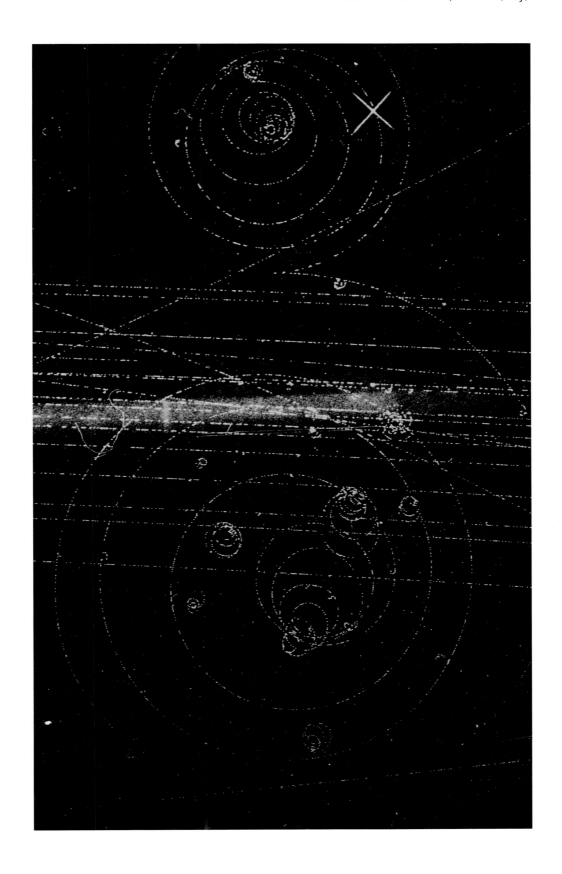

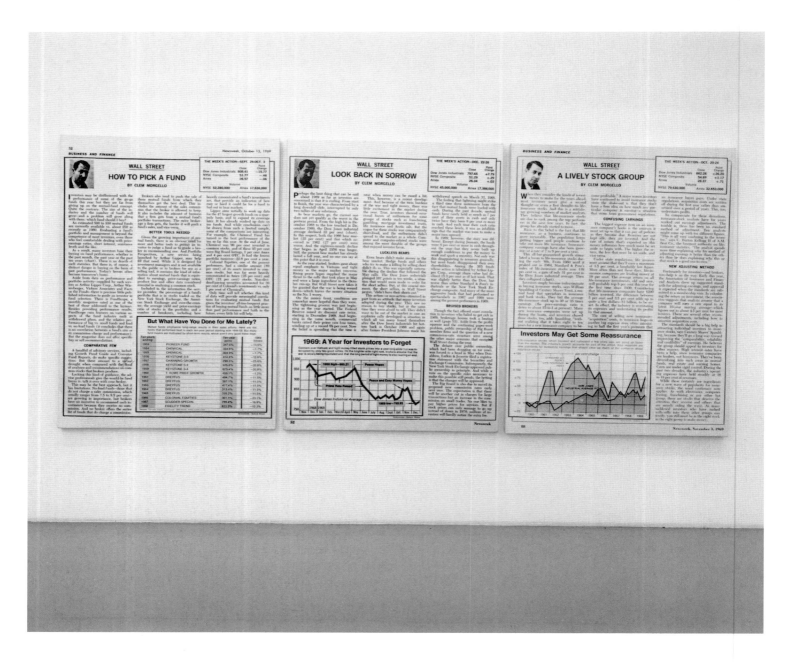

Wall Street Pieces, 1969
Photographic enlargement
Courtesy Grant Selwyn Gallery, New York

CONCEPTUAL OBJECTS 1967-1970

I have a liking for this form of abstraction, which consists in reducing things to an analytic proposition. To this day I remember the occasion when, in 1967, I first cut out a meteorological chart from the newspaper *Le Monde*. I though that after all this was another way of presenting a landscape. But a landscape that would be reduced to objective data. At that moment, it became obvious to me that what was most interesting in my work consisted in substituting analytic knowledge for empirical and sensory knowledge. Along similar lines of thought, I also presented charts taken from the *Wall Street Journal*. The kind of subject at a considerable distance from what we were used to at the time.

The *stock market* as a source of inspiration was virgin territory, and it interested me because it was so far away from what was generally defined as artistic. Cold, objective, non-poetic work.

Weather Reports, November 15, 1968, 1968
Photographic enlargement
Private collection, Milano (Italy)

Theory of Sets Union, Intersection, Product of a Family of Sets, 1969
Photographic enlargement
Exhibition at Nouveau musée, Institut d'Art contemporain,
Villeurbanne (France),1997

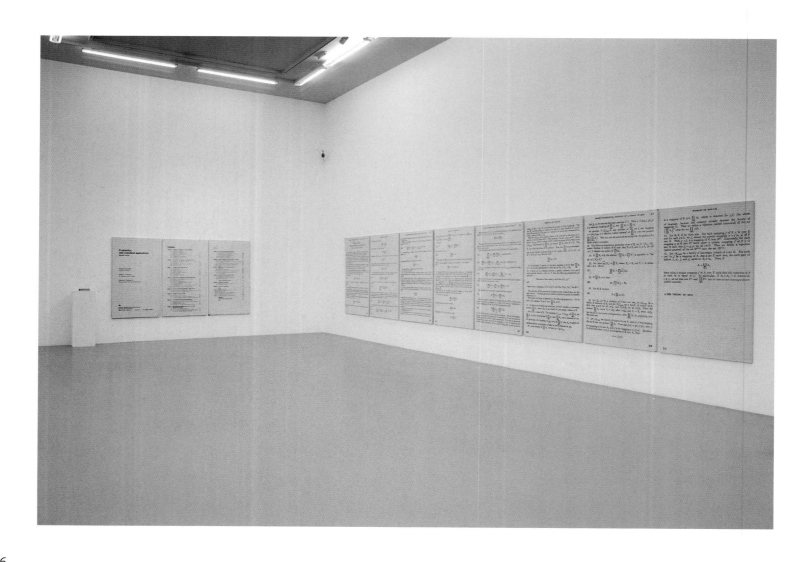

Elementary Number Theory, 1970
Photographic enlargement and book
Collection of the artist

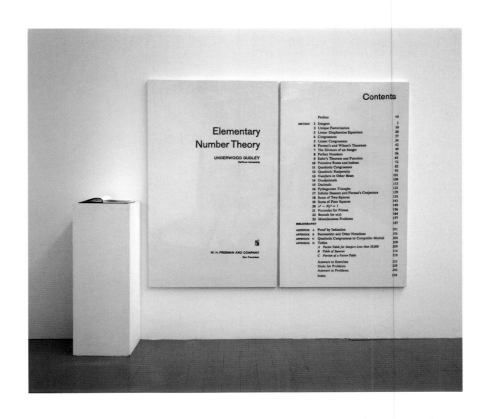

Some Characteristics of the Band of Stars in the Upper Scorpius Complex, 1967
Photographic enlargement and tape-recorder
Collection Georges Comandari, Santiago (Chili)

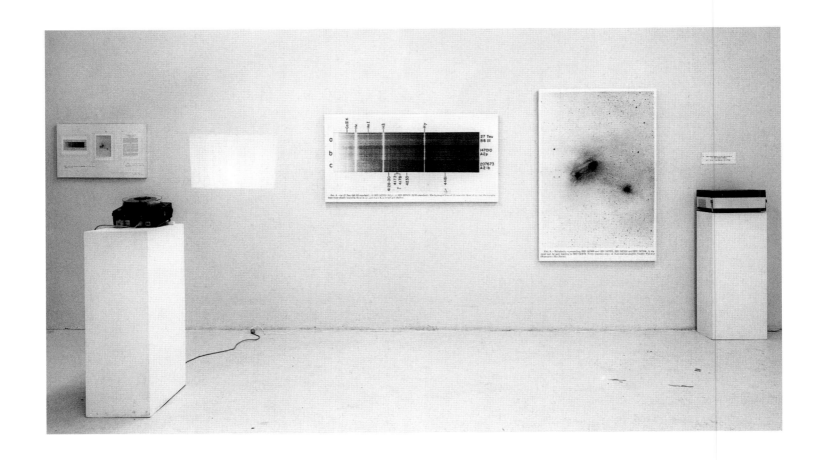

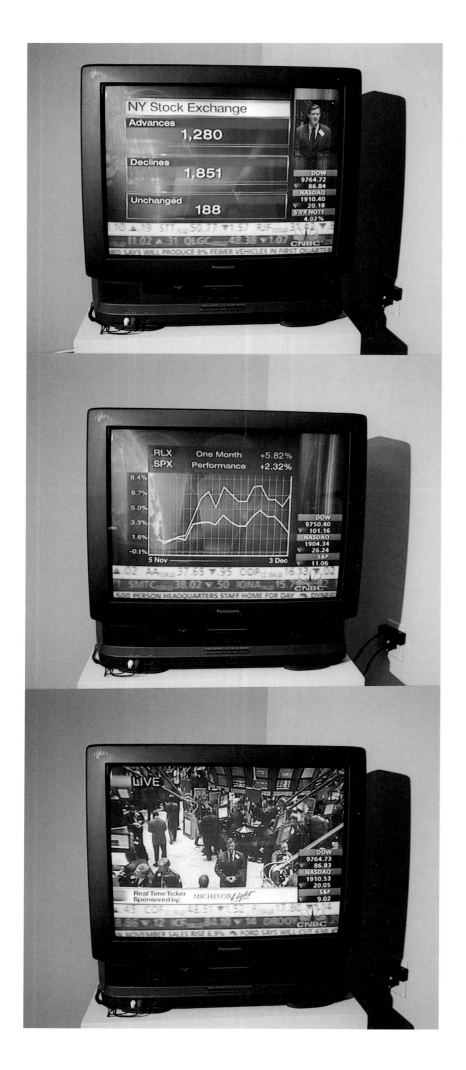

Stock Market, 1970
TV piece made for the exhibition *Information*, Museum of Modern Art, New York, 1970
A television monitor was installed in one of the rooms of the exhibition. Whenever stock market prices were shown on various channels at different times of the day, the television was switched on.

These images, which came within the framework of my work on the stock market, consisted of lists of figures and the abbreviated names of companies, and bore no relation to what had traditionally formed the content of works of art. Once again it involved subject matter oriented toward calculations and diagrams, an area where the personal feelings of the artist played no part. It was a cold and impersonal space in which the expressive was absent.

American Stock Exchange Transactions

American Stock Exchange Transactions, 1968
Photographic enlargement
Collection Arthur Ashman, New York

New York Stock Exchange Transactions, April 10, 1969, 1969
Collection G. S. Rosborough Jr., Saint Louis

Dr. Stanley Taub Conference: "The Speech Mechanism"
New York, Judson Church Theater, May 27 and 28, 1968

L'Auscultation Cardiaque, 1969
Sound piece record

Causal Groups of Space-Time, 1967
Lecture on tape recoder
Collection Alain Tarica, Paris

Generating Pseudo-Random Numbers by Shuffling a Fibonacci Sequence, 1967
Photographic enlargement

Exhibition at Nouveau musée, Institut d'Art contemporain,
Villeurbanne (France),1997

Partial view of the retrospective exhibit at
the New York Cultural Center, 1971

THE CONVERSION OF THE LOOK 1971-1976

To return to my activities from 1971 to 1975, this period of "rest", during which I focused on reflection rather than production – what I have called "the conversion of the look" – enabled me to use my own works as an object of investigation. The advantage of this type of analysis was that it enabled me to clarify the real meaning of the work and to define its latent content.

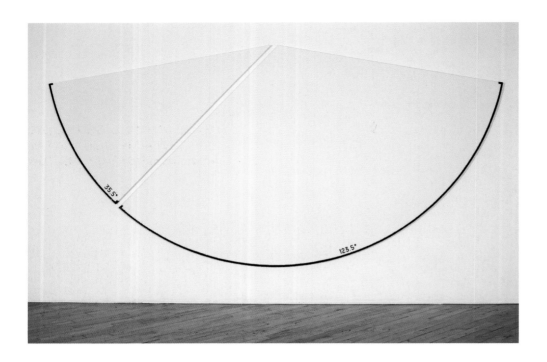

Two Arcs of 35.5° and 123.5°, 1976
Acrylic on canvas, 94.5 x 189 in.
Collection of the artist

Paintings (Arcs & Angles), 1976-1978
Exhibition at Nouveau musée, Institut d'Art contemporain,
Villeurbanne (France),1997

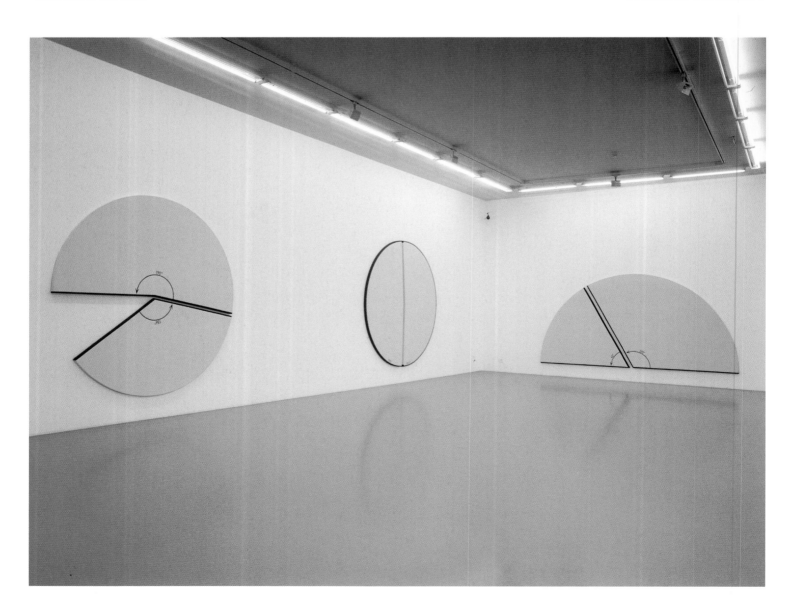

Two Arcs of 157.5° and 187.5°, 1977
Acrylic on canvas, ø 94.5 in.
Collection Museum of Modern Art, New York

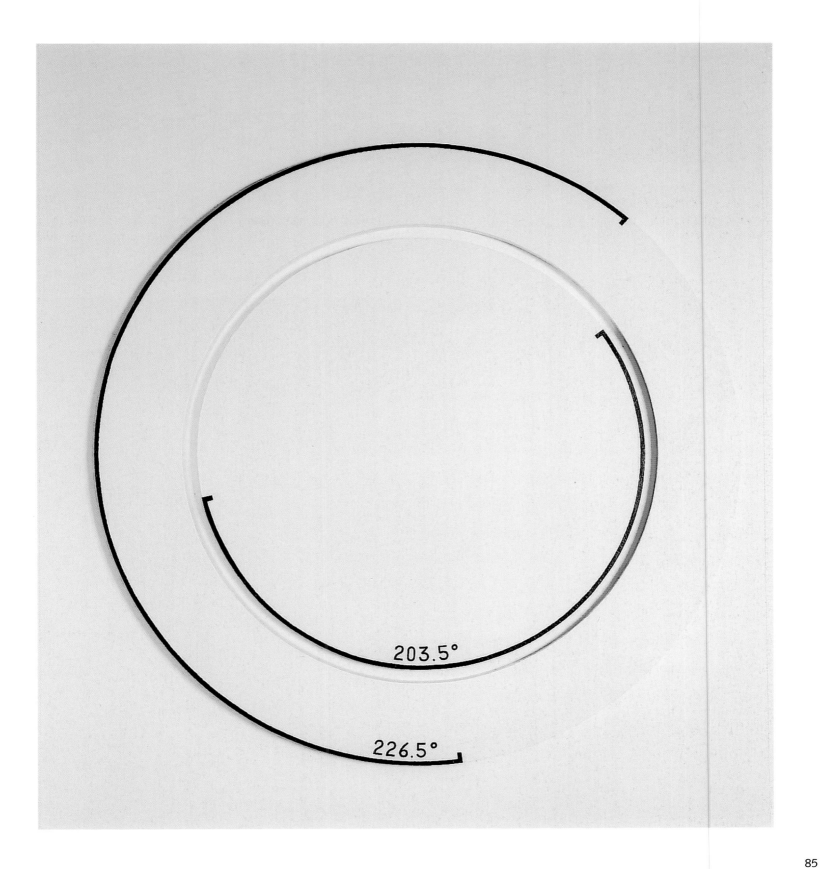

203.5°

226.5°

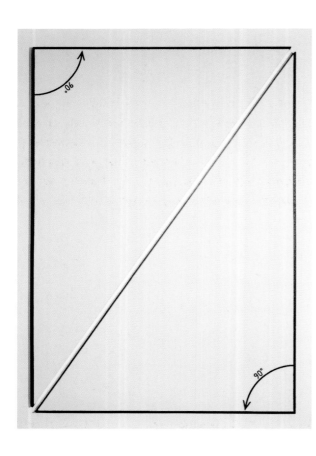

Two Right Angles
Acrylic on canvas, 94.5 x 67 in.

Paintings (Cords & Angles), 1976-1978
Exhibition at Nouveau musée, Institut d'Art contemporain,
Villeurbanne (France),1997

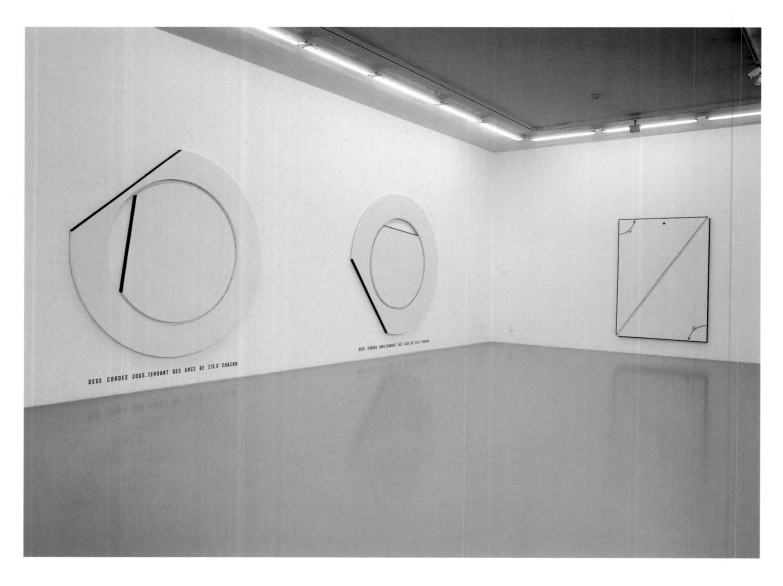

ANGLES AND ARCS

My most recent works, produced since autumn 1976, mark a new stage. They involve a series of drawings and paintings on canvas (sacrilege for a conceptual artist!). Frequently the work has two distinct parts, consisting of two angles drawn on the edges (front and side) of the painting and separated by a space, the larger of which is comparable to the dimensions of the work. The curved arrow indicating each angle gives its size in degrees. Thus, while retaining the essential element, namely the diagram (the angle being the most basic figure in geometry), for the theoretical reasons already mentioned, I wanted to give these works a self-evident physical significance, to make "paintings" of them, without however falling back into unproductive abstract formalism.

Exhibition at the ARCO Center for Visual Arts, Los Angeles, 1979

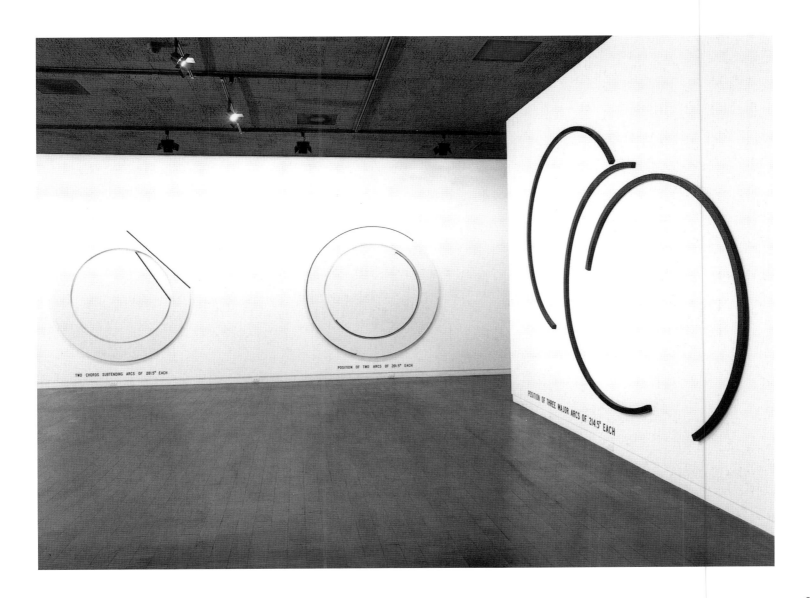

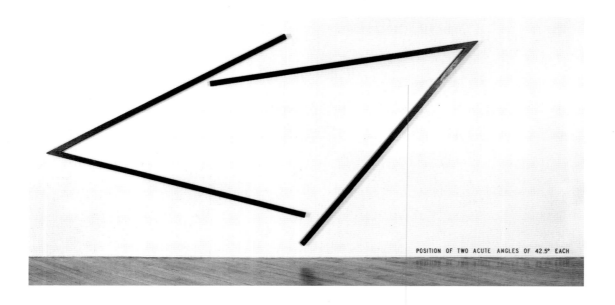

Position of Two Acute Angles of 42.5° Each, 1979
Graphite on wood, 117.75 x 274.75 in.
Collection Hirshhorn Museum and Sculpture Garden, Washington, D.C.

Angles and *Arcs*, 1979
Wood reliefs and graphite
Exhibition at Nouveau musée, Institut d'Art contemporain,
Villeurbanne (France),1997

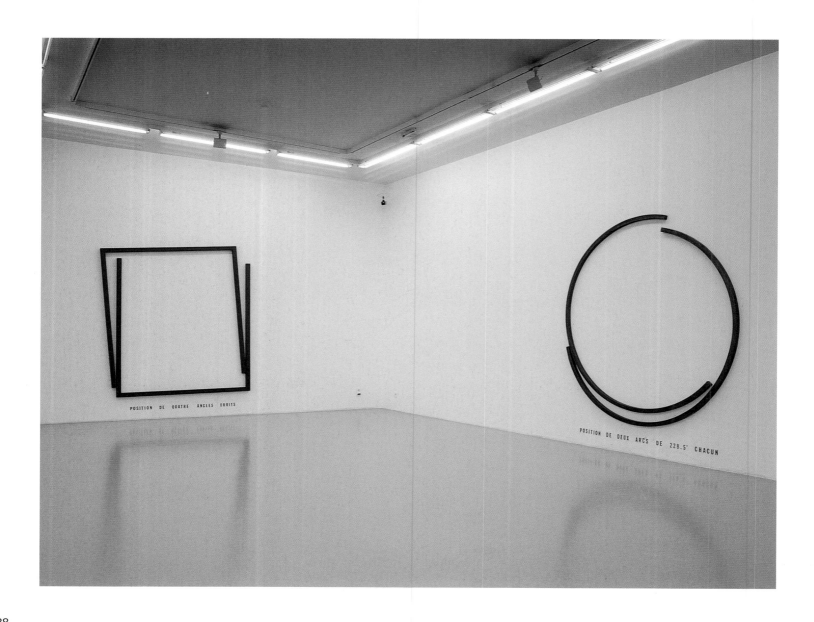

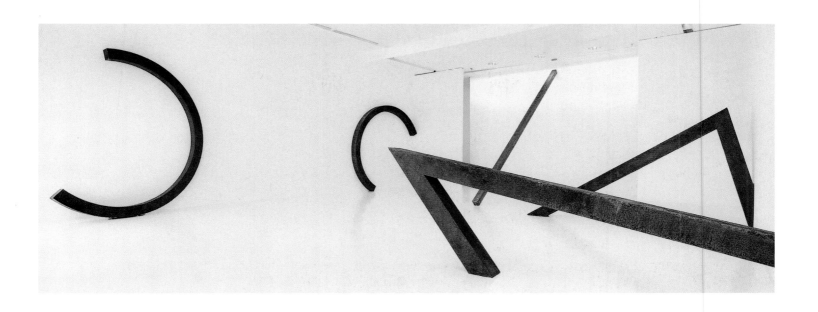

Angles, *Arcs* and *Diagonal Line*, 1979
Galerie Hans Mayer, Berlin (Germany), 2002

Position of three Arcs of 243.5° Each, and *Diagonal Line*, 1979
Graphite on wood
Exhibition at Nouveau musée, Institut d'Art contemporain,
Villeurbanne (France),1997

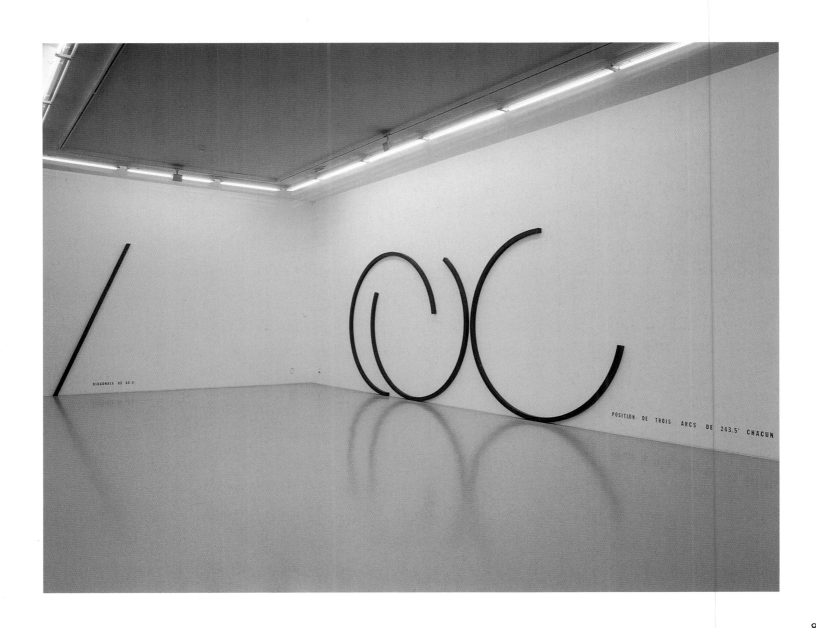

DETERMINATE – INDETERMINATE

In regard to the work in steel, this emerged after using other materials. In 1976 I was drawing my figures, angles, arcs and straight lines on canvas. I then moved on to wood reliefs in order to free myself from the artificiality of canvas and thereby to work directly on the wall. Each work was accompanied by its mathematical definition. In 1979 I drew a free line, i.e. one freed from mathematical constraints. I called it "indeterminate" and, in a kind of sliding of context, I took the line in all its forms as a key theme. From here, steel enabled my work to acquire another dimension and a stronger identity.

Three Indeterminate Lines, 1983
Paint on wood, 94.5 x 157 in.

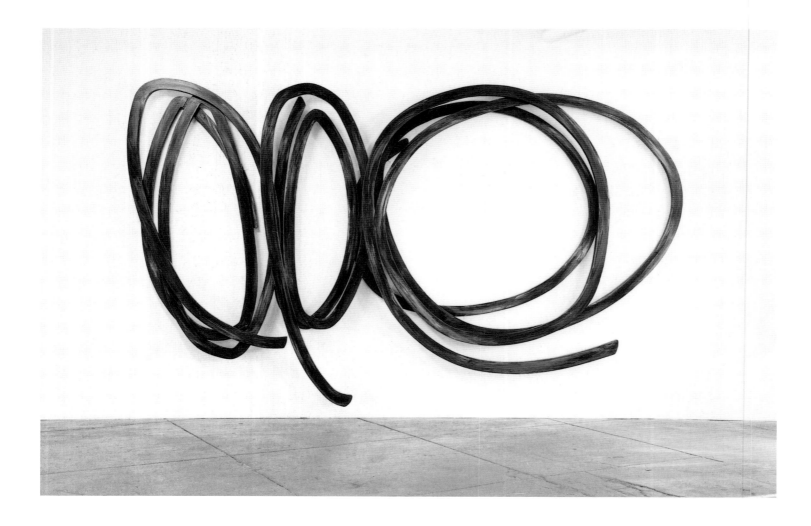

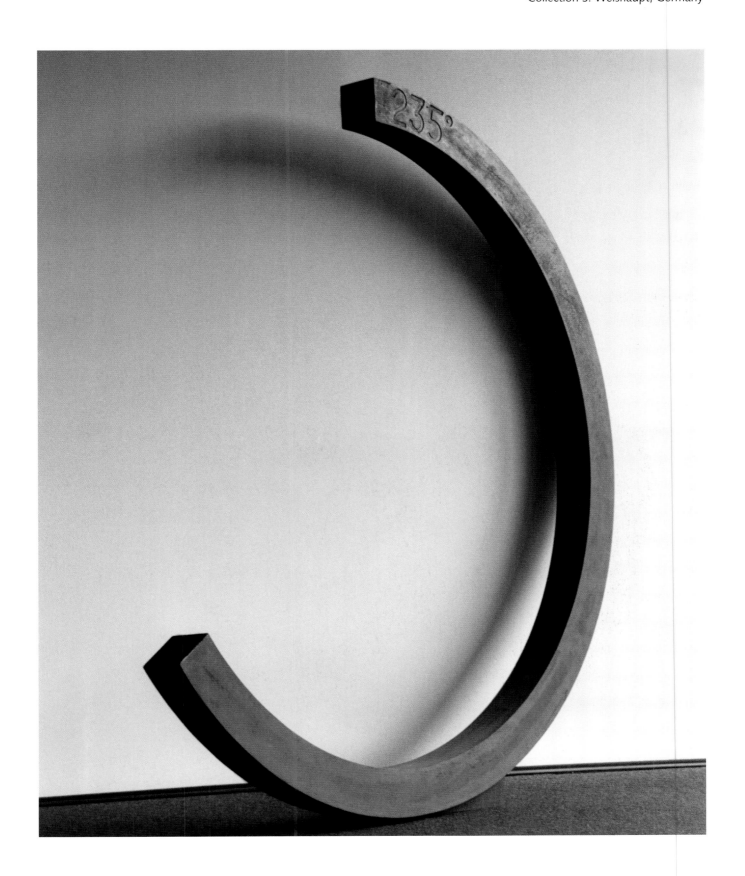

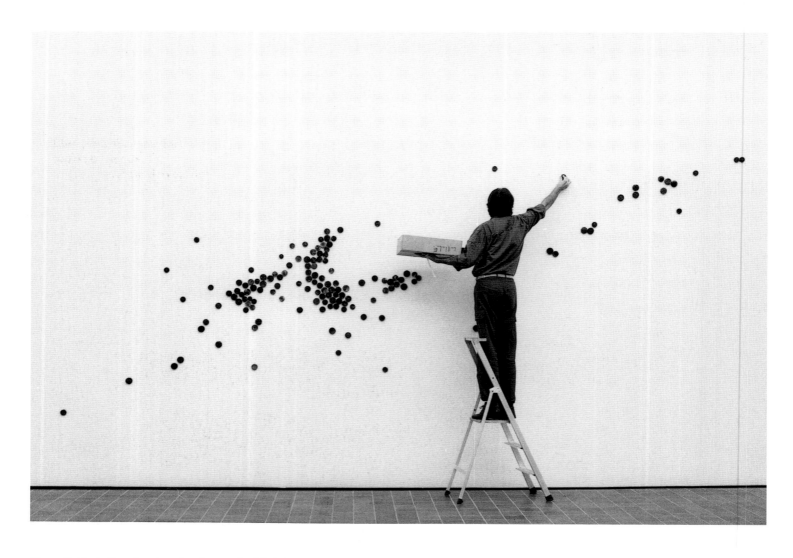

The artist installing *Random Deployment of Points*
Paint on wood, dimensions variable
Exhibition at musée d'Art moderne, Villeneuve-d'Ascq (France), 1984

Volume, Surface, Line, Points
Exhibition at musée d'Art moderne, Villeneuve-d'Ascq (France), 1984

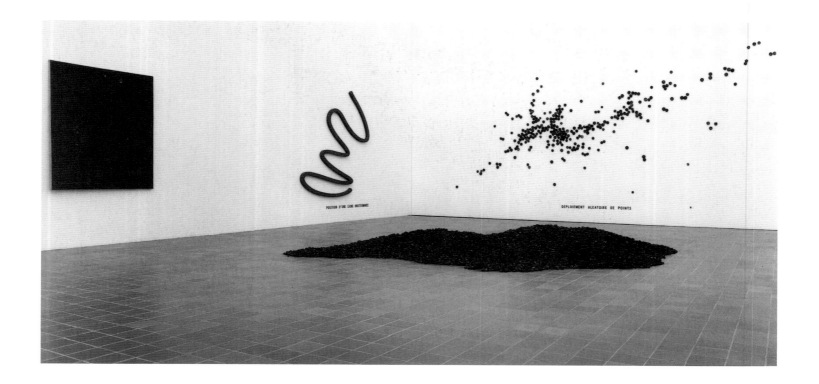

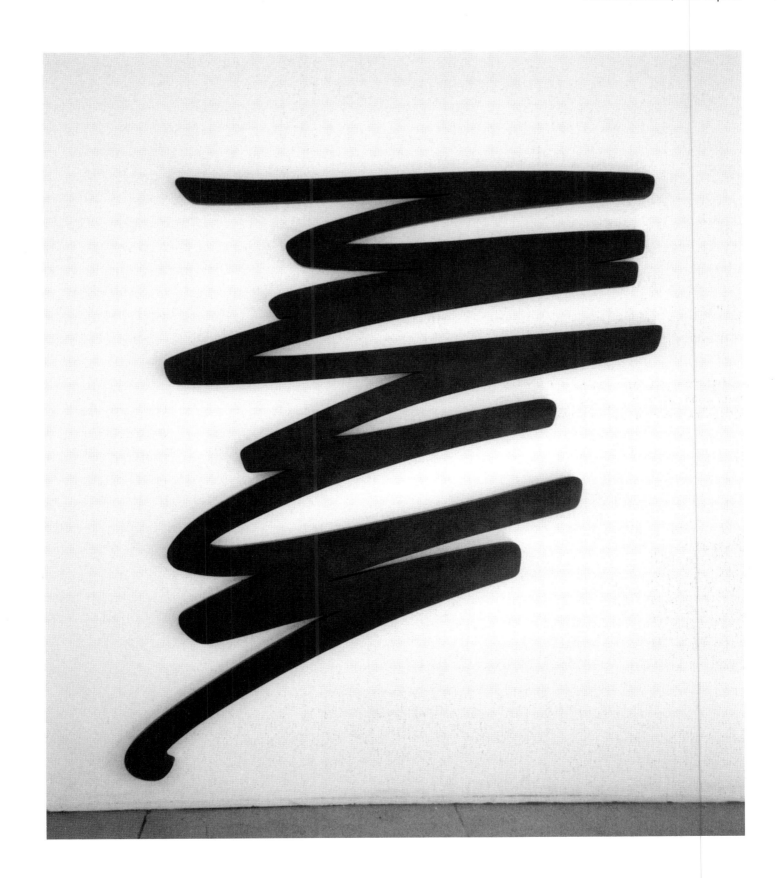

STEEL

My work at the factory is a game of natural constraints between my intentions and the material itself. Each orients the other and is oriented in its turn. I propose directions but am at the same time directed by the steel bar which resists, and will not surrender to my will to dominate… In his game of concessions I must leave its autonomy at the helm.

The result? A testimony to the act of forming and to the inherent possibilities of the material which I do not transform beyond its natural characteristics. By not changing its nature, I do not manipulate its appearance; that would involve creating artifices. In my sculpture, I am intent on keeping the energy of the atomic mass and its relationship to gravity, on respecting its singularity, its difference, its identity.

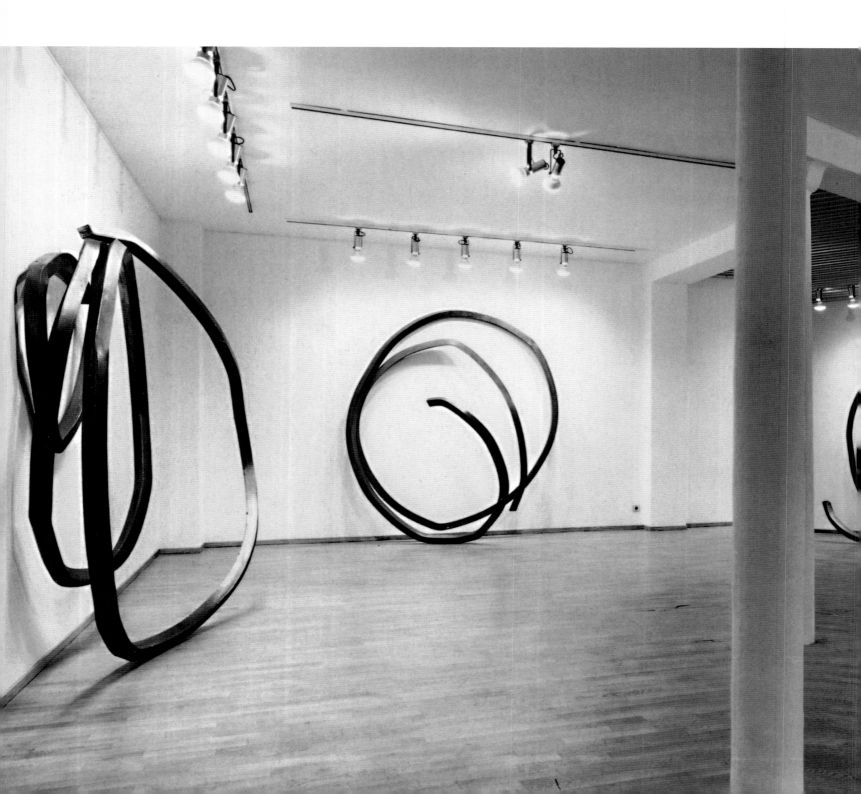

Indeterminate Lines, 1983-1984
Rolled steel
Galerie Daniel Templon, Paris, 1984

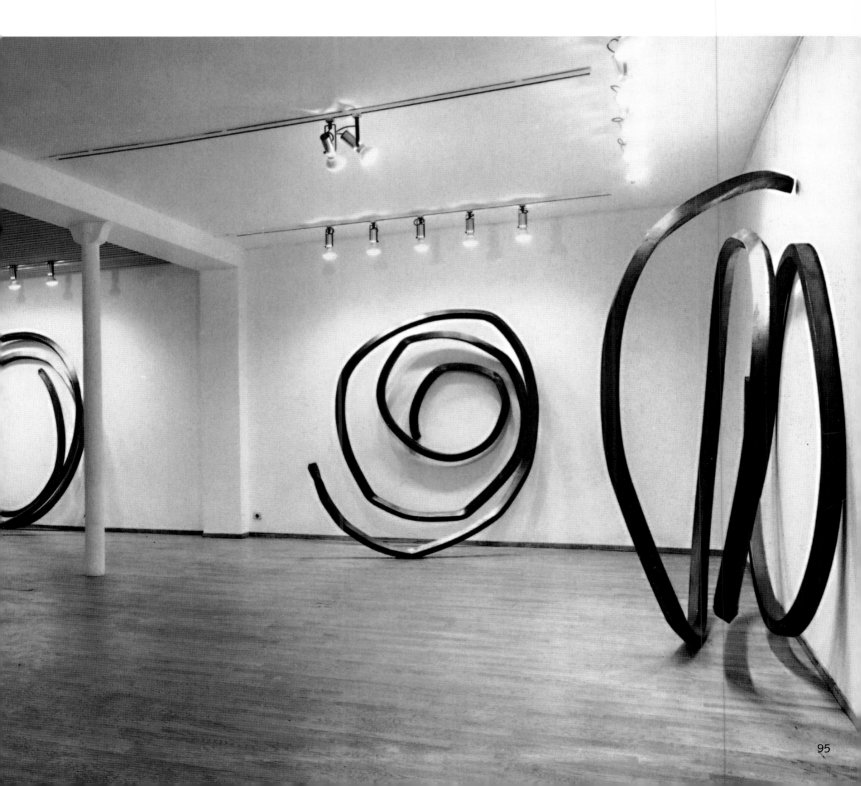

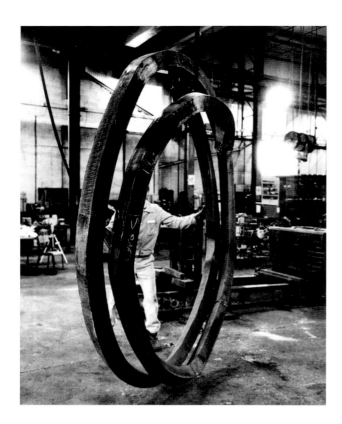

Atelier Marioni, Vosges (France), 1993

The artist's studio, Le Muy (France), 1997

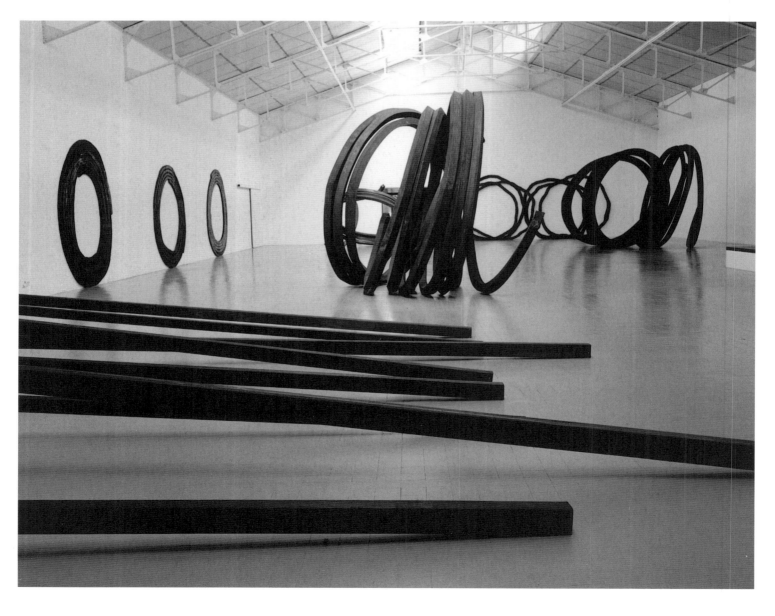

The artist's studio, Le Muy (France), 1997

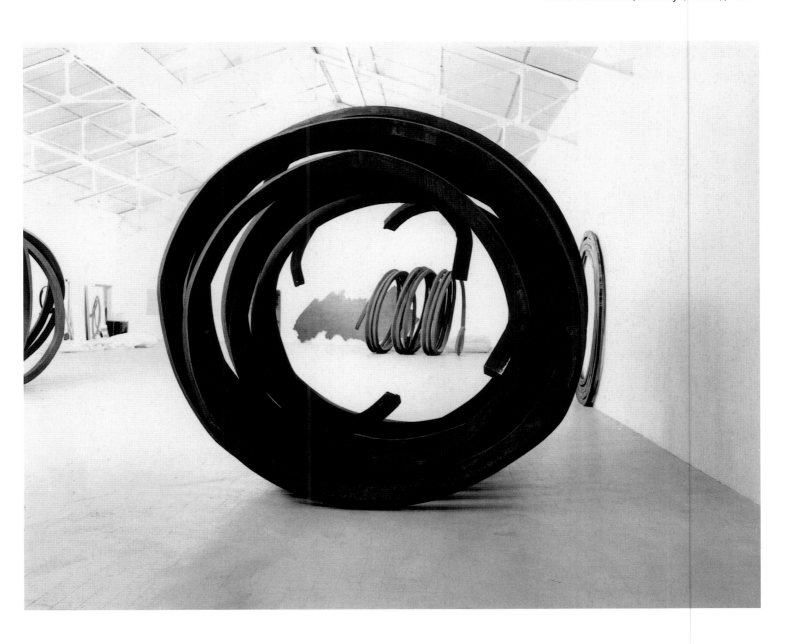

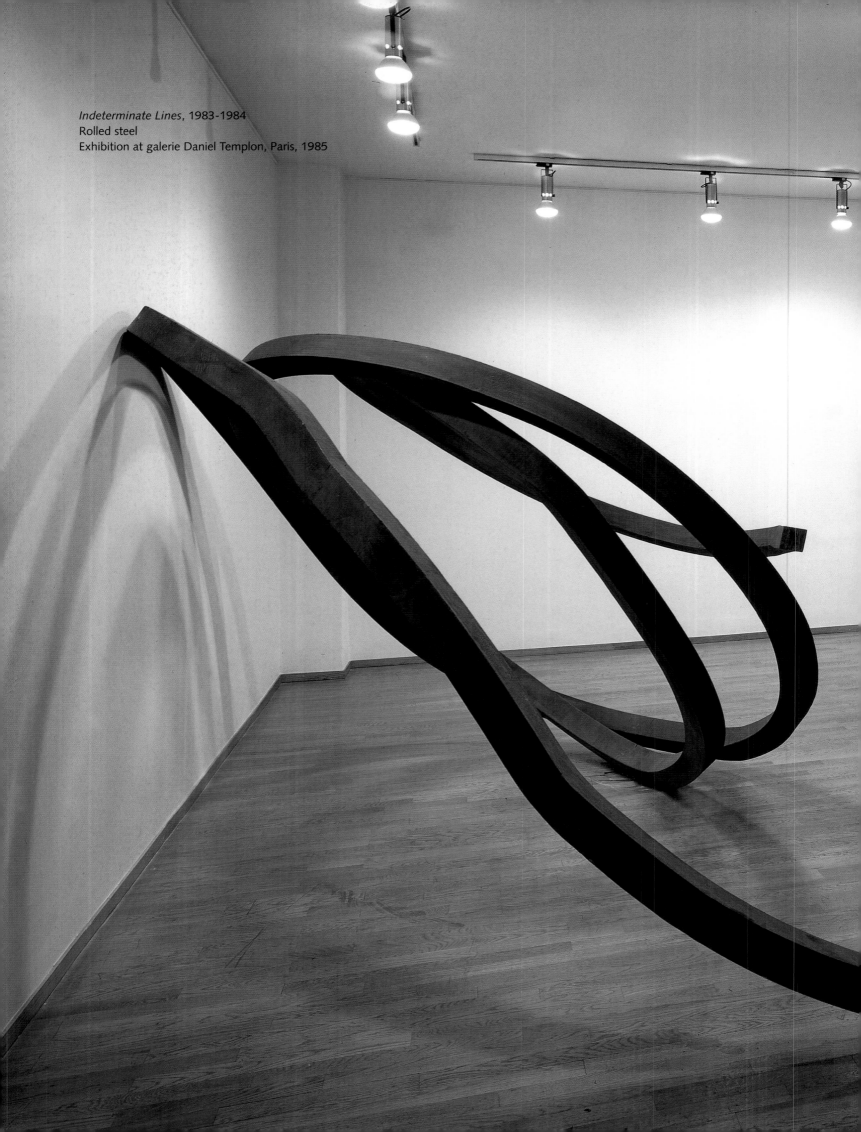

Indeterminate Lines, 1983-1984
Rolled steel
Exhibition at galerie Daniel Templon, Paris, 1985

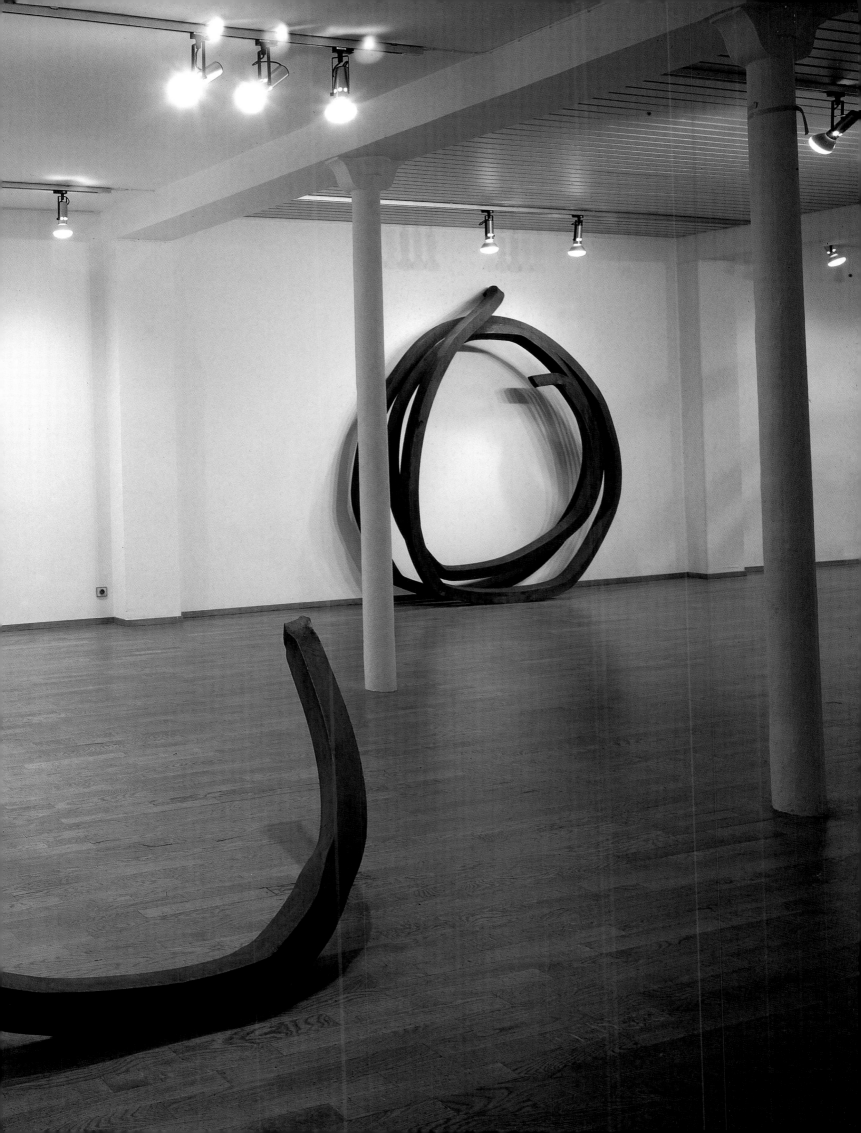

CONTINGENCY

These lines, while obeying the laws of gravity, tower up somewhat in space; they define and participate in the baroque space of sculpture. The installation of these works, in which chance plays a big role, changes each time they are exhibited in different places. While it is impossible to recreate the same form twice, to attempt to do so would indicate that its intention has been misunderstood. Contingency is essential: the aim is to liberate sculpture from the constraints of composition and of an ideal order.

Three Indeterminate Lines, 1994
Rolled steel, 104.25 x 104.25 x 137.5 in.
Champ-de-Mars, Paris, summer 1994

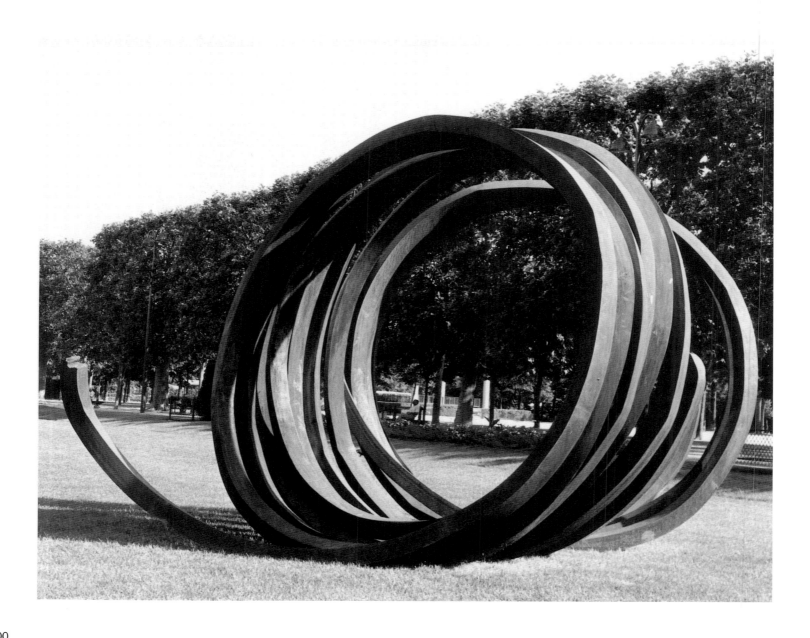

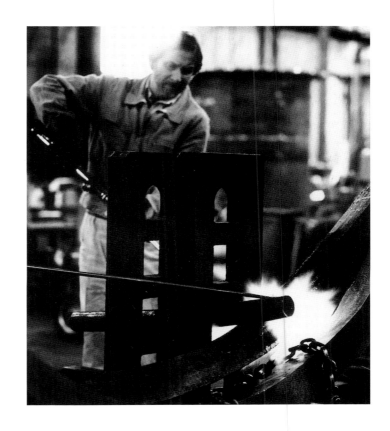

Four Indeterminate Lines, 1997
Rolled steel, 114 x 117.75 x 168.75 in.
Courtesy Grant Selwyn Gallery, Los Angeles

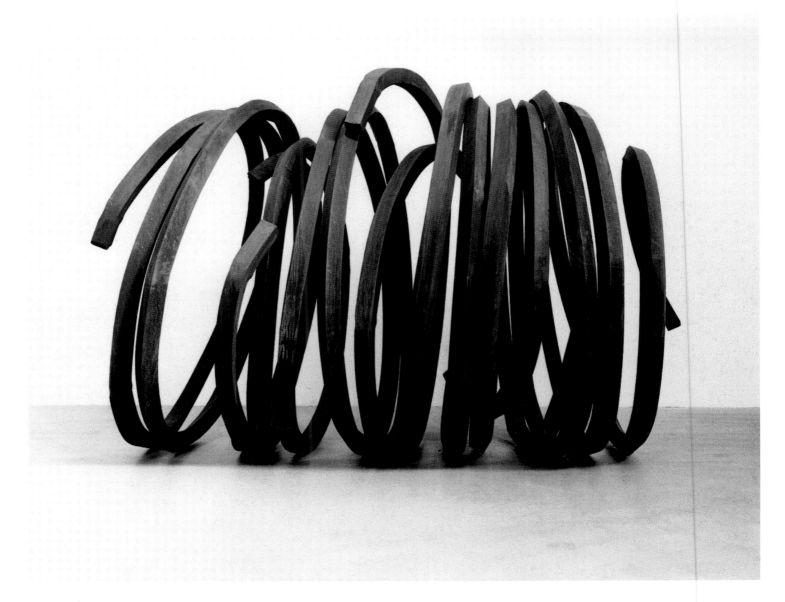

Indeterminate Line, 1995
Torch cut steel, 98 in.

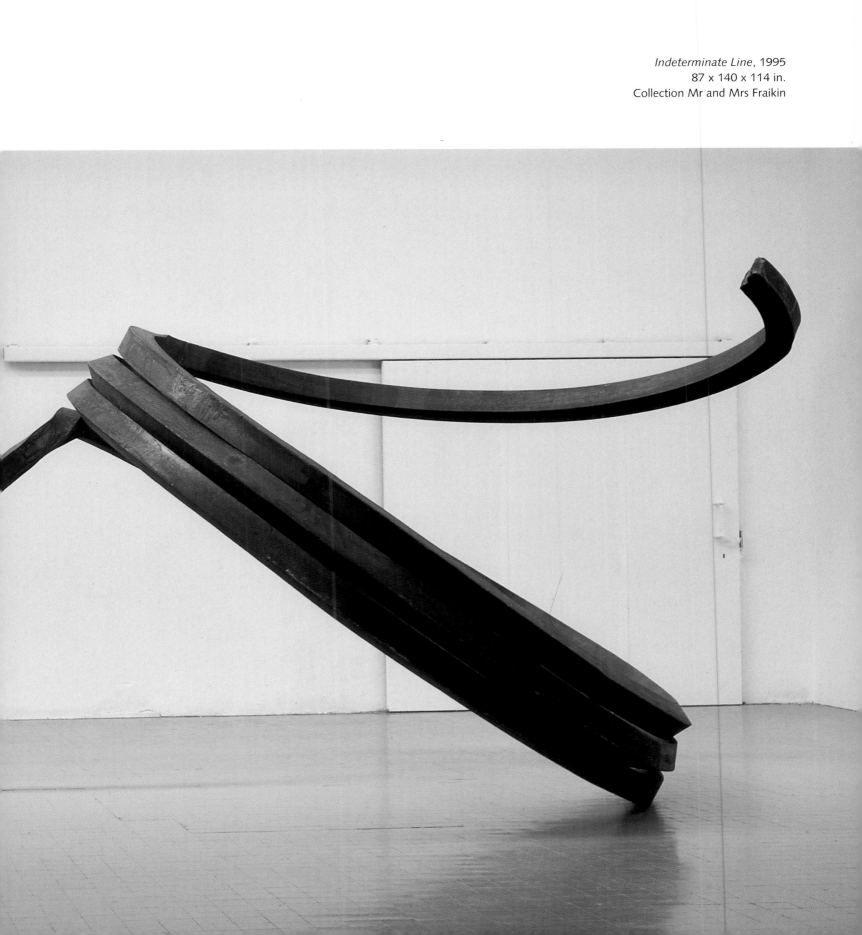

Indeterminate Line, 1995
87 x 140 x 114 in.
Collection Mr and Mrs Fraikin

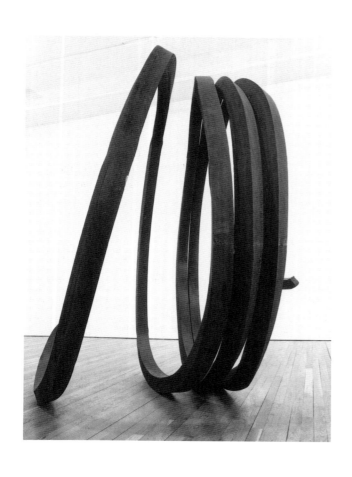

Indeterminate Line, 1990
Rolled steel, 106.5 x 103.5 x 88 in.
Collection Joan Borenstein, Los Angeles, CA

Indeterminate Line, 1990
Painted steel, 275 in. tall
Place de Bordeaux, Strasbourg (France)

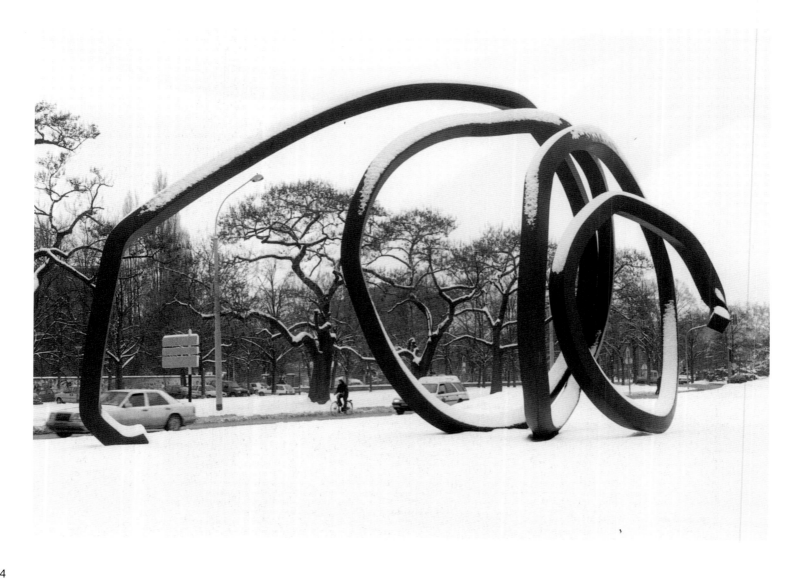

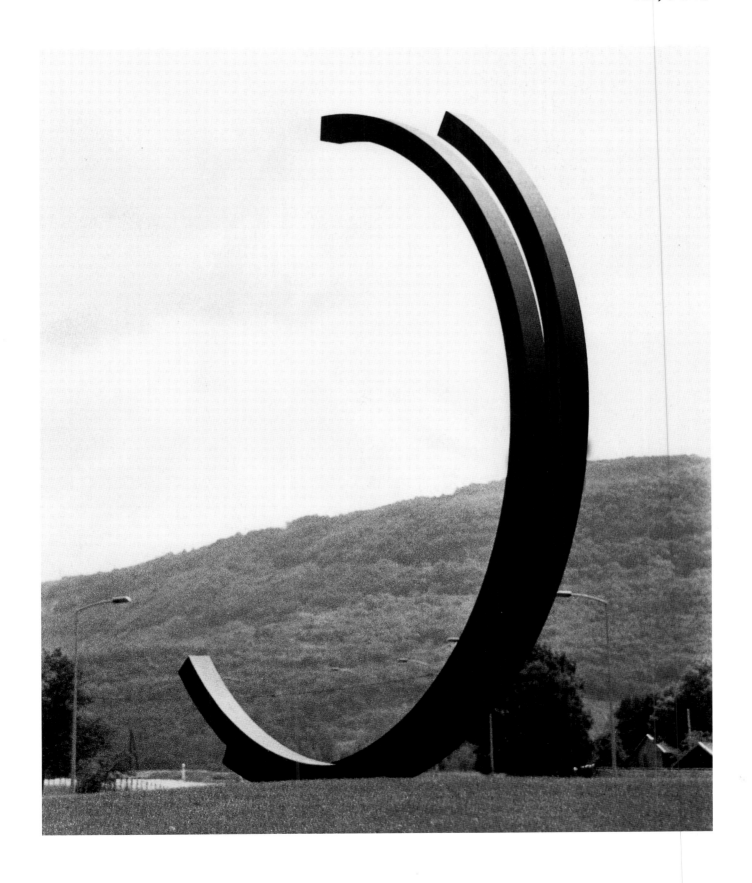

Two Arcs of 201.5°, 1989
Painted steel, 36 feet tall
Belley (France)

Arc of 124.5°, 1994
Painted steel
Collection Enrico Navarra, Le Muy (France)

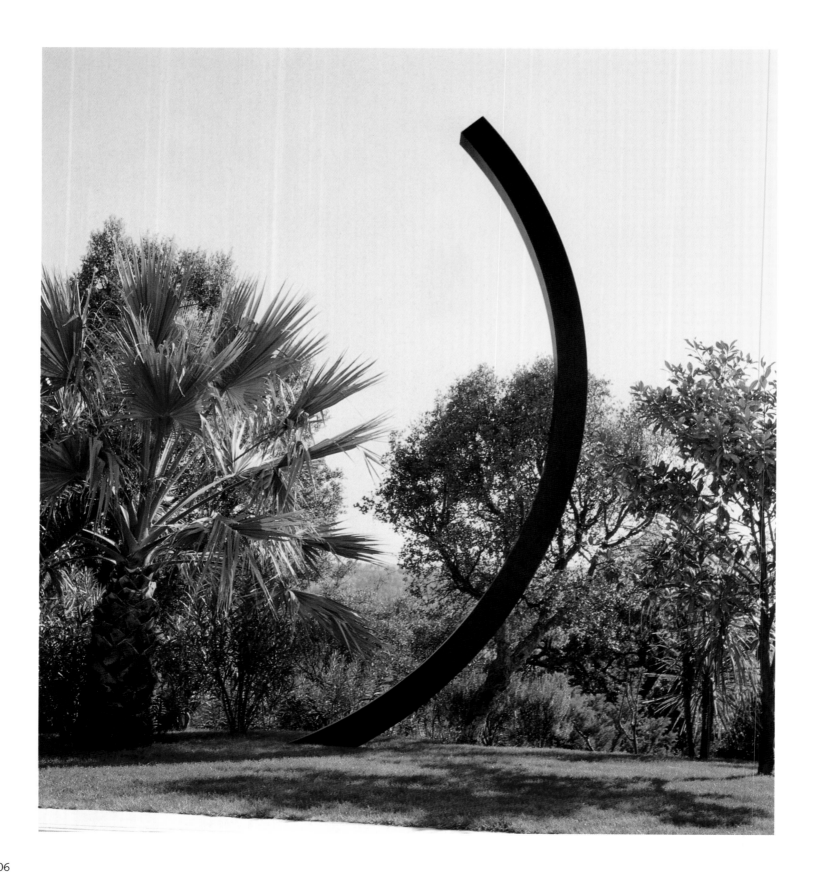

Two Indeterminate Lines, 1988
Painted steel, 39.25 feet tall
La Défense, Paris

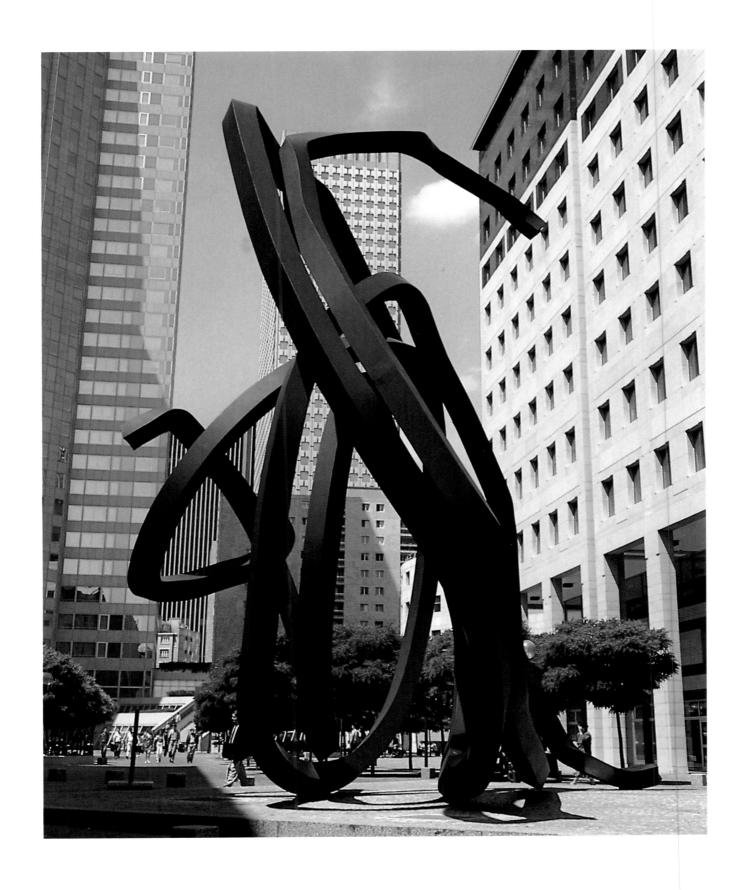

Six Indeterminate Lines, 1995
Torch cut steel, 230 x 98 x 4 in.

Indeterminate Line, 1995
Torch cut steel, 100.75 x 105 x 1.5 in.

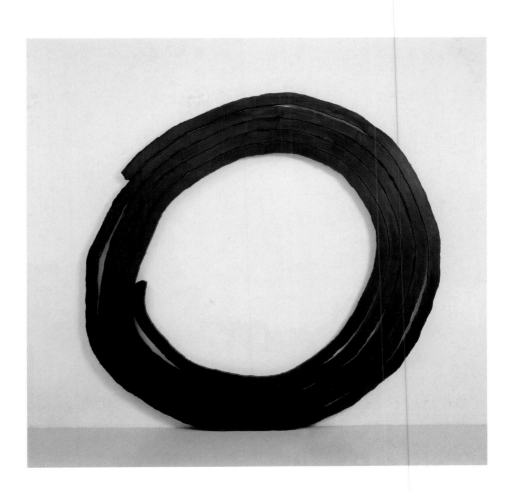

Four Indeterminate Lines, 1993
Torch cut steel, 96.5 x 106.75 x 5.5 in.

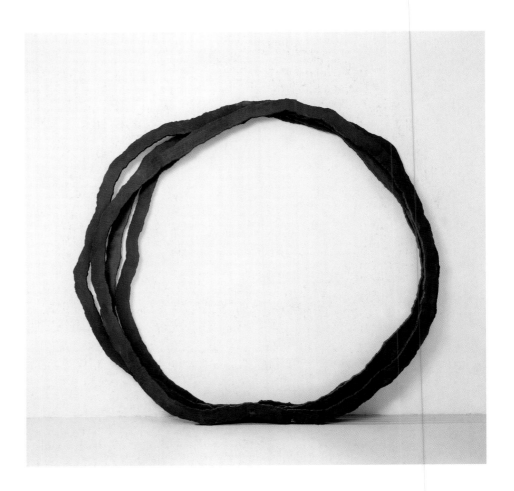

Arc of 115.5°, 1988
Painted steel, 62 x 124 x 3.2 feet
Jardin Albert 1^{er}, Nice (France)

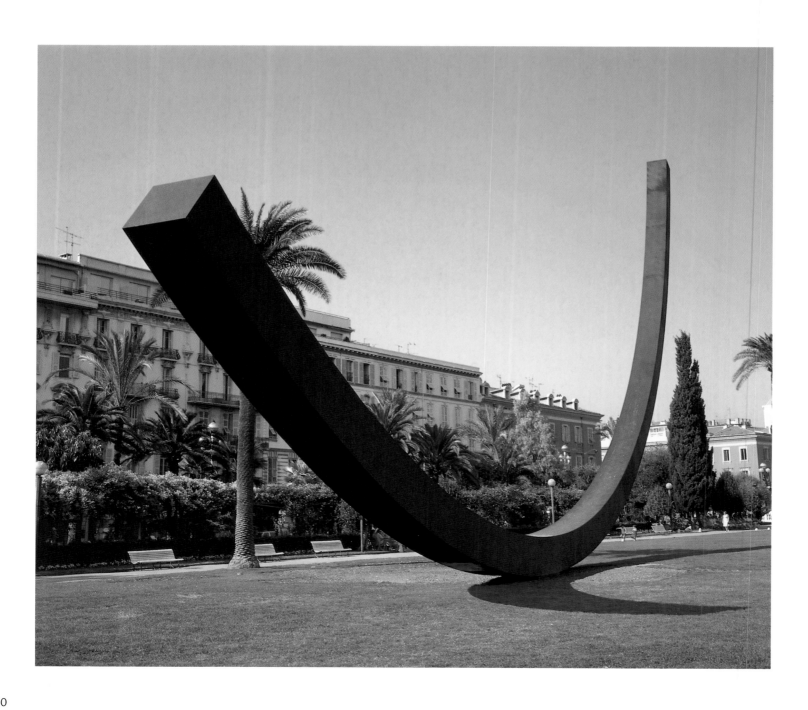

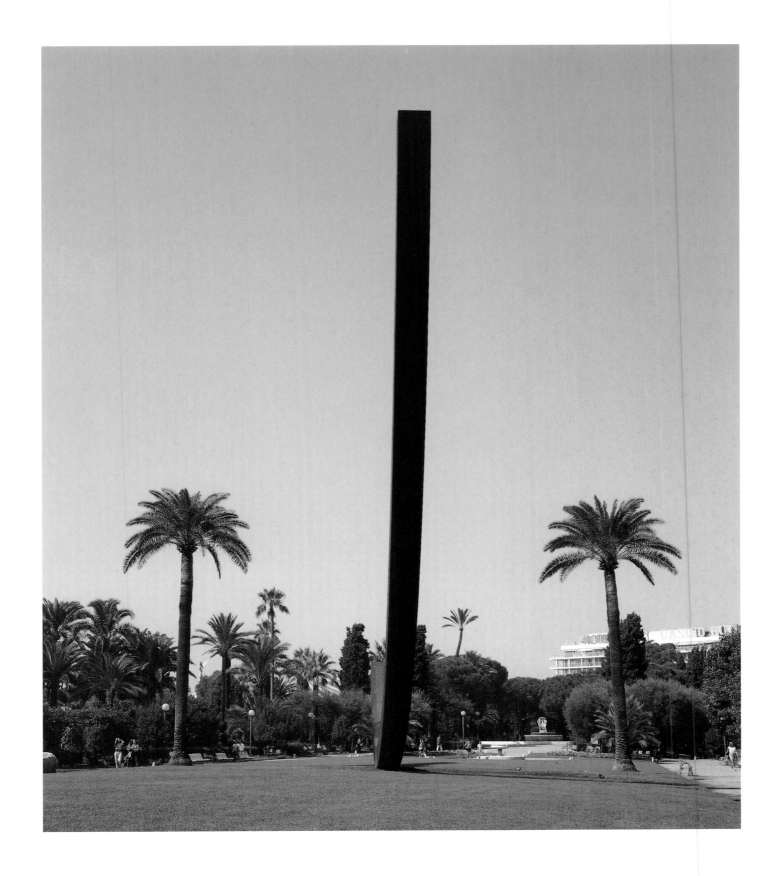

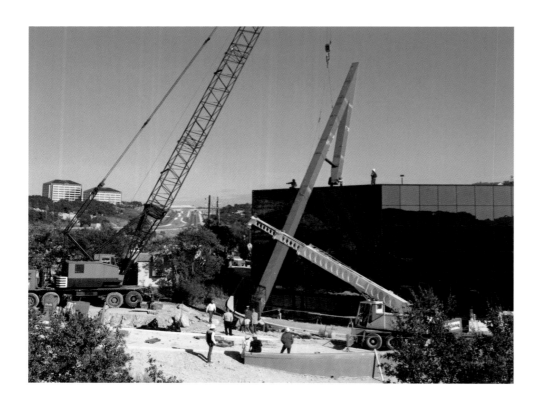

Acute Angle of 19.5°, 1986
Painted steel, 91.5 feet tall
Collection Westech 360, Austin, TX

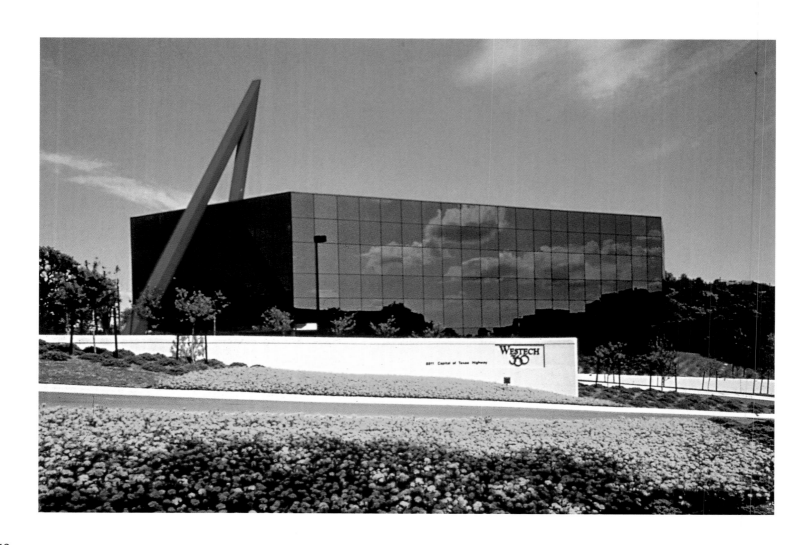

Two Arcs of 267.5°, 1999
Painted steel, 57 x 306 x 276 in.
Collection of the artist, Le Muy (France)

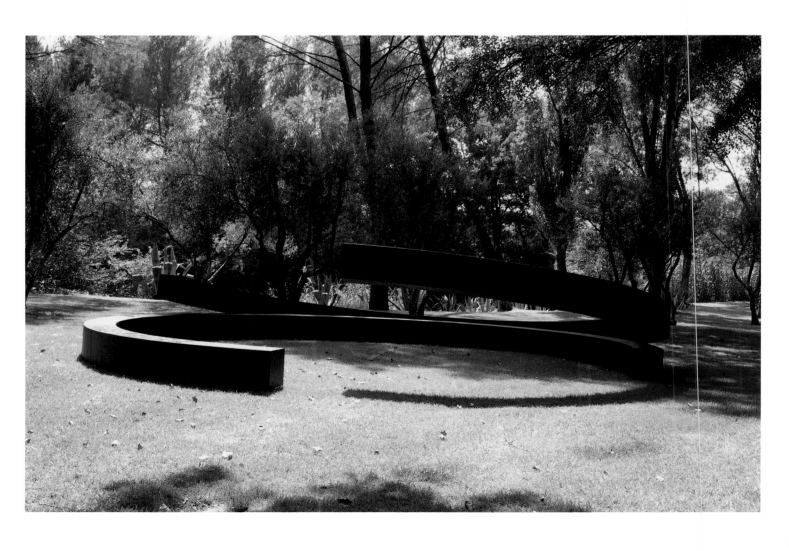

Artist's studio, Le Muy (France), 1996

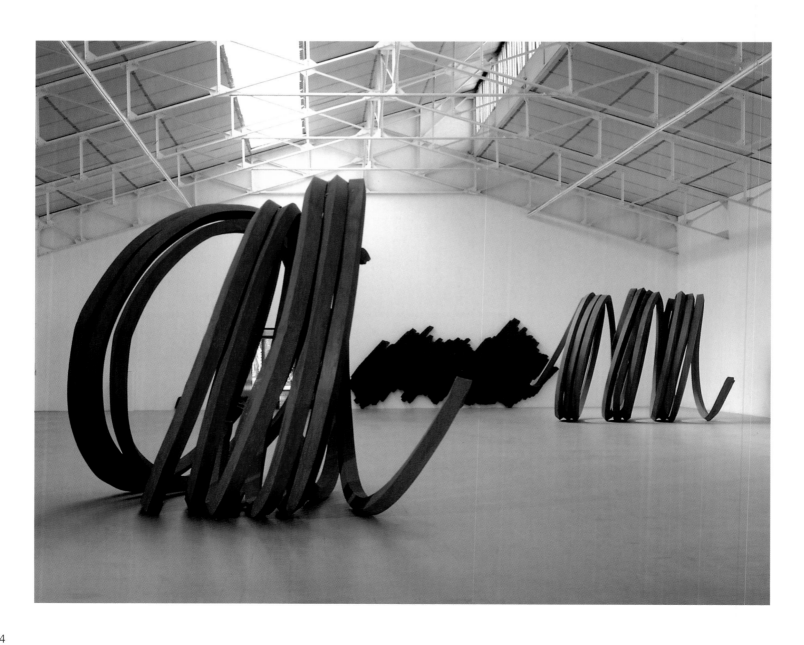

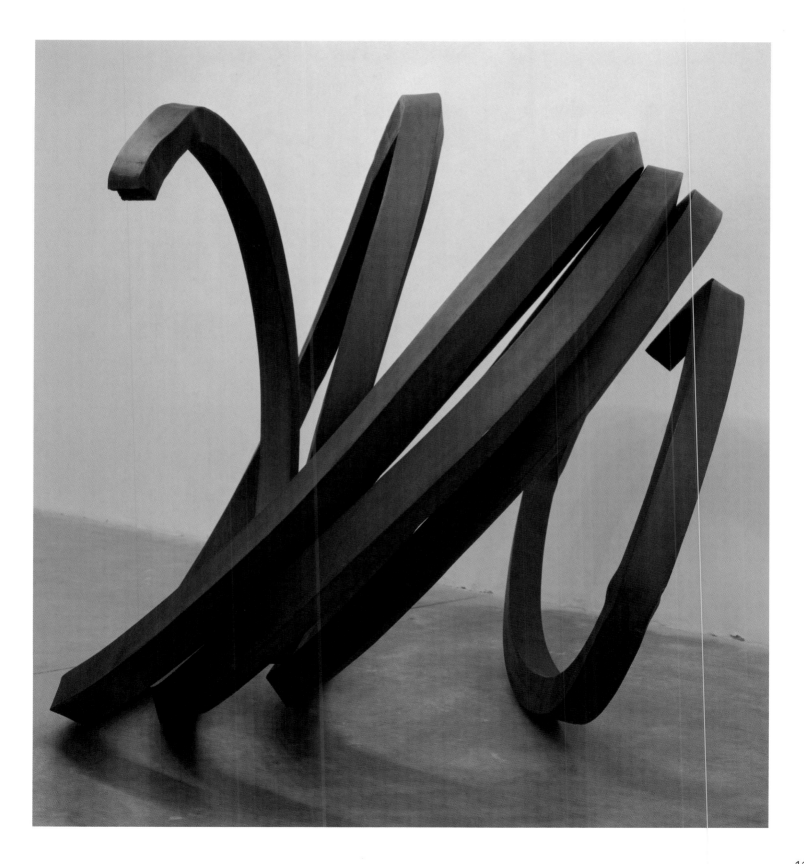

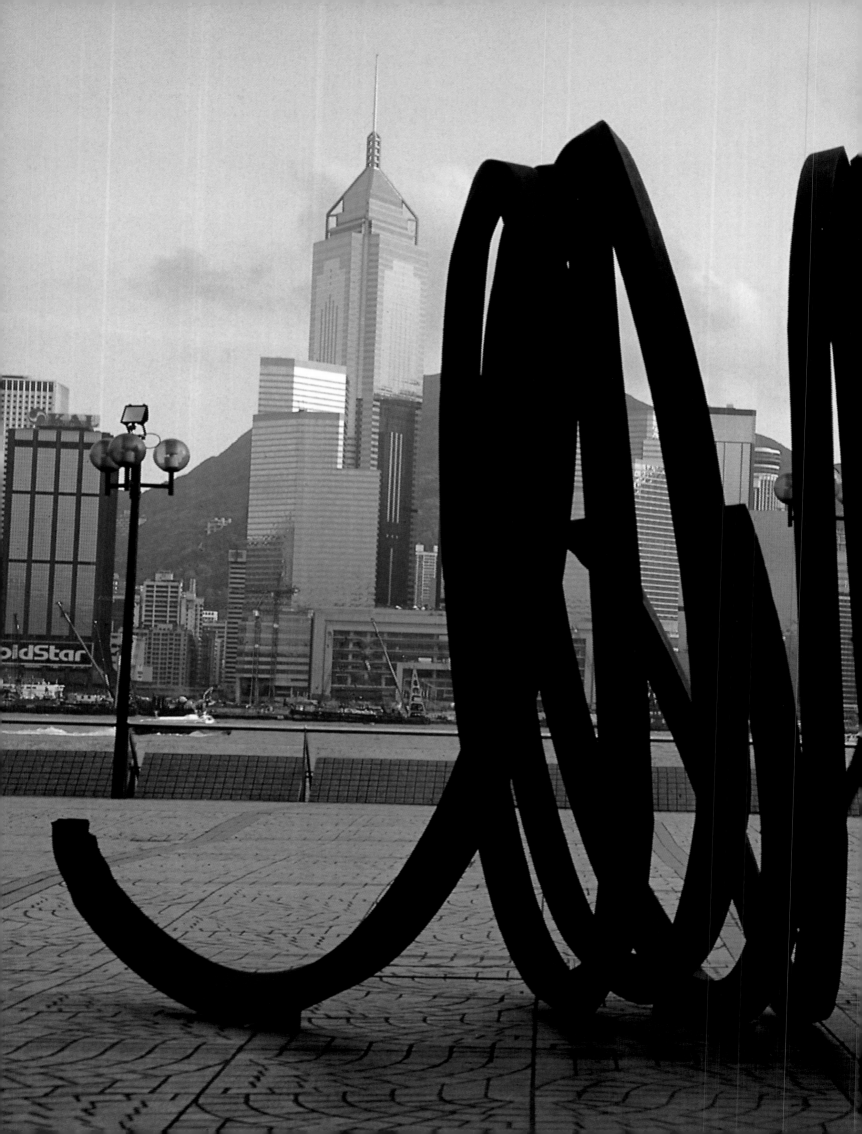

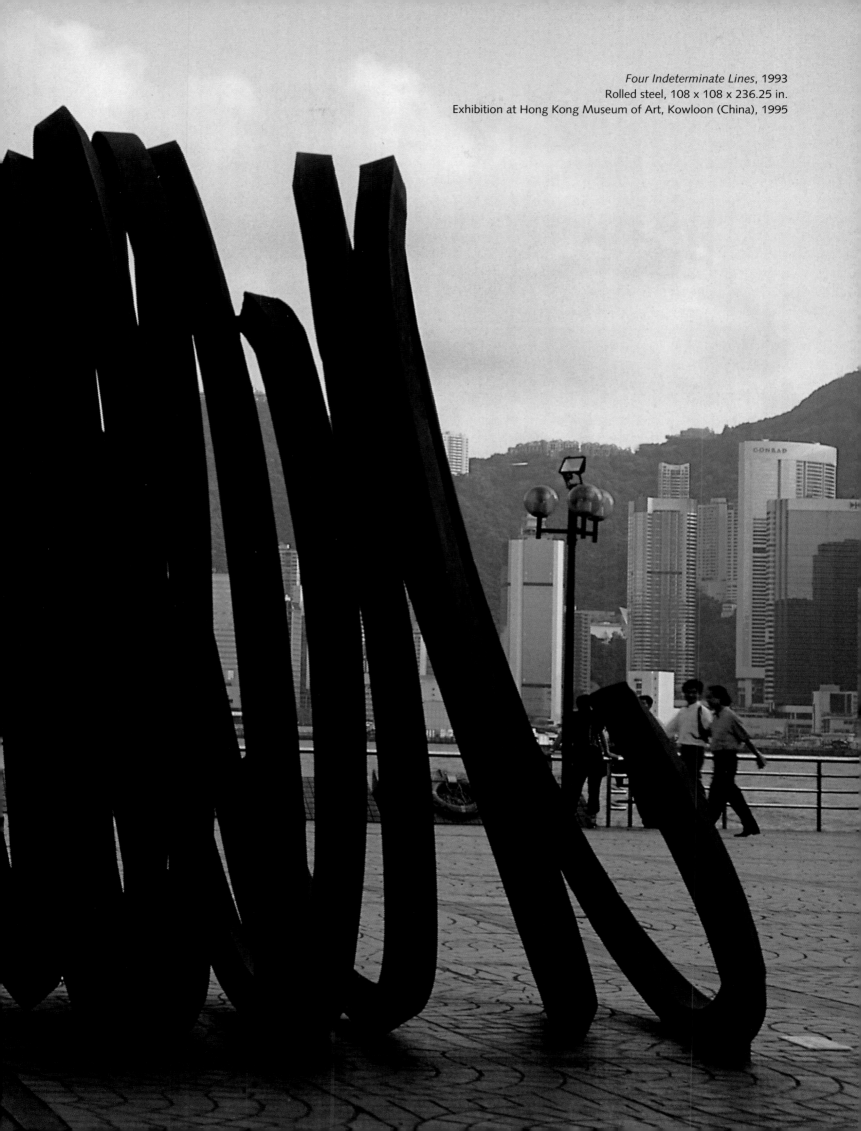

Four Indeterminate Lines, 1993
Rolled steel, 108 x 108 x 236.25 in.
Exhibition at Hong Kong Museum of Art, Kowloon (China), 1995

225.5° Arc x 4, 1998
Steel, 112 x 111 x 40.75 in.
Artist's studio

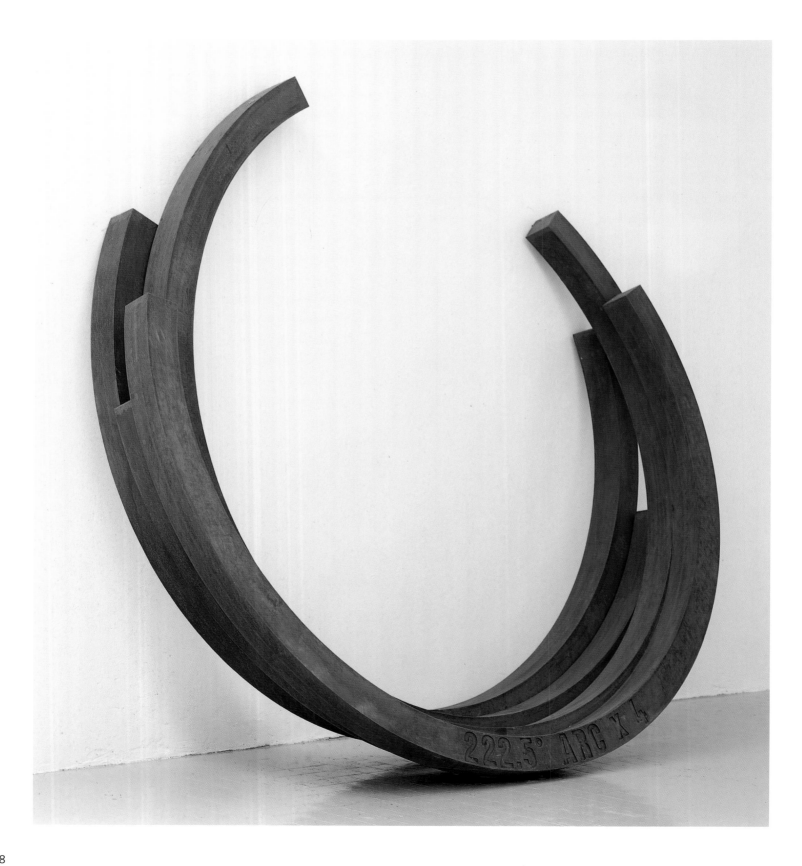

Oblique / Straight Lines, 1995
Laminated steel
Collection Musée de Grenoble, Grenoble (France)

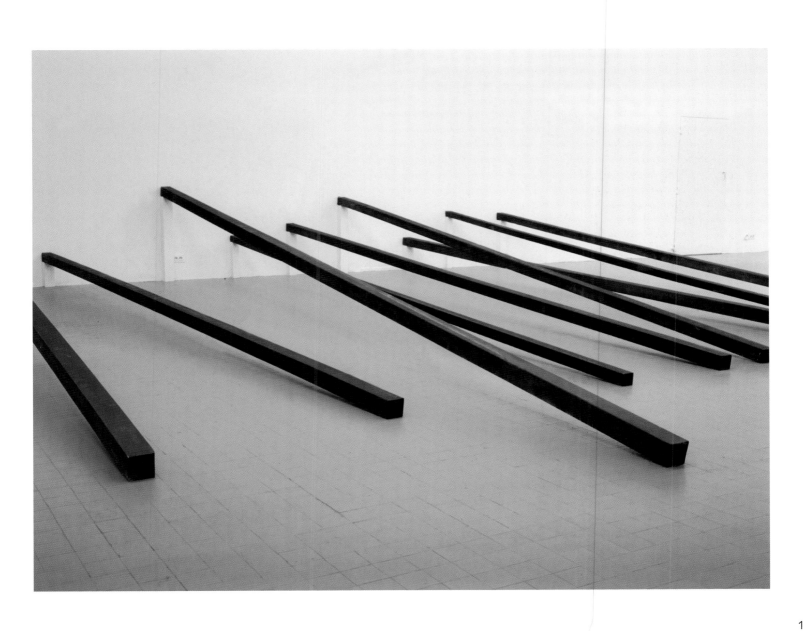

STRAIGHT BARS AND ACCIDENTS

The straight bars follow a logic from a work based on the theme of the line that I have been developing since 1976.
Already in 1966, some of my first conceptual works made on canvas or on paper contained functions represented by straight lines, notably a painting in the collection of the Museum of Grenoble entitled *La droite D' représente la fonction y = 2x + 1*.

Another example is the work entitled *Calculation of a diagonal of a rectangle*. It has the formal simplicity of the famous Rodchenko linear drawing of 1921. However, it separates itself from it by its monosemic character which leaves no doubt as to the real identity of the painting. The mathematical symbols accompanying it give the work a rigorously univocal aspect.

The *Cords subtending Arcs* painted on canvas in 1978 as well as the wood relief *Diagonal of 68.5°* are other examples of works composed of straight lines. More recently, when I endeavored to use straight lines in sculpture, I was able to make new work by taking formal liberties, closer to the notion of chaos and accident. The bars abandoned on the ground, piled up chaotically like a game of Mikado, bring to mind the *Random Combinations of Indeterminate Lines*. They also recall *Coal Pile* of 1963 in its elementary principles. The bars may also be arranged obliquely against a wall, in groups whose quantity vary according to the available space for the installation. Of unequal lengths and squared sections, they are never welded together. In opposition to my other works, these installations follow the principle according to which "the medium is not used to create forms… It is the form itself".

I never make preparatory sketches for these sculptures which are improvised each time. My work gains meaning at the moment when the gesture of placing the bars, of installing them makes the form concrete. The main point of my

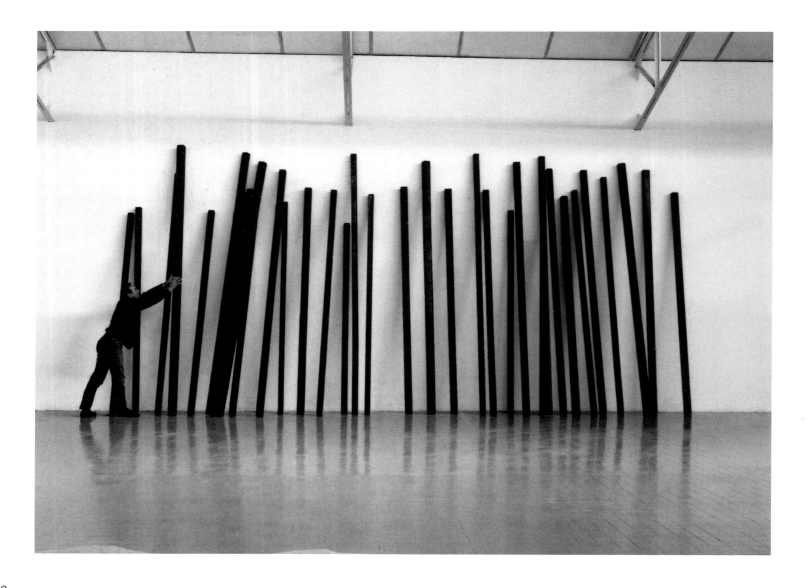

activity as a sculptor is the continuous experimentation with all available means, in the placement of these raw steel bars which have never been transformed, by acting with them in a perfect understanding.

"UNCERTAINTY AS A HYPOTHESIS OF WORK"

Some installations consist of about thirty bars. They lean against the wall, slightly tilted, at the limit of instability. With the help of a forklift, or by myself, I push some bars which provoke the fall of the majority of them. This collapse which scratches the wall creates a disorderly pile, spread out and are often unstable. This final result is what interests me, a product of chance which reveals the components of the sculpture.

a) The upright bars which reveal a prior arrangement.

b) The scratches on the wall as witnesses of the fall, of the collapse of the bars.

c) The bars on the floor both stacked and randomly dispersed by the logical and concrete effect of gravity – outcome of an action, a past event.

In these works, where the fall of the bars is the most important constitutive agent, the relation between the action and the outcome is obvious. Between the end and the means, unity is achieved. The sculpture becomes a fact of experience.

After having set the preliminary conditions, these works escape my control. From an exterior constraint, the disorderly movements of the bars, by activating encounters of chance, achieve a new organization, an unforeseen dispersion.

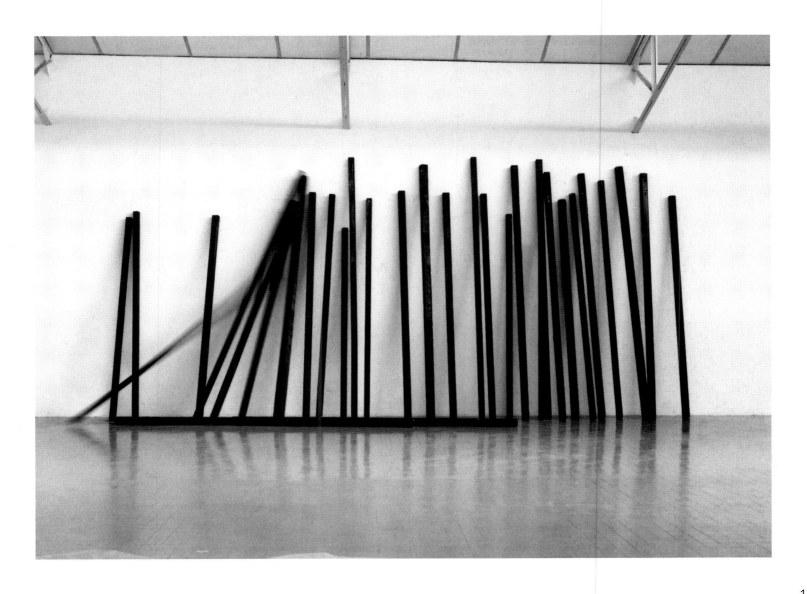

I do retain a real power concerning the choice and placement of the bars, but my disengagement is total as concerns the final result which is impossible for me to foresee. By pushing the bars, these unleash a chain reaction of unexpected reactions, always different and abiding by the principle of uncertainty. In a system of force interactions, an original configuration is achieved which varies in unlimited and unquantifiable possibilities. The collapse consists of undoing, of "deconstituting" that which I have intuitively and previously constituted. It is a movement towards immobility, the state of rest: a new unexpected balance, chaotic, logical because obeying the natural laws of force and mass in movement. With these sculptures, I seek to realize the best possible adequation between a formal, sober, elementary vocabulary and the structural principles which put it into effect.

WHY THE TITLE "ACCIDENTS"?

There is nothing "dramatic" in this title. The "accident" in the mathematical realm defines itself as a perturbation, an encounter between an organized phenomenon and an event; the whole creating the unexpected. The same is applicable to "catastrophe" which also results in a disintegration. For the moment, I prefer not to overuse the word catastrophe. This is a purely arbitrary choice on my part. These two terms, "accident" or "catastrophe" do not have negative connotations; they do not involve "destruction". Indeed, there is a disintegration, but there is also a genesis: a cascade of events which work towards a formation of something else. The collapse that we witness, as the bars fall,

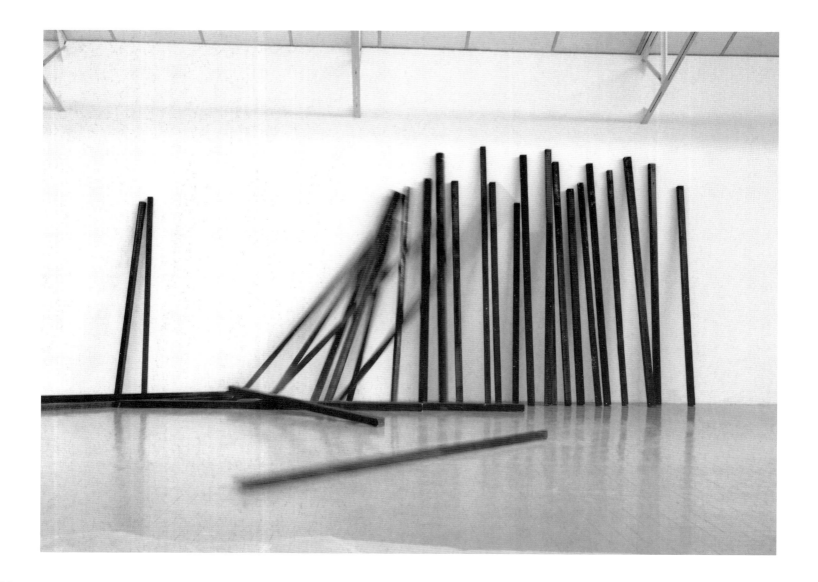

is an occasional collapse contributing to the understanding that the new organization of the bars edifies itself in and by the unbalance and the instability.

This work does not attempt to oppose other systems of composition. It does not attempt to exclude; on the contrary, it includes as hypotheses of possible experiences the ideas of disorder and especially of the unexpected. It even includes the latter in a genetic manner since the disintegration of the former form is the constituted and unforeseen process of the new form.

The notion of "accident" identifies itself to the whole of the process of the metamorphosis, of disintegrating transformation and hence: creation. I am attempting here to push to its extreme limits what I had outlined with my *Random Combinations of Indeterminate Lines*, as well as *Coal Pile* of 1963. Once more, I propose the ephemeral as possible parameters in a work which will each time be recreated, by stressing it's provisional and transitory character. I finally allow the principle of uncertainty to intervene. As I have already stated in regards to the works previously made and mentioned, my goal is to liberate sculpture of the constraints of composition and to critique the utopian notion of an ideal order. These works composed of straight lines (linked to geometry) presented on the floor in a disorderly fashion, (chaotic), are as far as I am concerned, the best example of a commitment which consists of developing an open system where one ceases to see things as compartmentalized, separated, with hermetic boundaries and where I propose interrelations. With a great sobriety of means, it is my way of reacting brutally to the academy of the square, the cube or the monochrome, this legacy passed on from Malevitch or Mondrian and which is lazily running it's course in it's umpteenth variation, in it's blind belief in an ideal order.

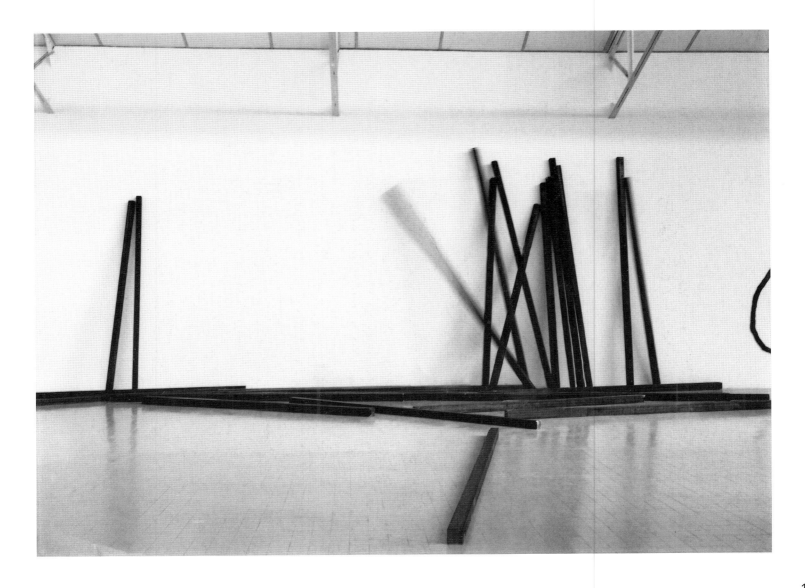

I wish to proposes a realm of the non-proportional, the non-structured, the non-predetermined. An area where the parameters are different to create the unforeseen, the unexpected.

Taking all straight steel bars, allowing them to fall like a game of Mikado in an unstable pile, is to enable the determinate and the indeterminate to coexist, as well as the principles of order and disorder which are at the same time complementary, concurrent and antagonistic.

My goal is to reunite these two opposite notions in an organizing process which allows for new hypotheses. I am not saying that one must blindly go from one orderly, simple, logical art form to a disorderly, complex and uncertain art form. Instead, this work proposes to search the possibilities, not in the alternative or in the exclusion, but rather in the interrelation of the ideas of order and disorder.

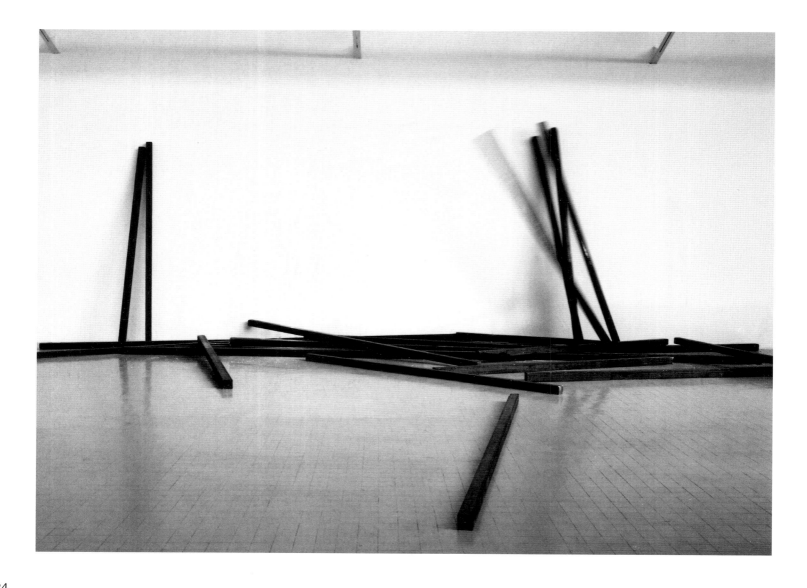

Accident, 1996
Laminated steel, variable dimensions

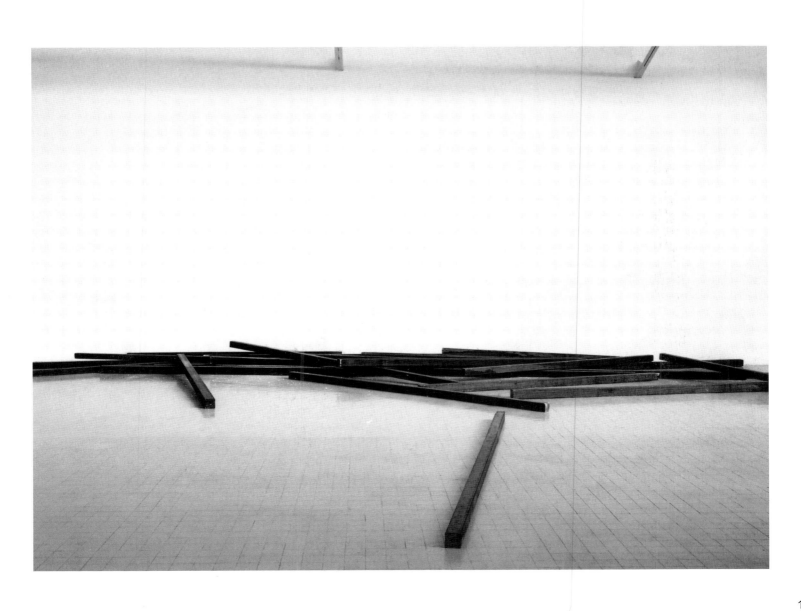

Random Combination of Indeterminate Lines, 1990
Rolled steel, variable dimensions
Exhibition at Vrej Baghoomian Gallery, New York, 1990

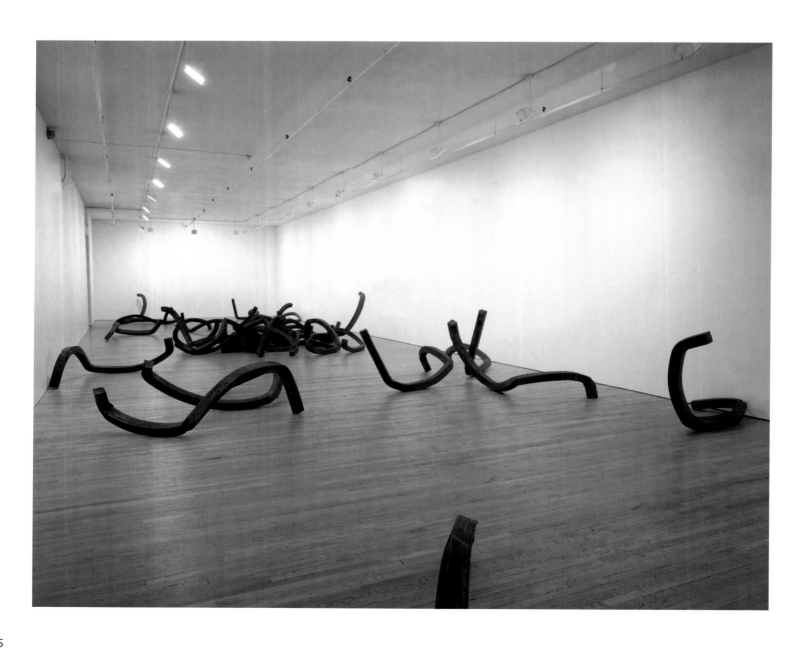

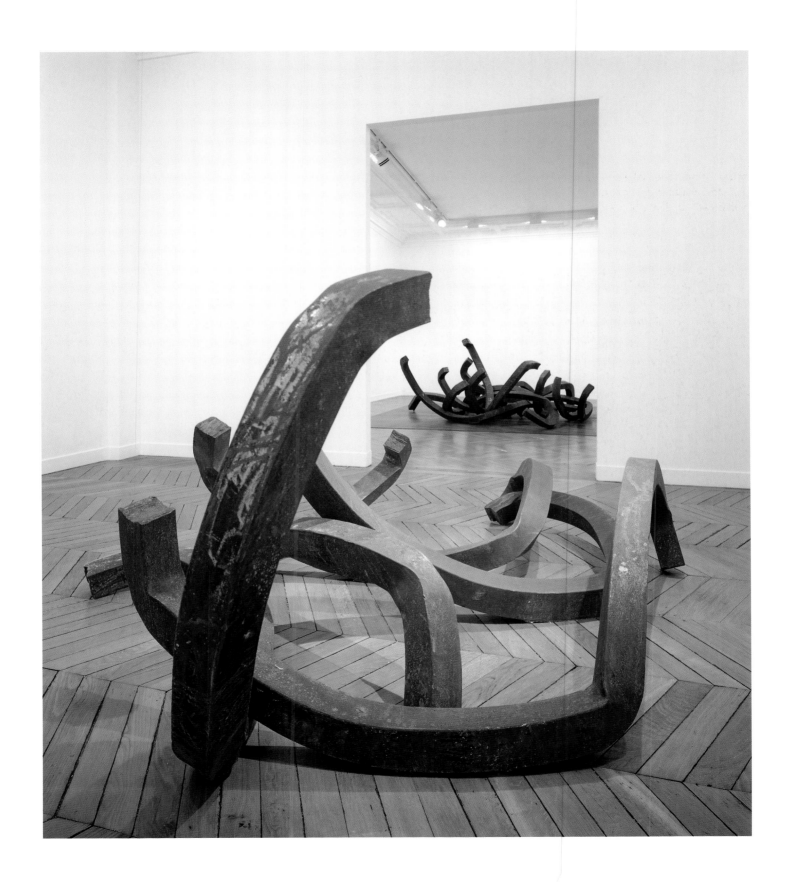

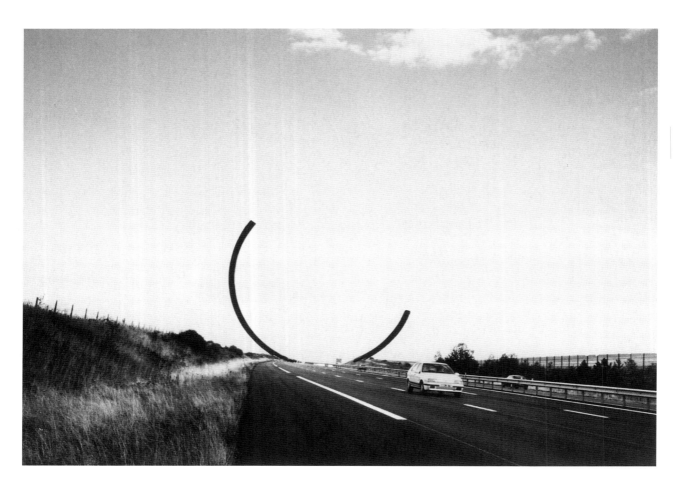

Major Arc, 1983
Project for Autoroute A6, France. Proposed height: 176.5 feet

Diagonal of 84.5°, 1984
Proposed height: 327 feet

Angle of 49.5°, 1984
Painted steel, 120 x 348 in.
Collection The City of Lille (France)

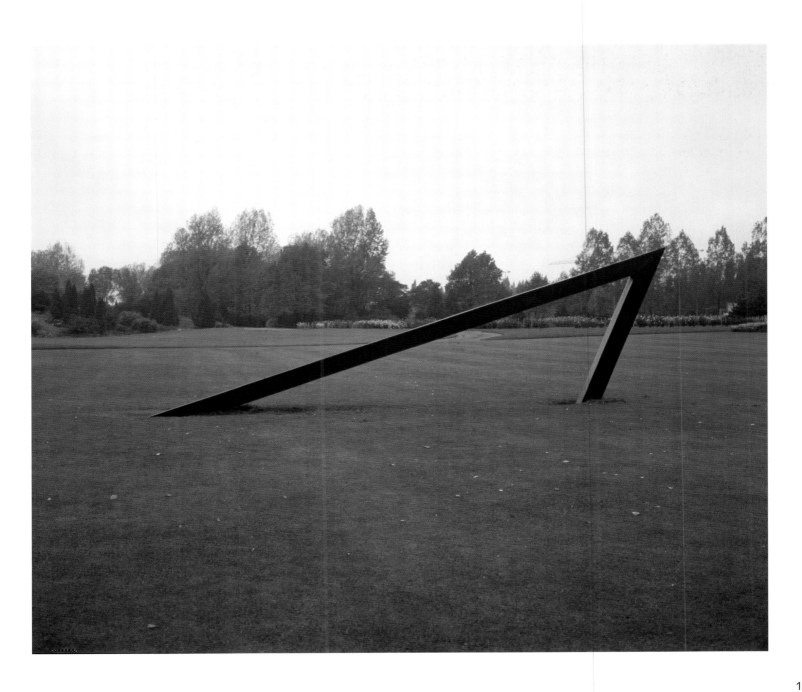

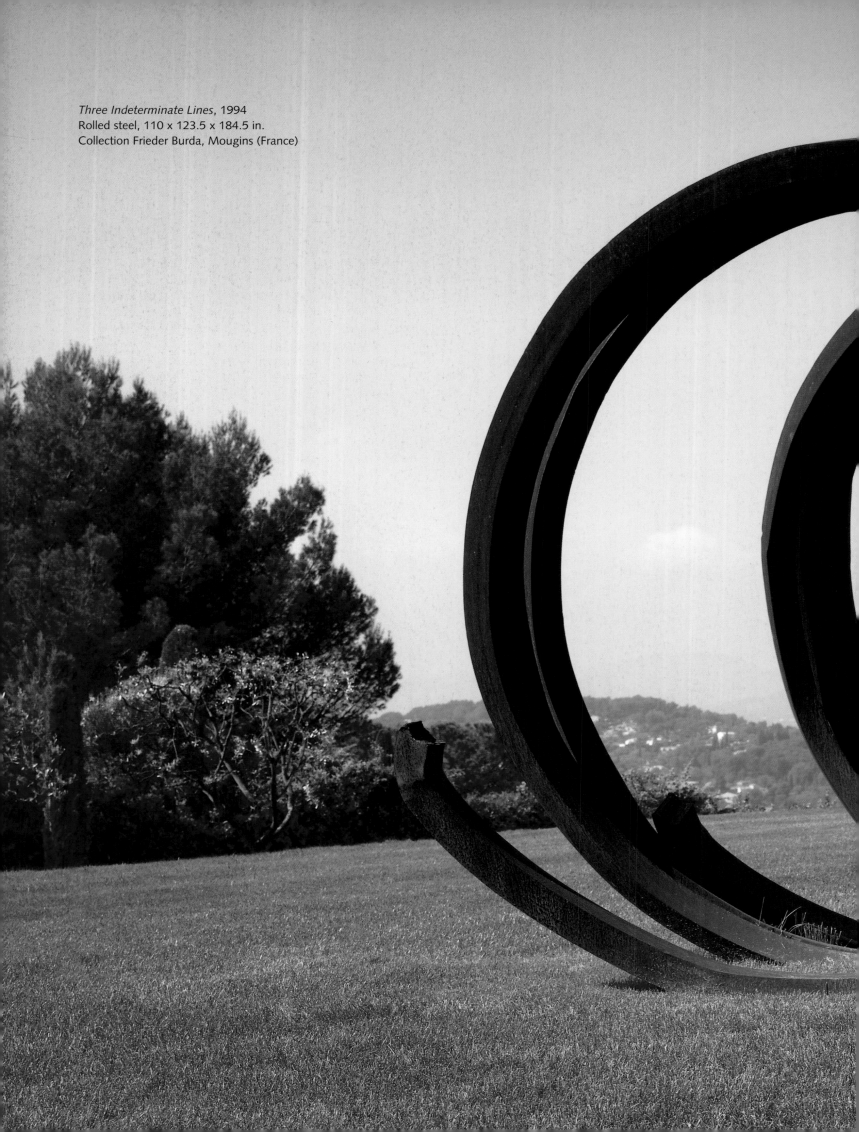

Three Indeterminate Lines, 1994
Rolled steel, 110 x 123.5 x 184.5 in.
Collection Frieder Burda, Mougins (France)

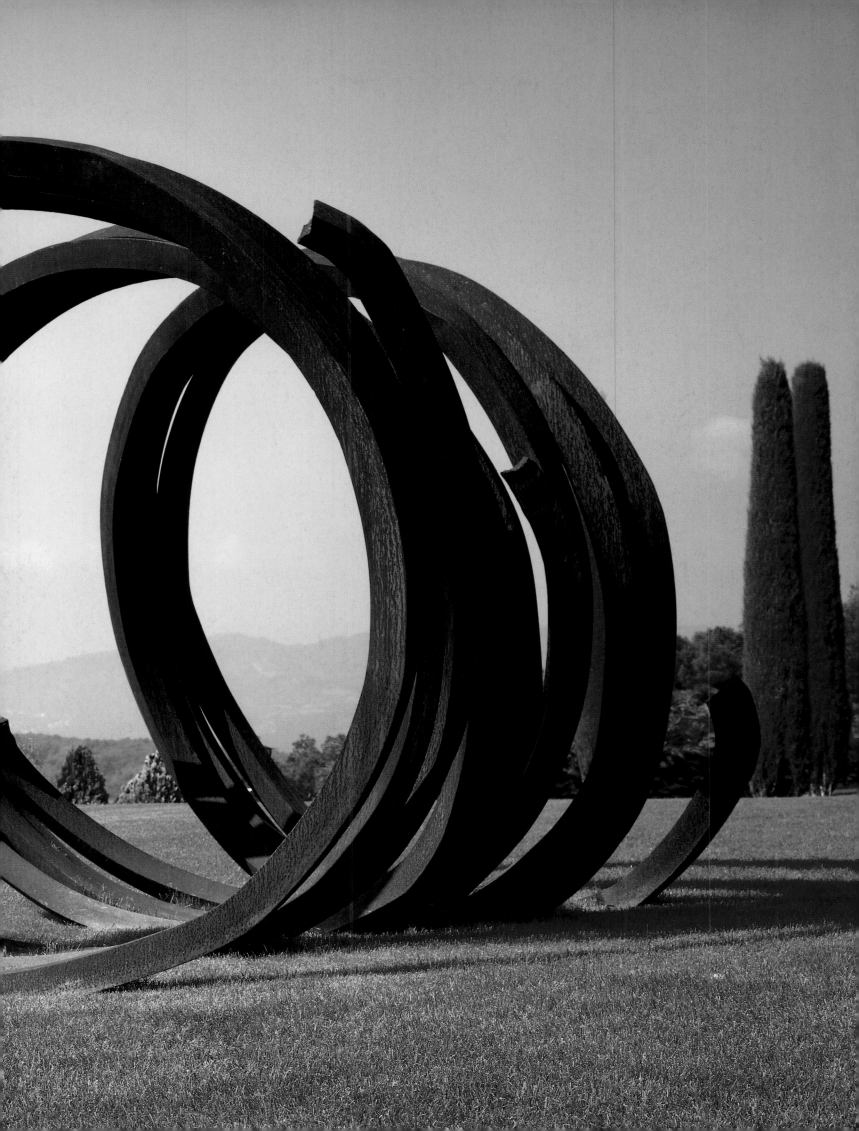

Indeterminate Line, 1993
Painted steel, 36 x 65.5 x 36 feet
Collection Runnymeade Sculpture Farm, Woodside, CA

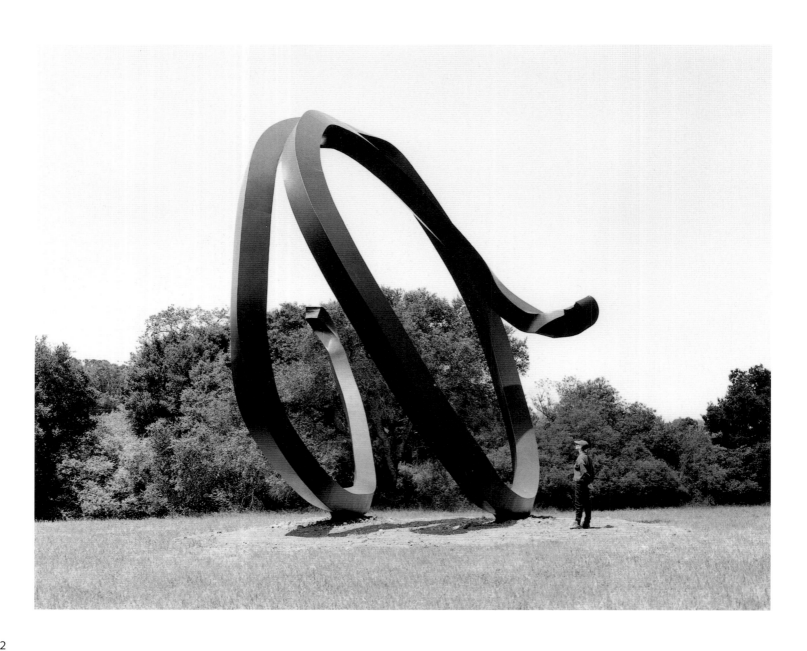

Three Indeterminate Lines, 1994
Rolled steel, 107.5 x 118 x 169.2 in.
Champ-de-Mars, Paris, summer 1994

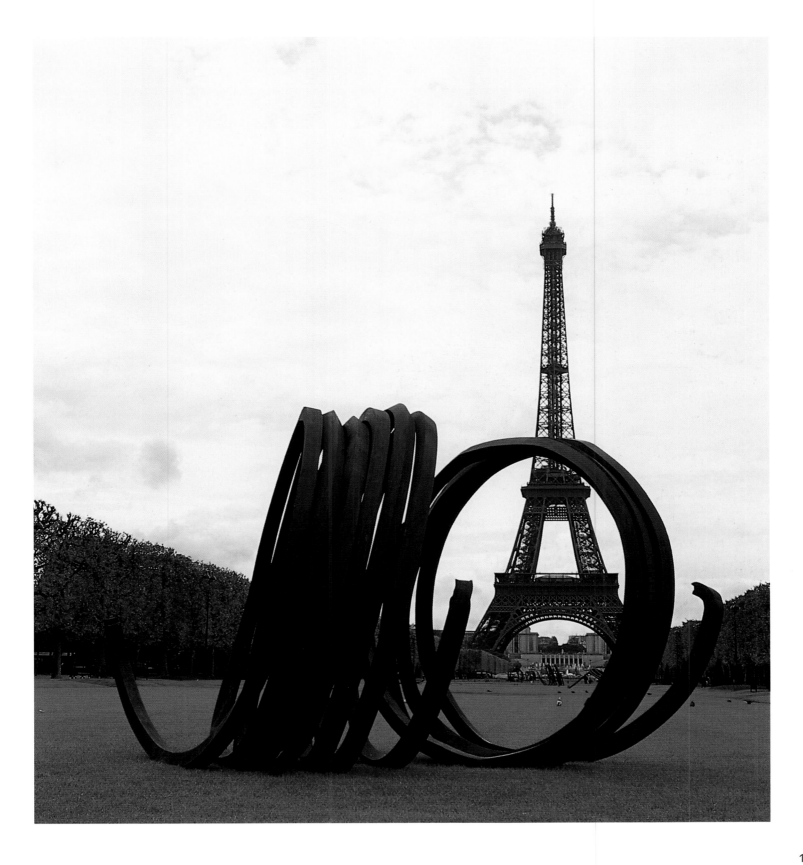

Indeterminate Lines
Rolled steel
Exhibition at the Schützenmattpark, Basel (Switzerland), 1998

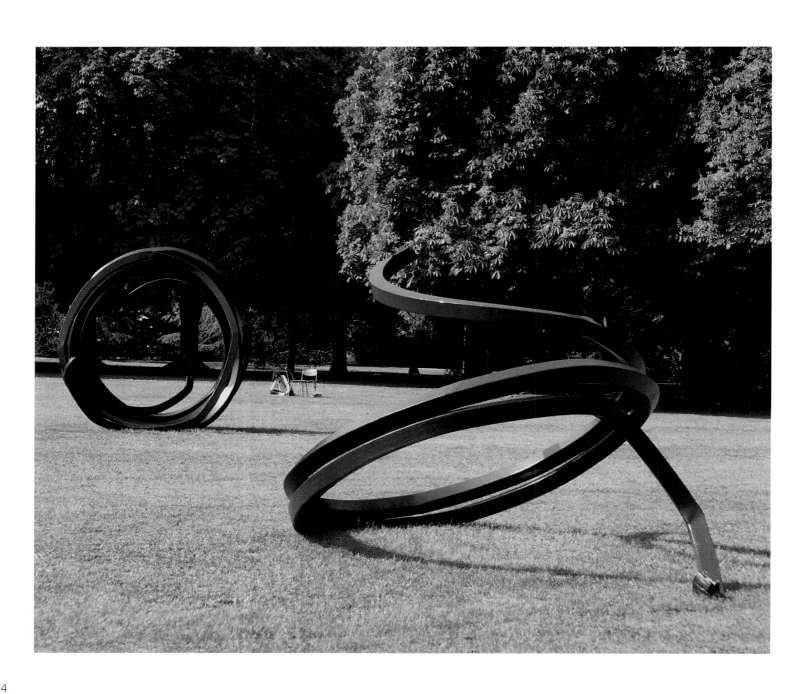

Indeterminate Line, 1985
Rolled steel, H: 108 in.
Collection Mr and Mrs Avellino, Fort Lauderdale, FL

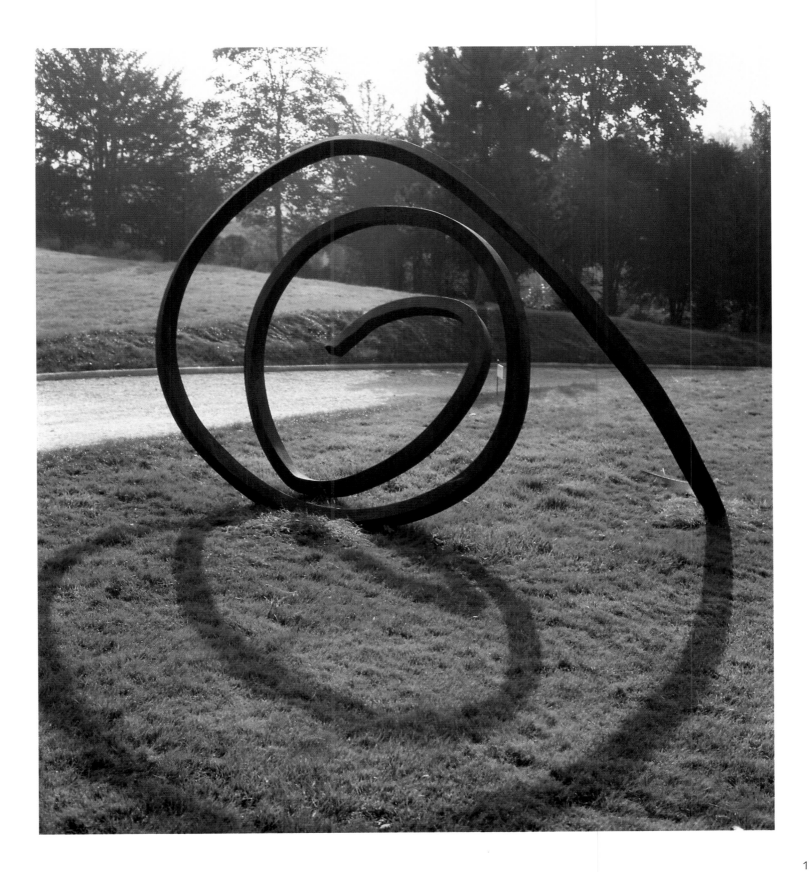

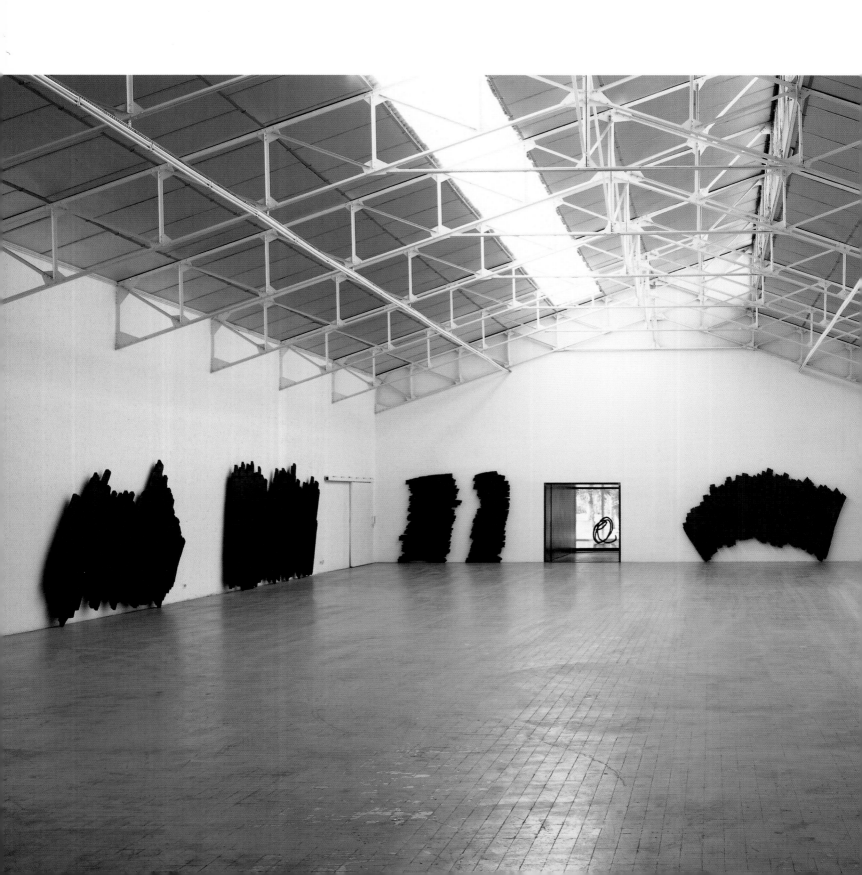

Indeterminate Areas, 1998
Artist's studio, Le Muy (France)

INDETERMINATE AREA

The first *Indeterminate Area* was made in very thick plywood covered with graphite.

When Donald and Mira Rubell asked to buy it, in 1980, I preferred not to sell, even though theirs is one of the finest collections in New York. At the time I saw it as a one-off experiment. I thought I might return to it later, but just then I wanted to concentrate on lines. Starting in spring 1989, to see how far I could take my work on the "indeterminate", I made a whole series of pieces that I titled: *Possibilité d'indétermination* (Possibility of Indeterminacy). These were thin lines of various sizes cut out of steel, which I fixed to the wall in parallel patterns to form hatched surfaces that I had defined beforehand.

The most recent reliefs were done in 1995. They are roughly cut using a blowtorch (oxy-acetylene) from sheets of steel 35mm thick. I had to be careful when I started this work, because it would have been easy to fall into the trap of making free forms in the manner of Jean Arp. I think I avoided it by using the nervous, staccato action of certain *Lignes indéterminées*, and by high-lighting the effect of surface saturation created by lines that touch each other.

Indeterminate Surface, 1996
Torch cut steel, 99.25 x 89 in.
Collection Frieder Burda, Baden-Baden (Germany)

Improvisé - Inachevé - Non formulé
Exhibition-Performance at
the Mücsarnok Museum,
Budapest (Hungary), April 1999

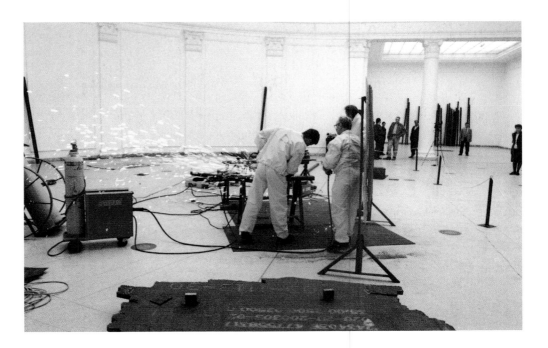

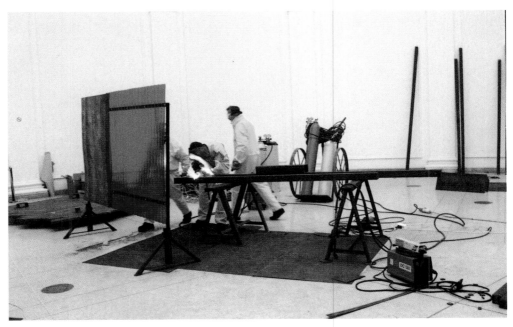

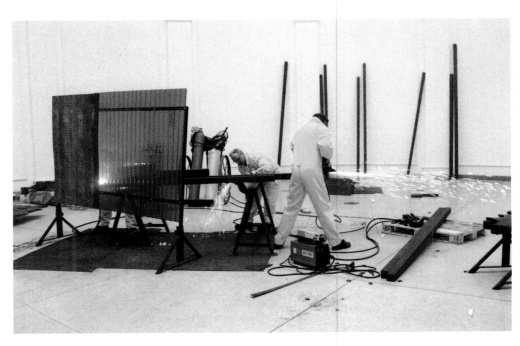

5 Arcs x 5, 1999
Steel, 161 in. tall
Champs-Elysées, Paris, 1999

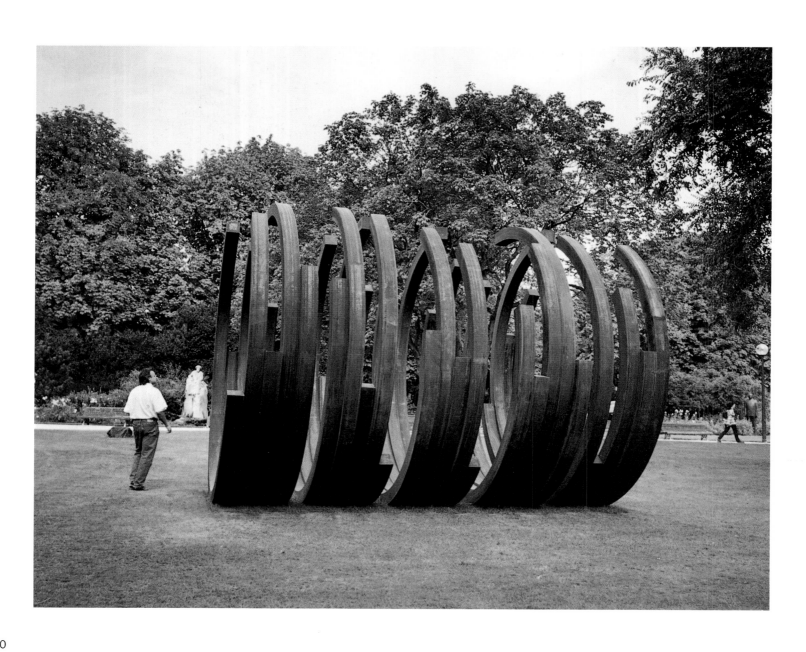

230° 5 Arcs x 5, 1999
Painted steel, 168.75 x 35.25 x 161 in.
Collection city of Shenzhen (China)

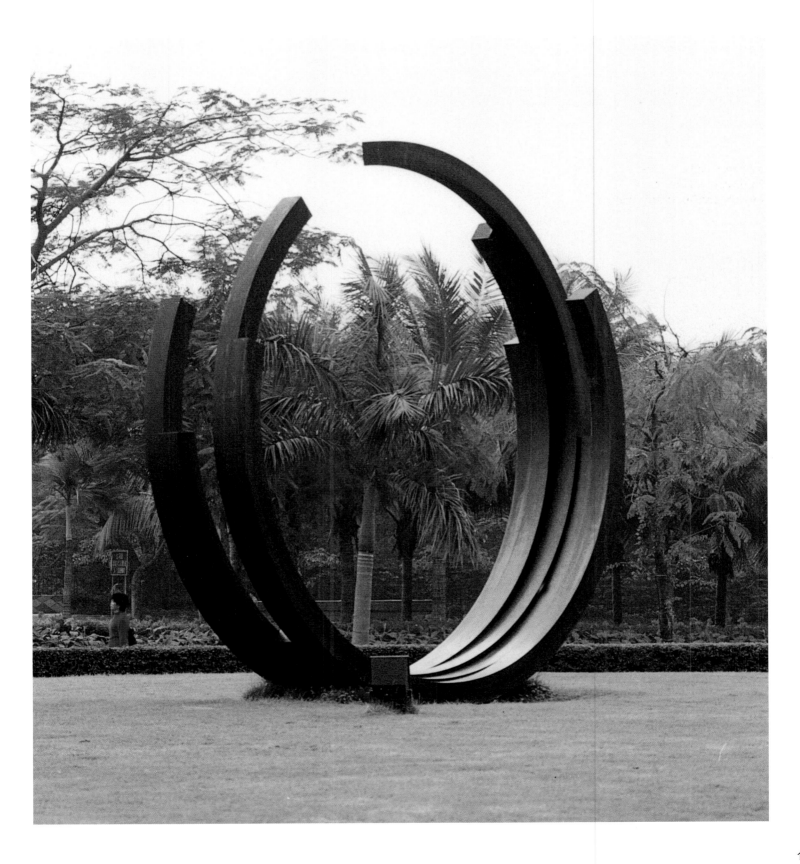

5 Arcs x 5, 1999
Steel
Galerie Karsten Greve, Köln Art Fair, Köln (Germany), 2000

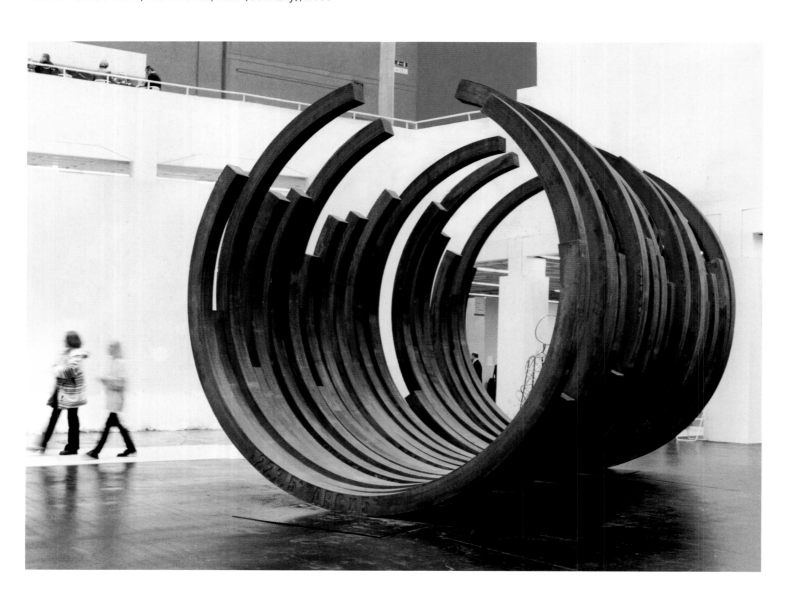

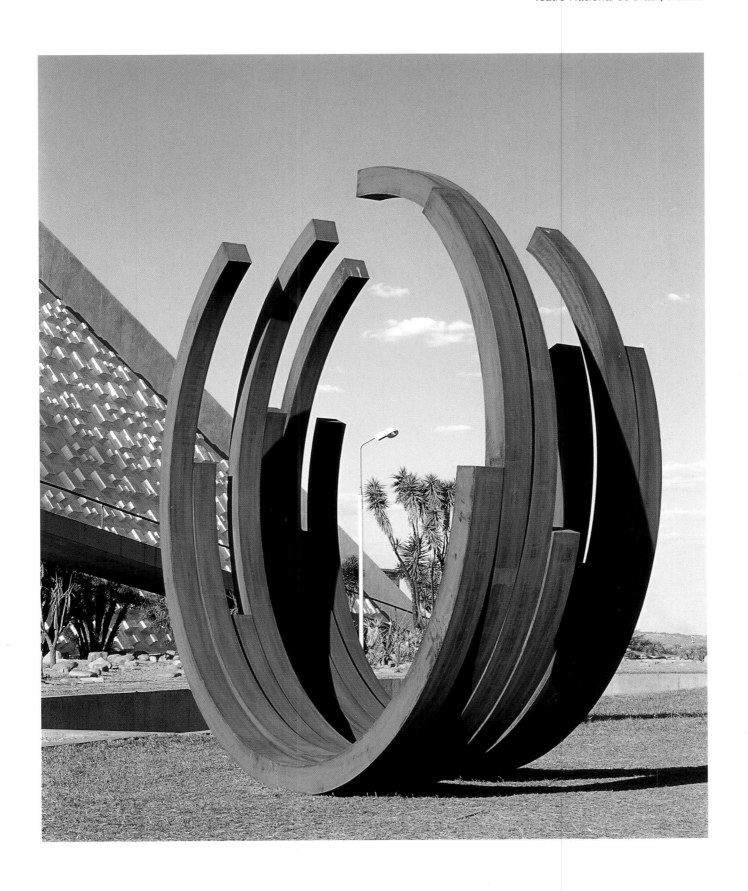

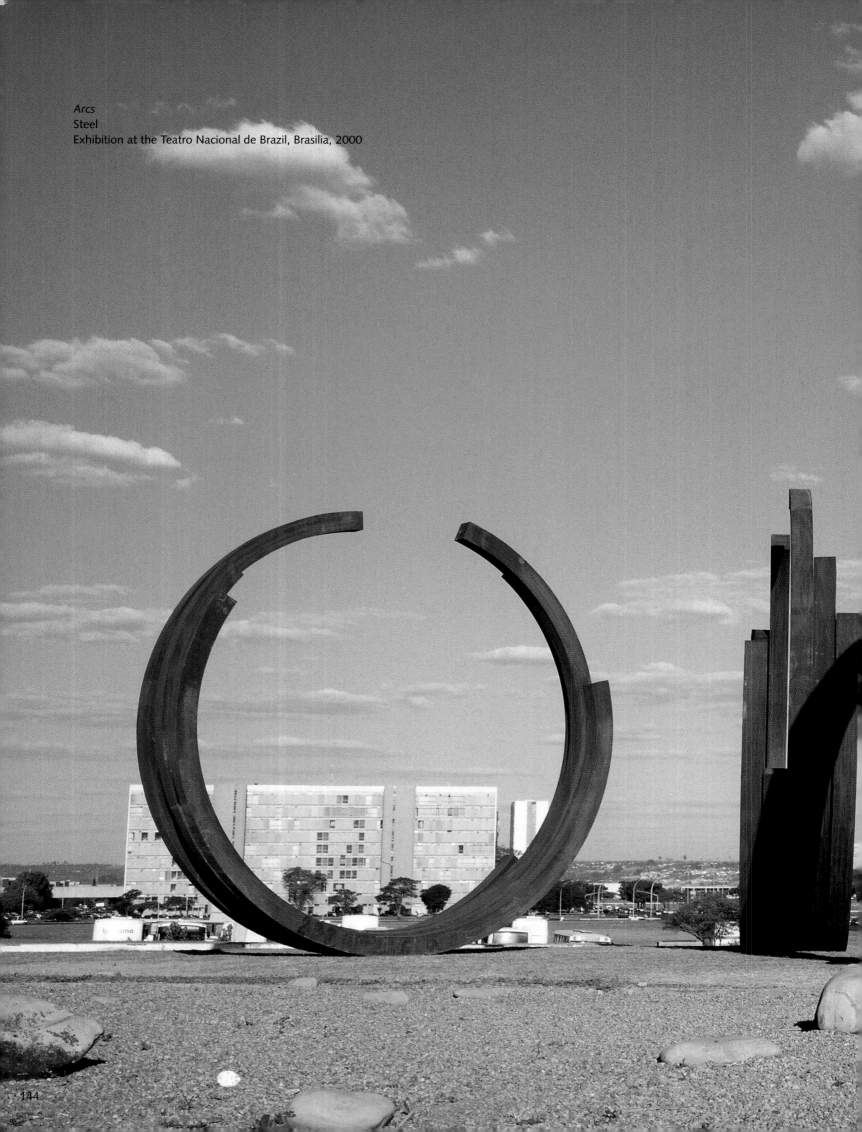

Arcs
Steel
Exhibition at the Teatro Nacional de Brazil, Brasilia, 2000

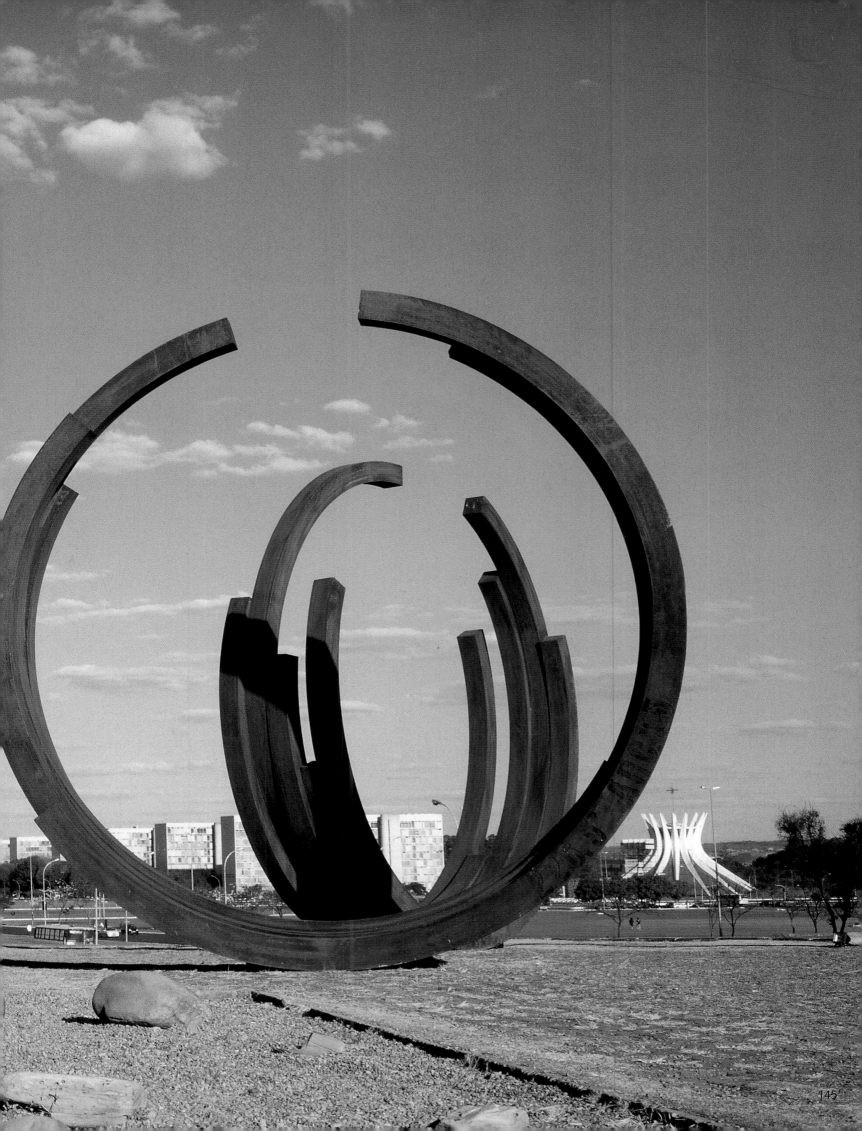

NON-REPRESENTATIONAL

I reject formalism just as much as the idea of abstraction, as they are commonly understood in the plastic arts. While abstract art refers to what is "non-representational", these new works function within another category. The "non-referential" is pushed to these extreme limits. We no longer have, as in abstract art, a symbolism of form or color, for instance. I offer a maximal self-referential system, which only a mathematical equation can contain.

Related to: *Sampling from a Normal Population*, 2000
Acrylic on canvas, 76.75 x 108.25 in.
Courtesy Grant Selwyn Galleries, New York and Los Angeles

Related to: *Homology of Simplical Complexes*, 2000
Acrylic on canvas, 77 x 94.5 in.
Courtesy Grant Selwyn Galleries, New York and Los Angeles

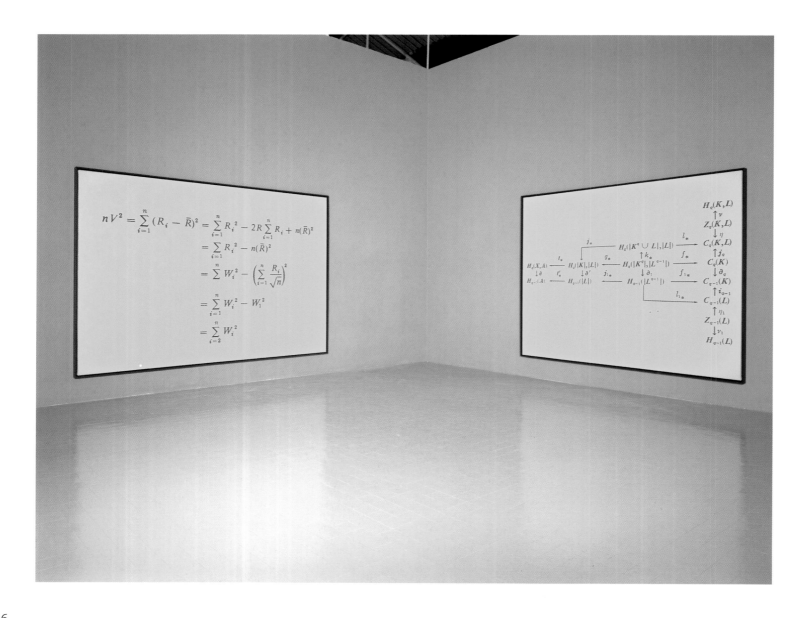

The artist's studio, Le Muy (France), 2001

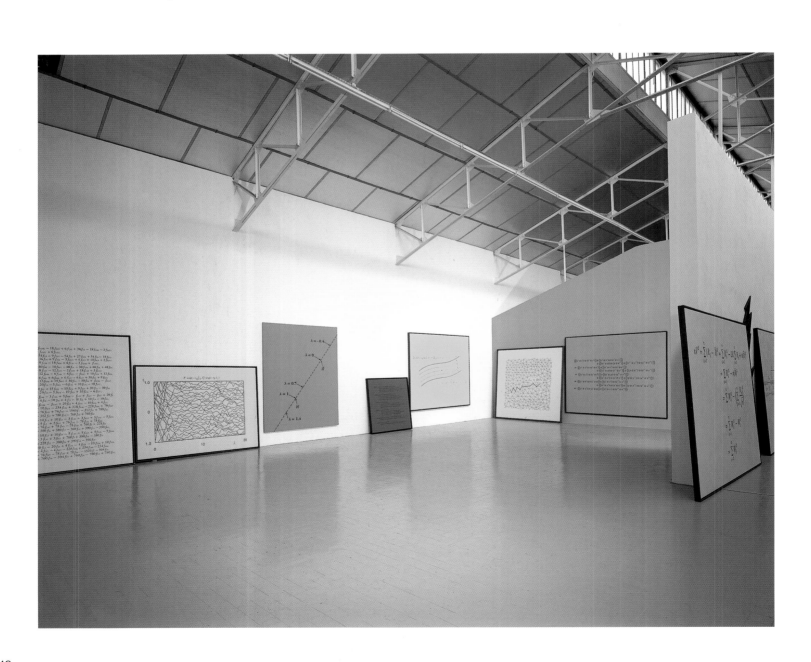

Related to: *Epitaxial Growth with Elastic Interaction*, 2000
Acrylic on canvas, 79 x 59.2 in.
Courtesy Grant Selwyn Galleries, New York and Los Angeles

Related to: *Algebraic Properties of Binary Operations*, 2000
Acrylic on canvas, 76.75 x 90.75 in.
Courtesy Grant Selwyn Galleries, New York and Los Angeles

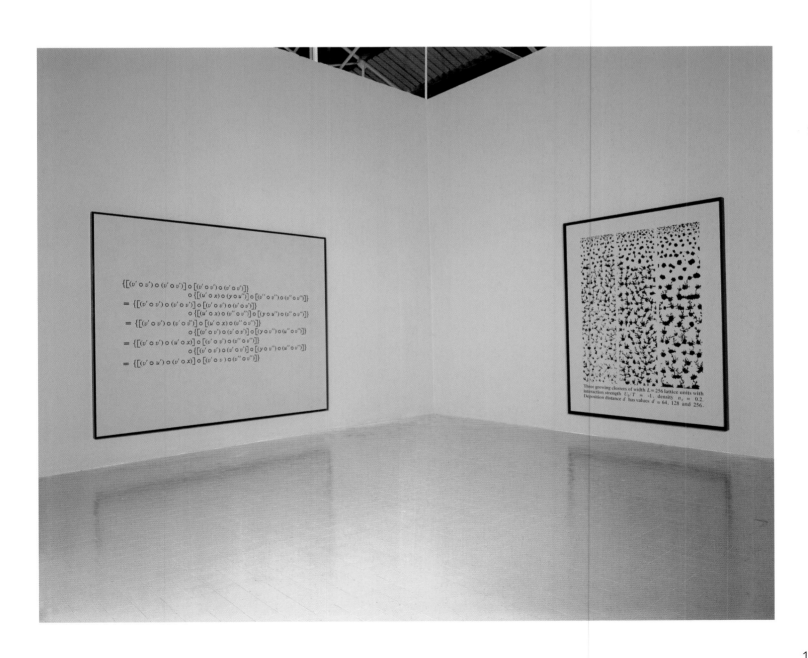

Wall Paintings exhibition: *Équations majeures*, Cajarc (France), centre d'Art contemporain Georges Pompidou, 2000

Foreign Security on May 15, 2002
Performance at the Centre Georges Pompidou, Paris, May 15, 2002
Film and poetry

Self-portrait tomodensitometric
Centre Georges Pompidou, Paris, May 15, 2002
Film and poetry

SELF-PORTRAIT

This project dates from 1967 when I approached various professors of medicine and asked them to carry out a complete physical analysis of all aspects of my body. This involved the most advanced technology available, including a radiological examination, blood test, electrocardiograms, functional respiratory exploration, etc.

In the same spirit, there are other self-portraits from this period, on graduated paper, treated with all the rigour of industrial designs. Viewed full face, in profile, from above, augmented by the exact dimensions and all the distinctive features needed for an objective description of the object "head of Bernar Venet".

It was a matter therefore of an objective self-portrait which replaced the traditional self-portrait (with its subjective viewpoint and interpretation expressing the artist's vision of the world and of human nature).

Through my friend Rodolphe Gombergh, an artist and radiologist, we have recently been able to produce what he himself calls a virtual clone in 3D. By using a spiral scanner, it is a description as close to reality as today's technology allows. The resulting image, projected onto a screen, is a highly realistic journey into the depths of the human body. The results of this "tomodensitometric" examination are read out on stage during the projection of the film.

Self-portrait tomodensitometric
Centre Georges Pompidou, Paris, May 15, 2002
Film and poetry

BIOGRAPHY

1941
Born on April 20 in Château-Arnoux-Saint-Auban, in the Haute-Provence Alps.
His father, Jean-Marie Venet, a schoolteacher and chemist, dies at the age of 40, leaving his widow Adeline Gilly in charge of their four sons, of whom Bernar is the youngest.

1947-1957
School at Château-Arnoux-Saint-Auban. As a boy, he suffers from asthma, and is forced to spend long spells at spas and a sanatorium in Saint Raphaël. During this period he is involved with religion, and aspires to become a missionary. With the encouragement of a local artist, he is already drawing and painting intensively by the age of ten.
At age eleven, Bernar is invited to exhibit in the Salon de Peinture Péchiney in Paris.

1958
He fails the entrance exams for the Decorative Arts School in Nice, and spends a year studying at the municipal art school, the Villa Thiole. There, his defense of Picasso's work shocks the Director, and he is suspended for a week.

1959
He works as a stage designer for the Nice City Opera, and produces highly stylized paintings that he describes as "symbolic".

1961
In February he begins 22 months of military service. Initially he is assigned to the army reception center in Tarascon. There, an attic is put at his disposal, which he converts into a studio. Initially his paintings are gestural, and executed with his feet, but they soon develop into black monochromes made of tar. In some cases, he works on a surface without leaving any trace of his action. The blank surface nevertheless becomes a work. These he calls "fetishist works".

1963
He returns to Nice, and establishes a studio in the old quarter, in Rue Pairolière. There are further developments of the tar paintings, and detailed photographs of heaps of gravel and tar. Other experimental photographic works. His first sculpture, *Coal Pile*, has no specific dimensions. It is characterized by extremely restrained means.
Towards the end of the year, he does the first *Cardboard Reliefs*, which he describes as "industrial paintings".
He becomes friendly with Arman and some New Realists in Paris (César, Hains, Villeglé), who offer to share exhibitions with him.

1964
He participates in the Salon Comparaisons at the Musée d'Art Moderne, Paris. He exhibits alongside the New Realist and Pop Artists, despite the intentionally divergent nature of his *Cardboard Reliefs*.

1966
His first trip to New York, in April and May.
He returns to Nice. He is invited to participate in *Impact 1*, an exhibition at the Céret museum, and sends a blueprint for a tube. He becomes aware of the objective aspect of blueprints, and their semantic characteristics. He works intently on diagrams, and creates his first mono-semiotic works.

He creates a project for a ballet to be danced on a vertical plane.
In December, he decides to permanently settle in New York. He initially lives in Arman's studio, 84 Walker Street, formerly Tinguely's studio.

1967

He stays at the Chelsea Hotel, and his conceptual work develops along logical lines.
He meets Minimalist artists through the Dwan Gallery.
He frequents the Mathematics and Physics Departments at Columbia University and befriends two researchers, Jack Ullman and Martin Krieger.
He produces "non-visual" works on magnetic tape. His focus is on content, not the visual characteristics of artworks.
He sets up a four-year program, intending to stop all artistic production upon its completion.

1968

He moves into a loft in SoHo, New York.
He works with scientists from Columbia University to stage a performance at the Judson Church Theater in SoHo, New York.
Work first exhibited in the USA and Europe.
Exhibition *Prospect 1968* at the at the Düsseldorf Kunsthalle, with Wide White Space Gallery wich also featured Beuys and Broodthaers,
Works are bought by the Krefeld Museum, which offers to stage his first museum exhibition.
The Museum of Modern Art, New York, acquires a Venet piece.
He meets Daniel Templon, who becomes his dealer in Paris at his gallery on Rue Bonaparte.
He participates in the exhibition *Conception-Konzeption* in Leverkusen, Germany.
He moves to a loft on Broadway, in SoHo. He meets Ella Bogval, whom he marries in 1971. They separate in 1982.

1969-1970

He travels and lectures across Europe, the United States and Japan. He decides, for theoretical reasons, to cease his artistique activities.
Retrospective at the Krefeld Museum, Germany.
He participates in the editions *Artists and Photography* at the Multiple Gallery, New York.

1971

Retrospective at the New York Cultural Center.
Publication of a *catalogue raisonné* of his conceptual work on the occasion of the exhibition at the New York Cultural Center.
Birth of his sons Stephane and Alexandre.

1972-1973

He returns to Paris.
A period of reflection: he writes about Conceptual Art and his own work. His purpose is to correct commentary that he judges to be erroneous, and to elucidate the nature and originality of his efforts.

1974

He teaches "Art and Art Theory" at the Sorbonne, Paris.
He lectures in France, England, Italy, Poland and Belgium.

A monograph by Catherine Millet is published by Editions du Chêne, France, and Edizioni Prearo, Italy.
Jean-Pierre Mirouze produces a film on Bernar Venet: *Œuvre terminée œuvre interminable*.
An exhibition of his conceptual works takes place at the Institute of Contemporary Art, London.
He represents France at the thirteenth São Paulo Biennale, Brazil, with Gottfried Honegger and François Morellet.

1976
He returns to New York in January. He moves to West Broadway and feels compelled to produce art again. The first canvases from the *Angles* and *Arcs* series are a group of extremely restrained paintings of elementary geometrical figures.
A retrospective of his conceptual works takes place at La Jolla Museum of Contemporary Art, La Jolla, USA.

1977
Exhibitions at Documenta VI, Kassel, Germany.
An exhibition of recent work at the Musée d'Art Moderne in Saint-Etienne, France.

1978
He participates in the exhibition *From Nature to Art. From Art to Nature* at the Venice Biennale, Italy.
Canvases: *Chords subtending Arcs*.

1979
He begins the series of wood reliefs *Arcs, Angles, Diagonals*, and creates the first *Indeterminate Line*.
He starts work on steel sculptures composed of two arcs. Concept for a monumental arc on a highway.
He receives a grant from the National Endowment of the Arts.
He develops the series of wood reliefs *Indeterminate Lines*.

1982
He moves to a loft on Canal Street, on the other side of the Hudson River.

1983
First maquettes for steel sculptures of indeterminate lines.
Seth Schneidman produces the film *Bernar Venet 1983* in New York.
Projects for monumental sculptures.

1984
November: he starts creating sculptures at Atelier Marioni, a foundry in the Vosges region of France.
First exhibition of *Indeterminate Lines*, (floor/wall) sculptures at Galerie Templon, Paris.
First plans for, and photocollages of, *The Major 185.4° Arc*.

1985
He meets Diane Segard, whom he marries in 1996.

1986
Public commissions in Epinal, France; Nice, France; Austin, USA; and Norfolk, USA.
These works are produced at François Labbé's foundry in Nice.

1987
For the 750th anniversary of the founding of Berlin, the French Ministry of Foreign Affairs and Air France, present the city with *Arc of 124.5°*. This sculpture measures 70 x 140 feet.

1988
Jean-Louis Martinoty asks him to stage his ballet *Graduation* (conceived in 1966) at the Paris Opéra. The artist is the author of the music, choreography, set designs and costumes.
He receives the Design Award for his sculpture in Norfolk, USA. Exhibition of photographs (1961-1988) at Galerie Michèle Chomette, Paris.
E.P.A.D. commissions the monumental *Two Indeterminate Lines* for the new business center at La Défense in Paris. Installation of *Arc of 115.5°* for Telic-Alcatel, Strasbourg.
Publication of a substantial monograph, *Venet*, by Jan van der Marck, Paris, Editions de la Différence.

1989
Awarded the Grand Prix des Arts de la Ville de Paris by Jacques Chirac, Mayor of Paris.
A series of new projects for steel reliefs called *Possibility of Indeterminacy*.
Performance of *L'intervention de l'artiste sur la Ligne à vif*, 23 November, at Galerie Templon, Paris.
He installs *Two Arcs of 197.5°* in Belley, France.
Aquisition of a factory at Le Muy, in the Var region of France, where he installs his works and collection. He lives and works there during the summer months.

1990
Inauguration of the monumental sculpture *Indeterminate Line* in Place de Bordeaux, Strasbourg, France.
First furniture exhibition at Galerie Mostra, Paris, and then Galerie Eric Van de Weghe in Brussels.
He creates the first maquettes and large-scale versions of *Random Combinations of Indeterminate lines*.

1991
He composes several pieces of music, including *Sound and Resonance* at Studio Miraval, Var, France.
Two CDs are released on the Circé-Paris label: *Gravier Goudron*, 1963, and *Acier Roulé E 24-2*, 1990.
He executes a series of new heavy, torch-cut steel furniture.
Noir, Noir et Noir, a book on Bernar Venet's photographic work from 1961 to 1991, is published by Editions Marval, Paris. Text by Jean-Louis Schefer.
He completes *Le Rocher des Trois Croix* (a joint tribute to Giotto, Grünewald and El Greco) installed atop the Roquebrune-sur-Argens mountain in the Var region of France.
Filming begins on Bernar Venet, *Lines*, by Thierry Spitzer and Jean-Marie del Moral.

1992
He records the sounds of an Air France Concorde engine for the musical composition *Wall of Sound*, and shoots the film *Acier Roulé XC-10* at the Marioni-Vosges workshop.
He travels to Japan for the inauguration of the sculpture at Adashi-ku, Tokyo.
He inaugurates a series of steel reliefs composed of arrows: *Arbitrary and Simultaneous Directions*.
Solo exhibition at the Person's Weekend Museum, Tokyo, Japan.
He participates in the *Manifeste* exhibition at the Centre Georges Pompidou, Paris, France.

1993
He is invited to participate in an artists' film festival in Montreal with his film *Acier Roulé XC-10* (Rolled Steel XC-10).

A retrospective exhibition takes place at the Musée d'Art Moderne et d'Art Contemporain in Nice, France, then travels to the Wilhelm-Hack Museum in Ludwigshafen, Germany.

1994
Jacques Chirac, then the Mayor of Paris, invites Venet to present twelve sculptures from his *Indeterminate lines* series on the Champ-de-Mars from May to July.
He works on the first *Barres droites* sculptures.
Publication of the monograph *Bernar Venet*, with a text by Carter Ratcliff, Abbeville Press, New York, USA, Cercle d'Art, Paris, France.

1995
In the spring, he travels to San Francisco for the inauguration of his monumental sculpture *Indeterminate line* at the Runnymeade Sculpture Farm.
In May, at the Museum of Modern Art in Kowloon, he inaugurates the first exhibition in the world tour of the works presented in 1994 on the Champ-de-Mars.
In June, he is the first artist to exhibit at the new Museum of Art in Shanghai.
A stay at Graphicstudio, Tampa, USA, for an edition of large monoprints made with tar and the use of a steam roller.
He develops new work on the theme of the straight line: *Accident Pieces*.
New reliefs executed in steel with an acetylene torch: *Indeterminate Area*.

1996
He is invited as a "Master in Residence" to the Atlantic Center for the Arts in Florida, USA.
He is awarded the honor of Commandeur in the Ordre des Arts et Lettres by the French Minister of Culture.
Thierry Spitzer films an installation of *Accident* – new works composed of straight lines, which are also exposed at the Galerie Karsten Greve in Paris, and in July at the Espace Fortant de France in Sète.
From May to July, the city of Brussels invites Venet to exhibit ten large sculptures from the *Indeterminate lines* series on Avenue Franklin Roosevelt.

1997
He moves to a studio in Chelsea, New York City.
He begins a new series of sculptures entitled *Four Arcs* and *Five Arcs*.
He designs a museum complex for an exhibition at the Espace d'Art Concret in Mouans-Sartoux, France.
He becomes a Member of the European Academy of Sciences and Arts in Salzburg, Austria.

1998
He travels to China. He is invited by the mayor of Shanghai to participate in the Shanghai International Sculpture Symposium.
He executes large-scale *Four Arcs* sculptures, and intensively develops *Indeterminate Area* reliefs during the summer in Le Muy.

1999
The third and definitive version of the film *Tarmacadam* (1963, black and white, 3' 20") is produced with the help of Arkadin Productions for the exhibition *Bernar Venet (1961-1963)* at the Musée d'Art Moderne et Contemporain, Geneva.
Installation of a public sculpture in Cologne, Germany, for the G8 summit meeting.
Publication of his poetry *Apoétiques 1967-1998* by the Musée d'Art Moderne et Contemporain, Geneva.
Public commissions for the new university in Geneva.

2000

He develops a new series of wall paintings called *Major Equations*, which are exhibited at the Museu de Arte Moderna in Rio de Janeiro, Brasília and Saõ Paulo, and at the Centre d'Art Contemporain Georges Pompidou in Cajarc, France, as well as Mamco in Geneva, Switzerland.
Public commission for the city of Bergen, Norway.
A year of important publications: *Bernar Venet 1961-1970*, a monograph about the young artist by Robert Morgan; *Sursaturation*, an original work about reflexions on the possibilities of literature; *Bernar Venet – sculptures & reliefs*, by Arnauld Pierre; *Furniture*, by Claude Lorent, with all the steel furniture designed by the artist since 1968; *La Conversion du regard*, with texts and interviews from 1975-2000; *Global Diagonals*, a catalogue concerning a humanistic, artistic and technological project with straight lines (300 feet each) virtually connecting the five continents.

2001

An exhibition of new paintings on canvas at the Jérôme de Noirmont gallery, Paris.
A poetry reading at the White Box (New York), with Robert Morgan.
The inauguration of the Chapelle Saint Jean in Chateau-Arnoux. The stained glass windows and the furniture are designed by Venet.
Furniture is exhibited at SM'ART (Salon du Mobilier et de l'Objet Design), at the Caroussel du Louvre in Paris.
An exhibition of furniture at the Rabouan Moussion Gallery in Paris. On this occasion, Editions Assouline published *Furniture* (written by Claude Lorent), covering all Venet's design work since 1968.

2002

Produces of a movie on the theme of saturation: *The Noise Theory*.
Performs (poetry reading, film and music) at the Musée National d'Art Moderne, Centre Georges Pompidou, Paris, France. (Bernar Venet shows his self-portrait: a film, the result of a tomodensitometric exam showing the artist's body in a three dimensional view.)
Twelve large sculptures are exhibited at "The Fields – Art Omi International Arts Center", New York state, USA.
Exhibition of the new paintings in the Ludwigmuseum in Koblenz (Germany).
Fall: two shows in NYC (paintings at the Grant Selwyn Gallery, sculptures at the Robert Miller Gallery).
The exhibition at Art Omi (upstate NY) moves to Florida, to the Atlantic Center of the Arts.
Works on important commissions for the cities of Denver, San Francisco, Toulouse (France), and Mouans-Sartoux (Var, France).

BIBLIOGRAPHY, EXHIBITIONS, COLLECTIONS

MONOGRAPHS

Catherine Millet, *Bernar Venet,* Editions du Chêne, Paris, France, 1974

Jan Van der Marck, *Venet,* Editions de la Différence, Paris, France, 1988

Jean-Louis Schefer, *Noir, Noir et Noir*, Marval, Paris, France, 1990

Carter Ratcliff, *Bernar Venet,* Cercle d'Art, Paris, France, Abbeville Press, New York, USA, 1993

Ann Hindry, *L'Equation Majeure,* Flammarion, New York, USA, Paris, France, 1997

Robert Morgan, *Bernar Venet 1961-1970*, Les Cahiers Intempestifs, Saint-Etienne, France, 1999

Bernar Venet, *Apoétiques 1967-1998*, Mamco, Geneva, Switzerland, 1999

Arnauld Pierre, *Bernar Venet, "Le discours et la méthode"*, Prearo Editore, Milan, Italy, & Editions Marval, Paris, France, 2000

Bernar Venet, *Sursaturation*, Centre d'Art Contemporain George Pompidou, Carjac, France, 2000

Bernar Venet, *La Conversion du Regard. Textes et entretiens 1975-2000*, Mamco, Geneva, Switzerland, 2000

Claude Lorent, *Furniture,* Assouline, New York, USA, Paris, France, 2001

SELECTED ARTICLES 1970-2001

Lawrence Alloway, "Bernar Venet", *Arts Magazine*, New York, USA, March 1970

Bruno d'Amore, "Dove va l'Arte Concettuale", *Gala International*, Italy, May 1978

Robert Arnoux, "Bernar Venet – La Ligne Dure", *No. 13 Magazine*, France, June 1994

Jacques Bouzerand, "Document – Art Contemporain. Bernar Venet l'aventurier de la ligne", *Le Point*, France, No. 1003, December 13, 1991

Jack Burnham, "Kunst und Structuralismus", *Dumont Actuel*, Germany, 1973

Elio Cappuccio, "Bernar Venet", *Tema Celeste*, Italy, October 1998

Nadine Descendre, "BERNAR entre les lignes VENET", *Beaux-Arts Magazine*, Paris, France, May 1994

Eddy Devolder, "Bernar Venet: Entretien", *Arte Factum*, Belgium, September-October 1991

Michel Ellenberger, "Lignes indéterminées aux Champ-de-Mars", *Cimaise*, France, July 1994

Dr. Amine Haase, "Bernar Venet – Kunst begegnet der Mathematik", *Kunstforum International*, Germany, February-May 1997

Jacques Henric, "Bernar Venet, un iconoclaste baroque", *Art Press*, France, October 1986.

David Higginbotham, "Position of an Indetermined Line, Position of a Determined Artist", *Arte Factum*, Belgium, September 1985

Ann Hindry, "La ligne continue de Bernar Venet ou le plaisir progressif du glissement de contexte", *Tema Celeste*, Italy, June 1988

Bernard Huin, "Institution radicalisation – sculptures contemporaines: 1970-1986", *Artstudio*, France, winter 1986-1987

Thierry Kuntzel and Bernar Venet, "Logique du Neutre" and "Analyse de: *Représentation Graphique de la fonction y =-x²/4*", *Art Press*, No. 14, France, 1974

Donald Kuspit, "Emblematic Line", *Galeries Magazine*, New York, USA, April-May 1990

Donald Kuspit, "Bernar Venet's New Wall Paintings", *NY ARTS*, New York, USA, September 2000

Sanford Kwinter, "The Pragmatic of Turbulence: The new Lines of Bernar Venet", *Arts Magazine*, New York, USA, December 1985

Bernard Lamarche-Vadel, "Dossier Bernar Venet", *Artistes*, France, October 1981

Marie-Lou Lamarque, "Interview – Bernar Venet", *Art thèmes*, France, December 1991-January 1992

Jacques Lepage, "Bernar Venet", *Canal*, France, 1985

Claude Lorent, "Tapis vert pour les lignes de Bernar Venet", *Art et Culture*, Belgium, June 1996

Alain Macaire, "Du Minimal au Complexe", *Canal*, France, spring 1984

Rosiak Mariusz, "Bernar Venet – Atelier 340 – Bruksela", *Artelier Kwartalnik Arty Styczny*, Poland, No. 3-4, 1993

Filiberto Menna, "Doppo il concettualismo", *Le Arte News*, Italy, January 1984

Catherine Millet, "L'art conceptuel comme sémiotique de l'art", *VH 101*, No. 3, Editions F. Esselier, Paris, France, 1970

Catherine Millet, "Bernar Venet, la fonction didactique de l'art conceptuel", *Art International*, Switzerland, December 1970

Catherine Millet, "Bernar Venet dans et hors la logique – Logic and chance", *Art Press*, No. 220, France, January 1997

André Parinaud, "Bernar Venet", *Aujourd'hui POÈME*, France, March 2000

Enrico Pedrini, "L'art conceptuel: L'idée de l'art et l'art sont la même chose", *Art Jonction – Le Journal*, France, 1998

Enrico Pedrini, "Bernar Venet ", *Segno*, France, June-July 2001

Philippe Piguet, "Bernar Venet – Spirale et Mouvement", *Connaissance des Arts*, Paris, France, May 1994

Philippe Piguet, "Bernar Venet variations pour équations", *L'Œil*, Paris, France, March 2001

Carter Ratcliff, "Venet's Platonic Disorder", *Art in America*, New York, USA, October 1992

Carter Ratcliff, "Bernar Venet", *Sculpture*, New York, USA, March 1999

Delphine Renard, "Bernar Venet", *Flash Art*, Italy, spring 1985

Pierre Restany, "Bernar Venet, la poursuite de l'analyse jusqu'au dépassement du moi", *Domus*, Italy, October 1970

Barbara Rose, "Bernar Venet: From Nice to New York", *The Journal of Art*, New York, USA, 1989

Gilbert Samel, *La couleur et la nature dans la Ville*, Editions du Moniteur, Paris, France, 1988

Hilarie Sheets, "Venet – From Simple Geometry to the Crazy Line", *Art News*, New York, USA, November 1994

Jan Van Der Marck, "Bernar Venet and the Rational Image", *Art Forum*, New York, USA, January 1979

Li Xu, "An Interview with the French Sculptor, Bernar Venet", *Jiangsu Art Monthly*, Nanjing, China, October 1995

Anna Zongh, "Abstract show to shape in Square", *Shanghai Star*, China, May 23 1995

SOLO EXHIBITIONS 1999-2002

For previous solo exhibitions, see Arnaud Pierre's monograph, *Bernar Venet, "Le discours et la méthode"*, Prearo Editore, Milan, Italy, & Editions Marval, Paris, France, 2000

1999
Centro Cultural de Recoleta, Buenos Aires, Argentina
Improvisé – Inachevé – Non-Formulé, Mücsarnok, Budapest, Hungary
Kunst im Bethmannhof, Galerie Scheffel, Frankfurt, Germany
Art Affairs, Amsterdam, The Netherlands
Musée d'Art Moderne et d'Art Contemporain, Geneva, Switzerland
Konstructiv Tendens, Stockholm, Sweden

2000
Eaton Fine Art, West Palm Beach, Florida, USA
Museu de Arte Moderna do Rio de Janiero, Rio de Janeiro, Brazil
Centre d'Art Contemporain Georges Pompidou, Cajarc, France
Salle des Ecritures, Figeac, France
Teatro Nacional de Brasília, Brazil
Musée d'Art Moderne et d'Art Contemporain, Geneva, Switzerland
Galerie Forsblom, Helsinki, Finland
Museu Brasileiro da Escultura, São Paulo, Brazil

2001
Galerie Jérôme de Noirmont, Paris, France
Galerie Haas & Fuchs, Berlin, Germany
Dorothy Blau Gallery, Bay Harbor Island, Florida, USA
Furniture, Galerie Rabouan Moussion, Paris, France
Galerie Hans Mayer, Berlin, Germany

2002
Galerie Academia, Salzburg, Austria
Galerie Art of this Century, Paris, France
Performance-Poetry, Musée National d'Art Moderne, Centre Georges Pompidou, Paris, France
LudwigMuseum, Koblenz, Germany
The Fields Sculpturepark, Art OMI, New York, USA

GROUP EXHIBITIONS 1999-2002

For previous solo exhibitions, see Arnaud Pierre's monograph, *Bernar Venet, "Le discours et la méthode"*, Prearo Editore, Milan, Italy, & Editions Marval, Paris, France, 2000

1999
Passions de France, Centre Culturel Français de Turin, Turin, Italy
Geometry as Form – Structures of Modern Art from Albers to Paik, Nationalgalerie, Berlin, Germany
Heroines & Heroes II, The Howland Cultural Center, Beacon, New York, USA
Passions de France, curated by Enrico Pedrini, Galleria Francese, Rome, Italy
Hors les Murs, Museu de Arte Moderna do Rio de Janiero, Rio de Janeiro, Brazil
Travelling to: Museo Pinacoteca de São Paulo, Parque da Luz, São Paulo, Brazil
Les Champs de la Sculpture 2000, Champs-Élysées, Paris, France
China Contemporary Sculpture Annual, The He Xiangning National Art Gallery, Shenzhen, China
A Broad View, Eaton Fine Art, West Palm Beach, Florida, USA
Une histoire parmi d'autres, Collection Michel Poitevin, FRAC Nord-Pas-de-Calais, Dunkirk, France
La nature imite l'art, Espace de l'Art Concret, Mouans-Sartoux, France
Eric Linard – L'Editeur du val des nymphes, Centre Rhénan d'Art Contemporain Alsace, Altkirch, France
Geometrisk Abstraktion XVIII, Konstructiv Tendens, Stockholm, Sweden

2000
Time, Suspend Your Flight, Bergen Kunst Museum, Bergen, Norway; also at Reykjavik Art Museum, Reykjavik, Iceland
From Albers to Paik – Œuvres constructives de la Collection DaimlerChysler, Stiftung für konstruktive und konkrete Kunst, Zürich, Switzerland
Objet de l'art, art de l'objet, Galerie Beaubourg, Château Notre-Dame des Fleurs, Vence, France

May in New York, Carl Schlosberg Fine Arts, New York, USA
Le musée du XXe siècle de Michel Ragon, Hôtel du Département de la Vendée, La Roche-sur-Yon, France
On Paper: A Large Selection, Eaton Fine Art, West Palm Beach, Florida, USA
Making Choices – Useless Science, MoMA, New York, USA
Fahrvergnügen / Play While You Wait, American Fine Arts Co., New York, USA
Stock from the Last Century (2): 1980-2000, Art Affairs, Amsterdam, Holland
Le Paradoxe d'Alexandre, Un Parcours: 1960-2000, Galerie Alexandre de la Salle, Château de Carros, Carros, France
Nice Movements – Contemporary French Art, Musées des Beaux Arts de Mâcon, France
Vancouver International Sculpture Project, Buschlen Mowatt Galeries, Vancouver, Canada
L'Art contemporain à Parly 2, Centre Commercial Parly 2, Le Chesnaye, France
Ligne(s) de conduite, Espace de l'Art Concret, Mouans-Sartoux, France
Musée d'Art Moderne et d'Art Contemporain, Geneva, Switzerland
The Eye of the Storm, curated by Victor de Circasia, Villa dei Laghi, Parco La Mandria, Turin, Italy
Donald Judd & Bernar Venet – Mobilier/Furniture, Biennale International Design Festival, Saint-Etienne, France
Dallas Art Fair, Buschlen Mowatt Galleries, Dallas, Texas, USA
Riva Yares 2000 – The First 35 Years, Riva Yares Gallery, Scottsdale, Arizona, USA
Tacit Messengers, Gertrude Stein Gallery, New York, USA

2001
Cordero King Venet, In The Same Space, curated by Victor de Circasia, Museo dell'Automobile, Turin, Italy
Neue Kunst in alten Gärten, Hanover, Germany
West Palm Beach Art Fair, Buschlen Mowatt Galleries, West Palm Beach, Florida, USA
Art Miami, Buschlen Mowatt Galleries, Miami, Florida, USA

Kirkland International Outdoor Sculpture Exhibition 2001, Buschlen Mowatt Galleries, West Palm Beach, Florida, USA, and City of Kirkland, Washington, USA.
The Armory Show 2001, Galerie Roger Pailhas, Pier 88/220, New York, USA
The Stockholm Art Fair, Galerie Kaj Forsblom, Stockholm, Sweden
After the Beginning and Before the End, Instruction Drawings, from the Lila and Gilbert Silverman Collection, Bergen Art Museum, Detroit, USA
Time, suspend your Flight, Bergen Art Museum, Detroit, USA
Open 2001, Venice, Italy
Sculptures Avenue Foch, Le Havre, France
10 Ans, Centre d'Art Contemporain, Bouvet Ladubay, France
Arte Abstraco y La Galerie Denise René, Centro Atlantico de Arte Moderno, Las Palmas, Spain
Collections d'Artistes, Lambert Fondation, Avignon, France
Konstruktiv-konkrete Kunst-Bilder und Skulpturen – gesammelt in 25 Jahren, Josef Albers Museum, Quadrat Bottrop, Bottrop, Germany
Stöffel Collection, Stöffel, Cologne, Germany

2002
What about Hegel (and You), Brigitte March Galerie, Stuttgart, Germany
Water-Sand-Space, New Sarjah Art Museum, United Arab Emirates
Quinze Variations sur un même thème, Espace de l'Art Concret, Mouans-Sartoux, France
1968-1977 L'art en cause(s), CAPC, Musée d'Art Contemporain, Bordeaux, France

PUBLIC COLLECTIONS

Akron Art Institute, Akron, USA
Art Omi International Arts Center, New York, USA
Atlantic Richfield Corporation, Los Angeles, USA
AT&T, Minneapolis, USA
Citibank Corporation, New York, USA
Cleveland Center for the Arts, Cleveland, USA
Colonnade III Plaza, MEPC & Equity Properties, Dallas, USA
Contemporary Art Center, San Diego, USA
DaimlerChrysler Collection, Stuttgart, Germany
Dartmouth College Museum and Galleries, Hanover, USA
Elvehjem Museum of Art, University of Wisconsin-Madison, Madison, USA
Espace de l'Art Concret, Mouans Sartoux, France
Esplanade de Uni Mail, Geneva, Switzerland
Esquire Company, Seoul, Korea
First National Bank, Seattle, USA
Fond d'Art Contemporain des Musées de Nice, Nice, France
Fondation Pierre Gianadda, Martigny, Switzerland
Foundation Domnick, Nürtingen, Germany
Georgia Museum of Art, Athens, USA
Goldman Sachs, New York, USA
He Xiangning Art Gallery, Shenzhen, China
Hirshhorn Museum and Sculpture Garden, Washington DC, USA
Ho-Am Art Museum, Seoul, Korea
Ilshin Spinning Company, Seoul, Korea
Josef Albers Museum, Quadrat, Bottrop, Germany
Jumex Foundation, Mexico City, Mexico
Kaiser Wilhelm Museum, Krefeld, Germany
Maison Européene de la Photographie, Paris, France.
McCrory Corporation Collection, New York, USA
Milwaukee Art Museum, Milwaukee, USA
MIT Permanent Collection, MIT, Cambridge, USA
Musée d'Art Contemporain de Dunkerque, Dunkirk, France
Musée d'Art et d'Histoire, Geneva, Switzerland
Musée d'Art Moderne et d'Art Contemporain (Mamco), Geneva, Switzerland
Musée d'Art Moderne, Saint-Etienne, France

Musée d'Art Moderne et d'Art Comtemporain, Nice, France
Musée de Peinture et de Sculpture, Grenoble, France
Musée des Arts Décoratifs, Paris, France
Musée du Québec, Québec, Canada
Musée National d'Art Moderne Centre Georges Pompidou, Paris, France
Musée National d'Art Moderne de Liège, Liège, Belgium
Musée Sainte-Croix, Poitiers, France
Musées Royaux de Belgique, Brussels, Belgium
Museum of Art, University of Iowa, Iowa City, USA
Museum of Contemporary Art, Chicago, USA
Museum of Contemporary Art, Los Angeles, USA
Museum Sztuky W. Lodzi, Lodz, Poland
Neue Galerie im Alten Kurhaus, Aachen, Germany
North Fork Bank Collection, Melville, USA
Person's Weekend Museum, Tokyo, Japan
Polk Museum of Art, Lakeland, USA
San Diego Art Center, San Diego, USA
Santa Barbara Museum of Art, Santa Barbara, USA
Sara Hildén Fundation, Tampere, Finland
Skulpturenpark, Cologne, Germany
Smalley Sculpture Garden, University of Judaism, Los Angeles, USA
Sonja Henie – Niels Onstad Foundations, Hovikodden, Norway
Sonje Museum of Contemporary Art, Kyongbuk, Korea
The Arkansas Arts Center, Little Rock, USA
The Detroit Institute of Arts, Detroit, USA
The Museum of Modern Art, New York, USA
The National Gallery of Art, Washington DC, USA
The New York University Art Collection, New York, USA
The Solomon R. Guggenheim Museum, New York, USA
Total Museum of Contemporary Art, Seoul, Korea
Von der Heydt Museum, Wüppertal, Germany
Wadsworth Athenaeum, Hartford, USA
Wilhelm-Hack-Museum, Ludwigshafen, Germany
Yale University, New Haven, USA

PUBLIC COMMISSIONS

Acropolis, Nice, France
Archon Company, Austin, USA
Bank Al Maghrib, Agadir, Morocco
Beijing Silver Tower Real Estate Development Co., Beijing, China
Belley, France
City of Adachi, Tokyo, Japan
City of Bergen, Bergen, Norway
City of Cologne, Cologne, Germany
Collège & Ecole de Commerce Emilie-Gourd, Geneva, Switzerland
Epinal, France
Espace Fortant de France, Sète, France
Goodman Segar Hogan, The World Trade Center, Norfolk, USA
Hansol Company, Seoul, Korea
Jardin Albert 1er, Nice, France
Kurpark, Bad Hamburg, Germany
La Chapelle Saint Jean, Châteaux-Arnoux, France
La Défense, Paris, France
Lille, France
Miyagi Prefectural Library, Sendai, Japan
Place de Bordeaux, Strasbourg, France
Rocher de Roquebrune, Roquebrune-sur-Argens, France
Runnymeade Sculpture Farm, Woodside, USA
Urania Platz, Berlin, Germany

ACKNOWLEDGMENTS

Christian Bernard
Pierre Bourrier
Aurélie Bouvart
Bernard Ceysson
Jean-Luc Daval
Bruno Enten
Rodolphe Gombergh
Stephan Fowlkes
Jean-Louis Mauban
Till Schaap
Laszlo Szalaï

PHOTOGRAPHIC CREDITS

Peter Knapp – Paris
Burkhard Maus – Germany
André Morin – Paris
Bill Orcut – USA
Georges Poncet – Paris
David Reynolds – New York
Sammlung Domnick – Germany
Fotostudio Schaub, Bernhard Schaub, Ralf Hoffner – Cologne
Diane Segard – Paris
Harry Shunk – New York
Sygma, Vo Trung Dung – Paris
Bernar Venet Archives – New York
All rights reserved

Cover : Bernar Venet, *5x5 Arcs*, 2002, Art Omi International Arts Center,
New York, USA

Artha, Lyon – gilles.fage@wanadoo.fr
Copy editing : Philippe Grand
Translation : John Doherty, Michael Westlake
Graphic design : Estelle Daval, Saint-Julien-en-Genevois
Photolithography : Fayolle, Vaulx-en-Velin
Printing : Graphicom Srl, Vicenza (Italy)

ISBN 2 84845 006 1 (English edition, Artha and Benteli Publishers)
ISBN 2 84845 002 9 (French edition, Artha Publishers)
ISBN 3 7165 1282 6 (German edition, Benteli Publishers)